MW01169185

Graphis is committed to presenting exceptional work in international Design, Advertising, Illustration & Photography. In the following pages, we celebrate the year's best student work from around the globe. Six instructors, whose inspiration consistently resulted in outstanding work, have each earned a Graphis Platinum Award. Each of the students have also earned a Graphis Gold Award. We are proud to honor them here, and look forward to their future success.

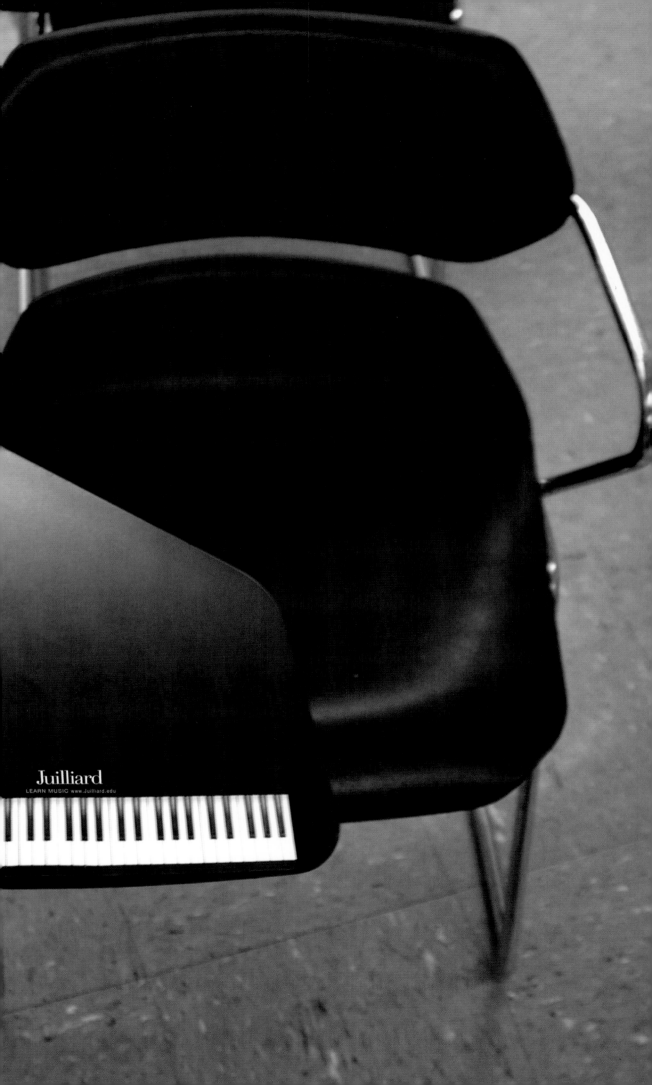

Juilliard
LEARN MUSIC www.Juilliard.edu

Published by Graphis | **Publisher&CreativeDirector: B. Martin Pedersen** | **Design: Yon Joo Choi, JiEun Lee** | **Editorial: Ariel Davis, Eby Gagel** | **Production: Jennifer Berlingeri, Abigail Jemma Newman** | **Support Staff: Rita Jones, Carla Alicia Miller** | **Design&Production Interns: Jarrod Francis Barretto, Natalie Marie Davis, Joseph Lee, Kimberly Lennex**

Remarks: We extend our heartfelt thanks to contributors throughout the world who have made it possible to publish a wide and international spectrum of the best work in this field. Entry instructions for all Graphis Books may be requested from: Graphis Inc., 307 Fifth Avenue, Tenth Floor, New York, New York 10016, or visit our web site at www.graphis.com.

Anmerkungen: Unser Dank gilt den Einsendern aus aller Welt, die es uns ermöglicht haben, ein breites, internationales. Spektrum der besten Arbeiten zu veröffentlichen. Teilnahmebedingungen für die Graphis-Bücher sind erhältlich bei: Graphis, Inc., 307 Fifth Avenue, Tenth Floor, New York, New York 10016.Besuchen Sie uns im World Wide Web, www.graphis.com.

Remerciements: Nous remercions les participants du monde entier qui ont rendu possible la publication de cet ouvrage offrant un panorama complet des meilleurs travaux. Les modalités d'inscription peuvent être obtenues auprès de: Graphis, Inc., 307 Fifth Avenue, Tenth Floor, New York, New York 10016. Rendez-nous visite sur notre site web: www.graphis.com.

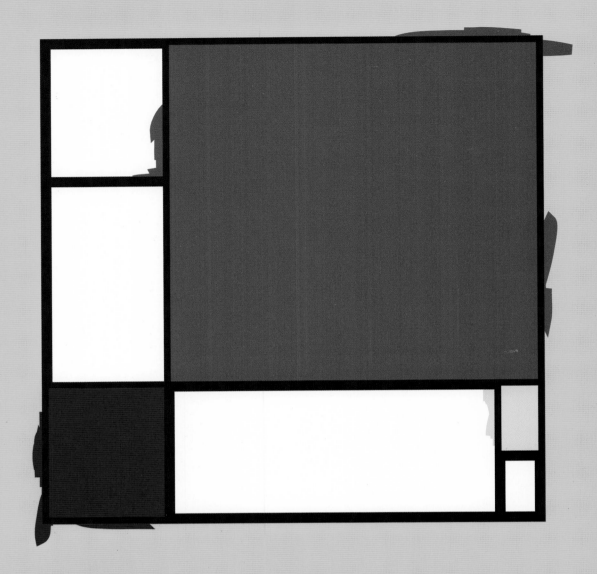

Painter Piet Mondrian was five once, too.

Contents

Page 1: Award photograph by Henry Leutwyler | *Previous Spread:* Jeongjyn Yi, School of Visual Arts | *Opposite Page:* John Gilmore, School of Visual Arts

Jeffrey Metzner passed away on February 15th, 2008 at his home in Red Hook, Brooklyn. He was 66 years old. It was a sudden and unexpected passing, and the cause was determined to be heart failure. Jeffrey was the patriarch of a large and loving family that will miss him greatly and do their best to carry on his memory. His wife Sheila Metzner and his children—Alison, Evyan, Jesse, Raven, Bega, Ruby, Stella and Louie—survive him. His legacy also continues with his grandchildren—Harrison, Parker, Fortune, Sitara, Olivia, Clarissa, Silver, Hugo, Kestrel and Orion. Jeffrey Metzner was born in New York City on May 9th, 1941. He attended Forest Hills Elementary and High School and left home at the age of 16 to enter the field of advertising. Mentored by the great George Lois, he was the youngest art director hired at Doyle Dane Bernbach in the glory days of the "Golden Age of Advertising" and was an innovator on many of their top accounts. Jeffrey later became a television commercial director and formed Jeffrey Metzner Productions and later Metzner, Bruce, Mitchell Productions. Jeffrey briefly went back to Advertising as a freelance creative director before finding his true calling as a teacher at the School of Visual Arts in New York City. For many years he taught an acclaimed "Senior Portfolio Class" and a class called "The Process" that was designed to help students unlock their creative potential. He also taught a breakthrough class in digital video that was on the cutting edge of technology and concept and led to his founding and running the Motion Graphics Department at SVA. In his spare time Jeffrey also conceived a book called "Stick: Great Moments in Art, History, Film and More" that was published by Random House in 2006. The Museum of Modern Art currently carries the book and other Stick merchandise at its museum store.

Jeffrey received many awards and accolades over the years, but for all his professional accomplishments his true passion and creativity were rarely glimpsed. Only his family and friends knew of his range and tremendous talent as a visual artist. He was a visionary painter, sculptor, typographer, craftsman, designer, graphic artist and storyteller. He brought a wholly original viewpoint to any artistic medium he chose to pick up, and was always willing to share his ideas and creations with anyone who would take the time to listen or look. Jeffrey was my father, and I am comforted by the fact that his life was, by his own admission, an amazing adventure. He traveled the world and saw all the places he had ever dreamed of visiting. He made many fulfilling friendships and fathered a large and loving family. He did everything he set out to do and did it well. He always maintained that his greatest achievements were the children he had brought into the world and the long and passionate love affair with my mother, in which he remained entangled until the moment he was gone. Jeffrey was a caring and wonderful father who left us many wonderful memories and impressions. He also left us the treasure of his beautiful work and a legion of students inspired to follow in his footsteps and continue it. Arguably the most important thing that remains is his mantra, one that bears repeating. In times of trouble, whether personal or professional, Jeffrey always had the same sage advice: "Follow your heart," he would say, "it will never steer you wrong." This great truth and the indelible memory of his daybreak of a smile are the great legacies he has left to those of us who loved him and will forever miss his presence among us.
Raven Metzner, 2008

"He always maintained that his greatest achievements were the children he had brought into the world and the long and passionate love affair with my mother, in which he remained entangled until the moment he was gone."

Raven Metzner, *Son*

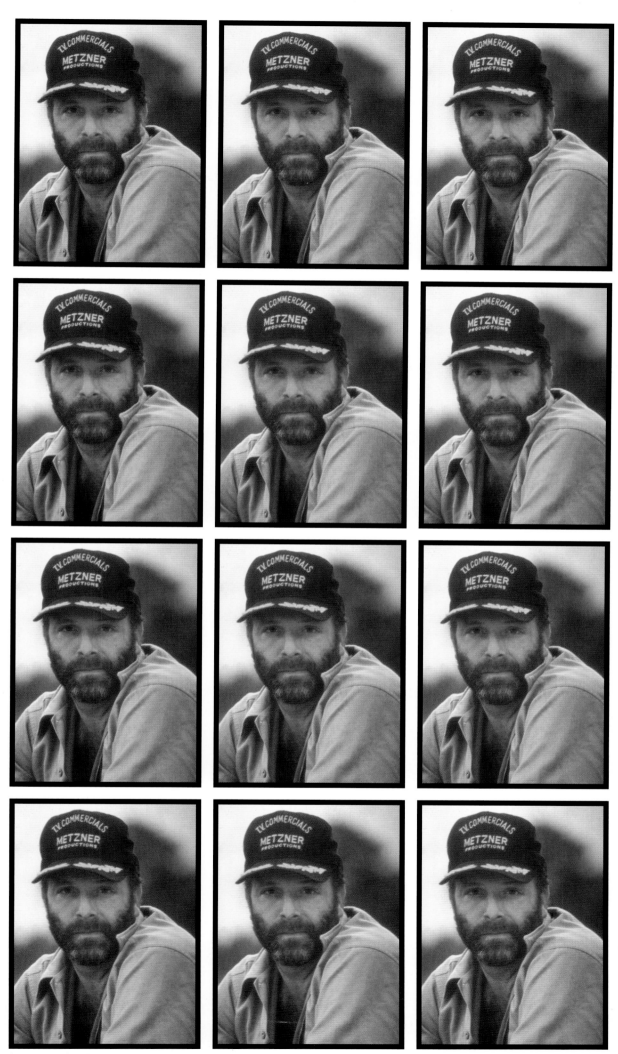

Opposite page: Stick Book | *This page:* Jeffery Metzner headshot photographed by Sheila Metzner | *Following Spread: (top)* Family Portrait, *(bottom)* Stick-Last Supper

"Jeffrey was my father, my teacher, my shaman and my friend. He taught me to follow my heart, and make every decision based on what my heart told me."

Louie Guy Metzner, *Son*

"'These dreams that you have, do them, do them all.' That's Jeffrey in 1996, giving me a pep talk when I was 21 years old at The Jerusalem Restaurant on Broadway and 103rd Street, NYC."

Samuel Merians, *Nephew & Artist*

"Metz was my greatest mentor. When I think of my school experience, it will forever be defined as two periods—the times before and after he entered my life. I will love and miss him always."

Elinor Zach, *Former Student*

"Jeffrey was not only my teacher; he was my mentor, colleague, good friend and inspiration. He will be forever missed, and his vision will keep on going because that is the way he would have wanted it."

Jean Marco Ruesta, *Former Student*

"Despite his decades as a professional and an instructor, Jeffrey never stopped being a student himself, and his enthusiasm for learning made me more courageous with my own work."

Ben Kim, *Former Student*

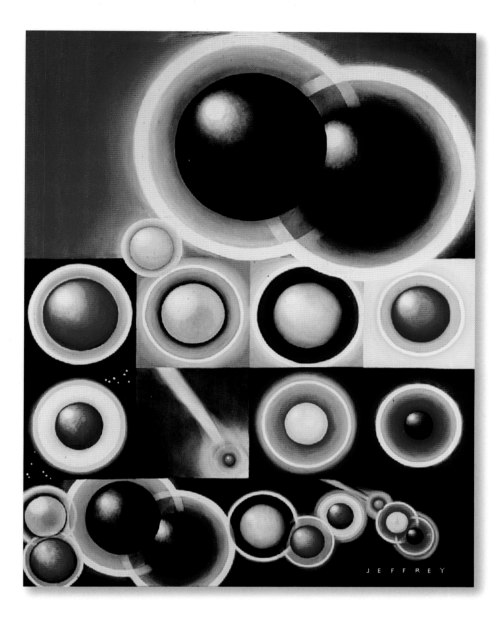

"His greatest role was that of teacher; but he lived many lives before he came to teach. He taught from experience only. Every student was a challenge to him, from the worst to the best. He nurtured each one to be the best that they could be. There were no regular hours that he taught. They emailed their work to him 24 hours, seven days of the week. They called each other all hours of the day and night. His influence was dashing and daunting, but the powerful work they produced was in the end their own."
Sheila Metzner, Wife & Artist

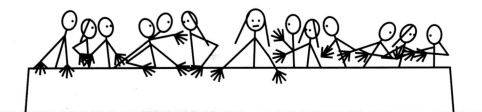

Elegant Feedback Hybrid: Full Circle at the Creative Summit by Michael Cronan

Now in its 24th year, the Creative Summit continues to be a one-of-a-kind design conference. The ingredients of the conference make it unique. Each year there is a large regional student design competition. Judged by a flotilla of accomplished design pros, most are former or current speakers, and recent conferences have included design pros that are also former student winners. The culmination of the Creative Summit takes place with judges awarding cash prizes and scholarships to the winners. To date, over one quarter of a million dollars have been awarded to students, and each winner receives a small figurine trophy of a pig (long story), known as the coveted Memorial Ralph Award, or Ralph, for short. At the request of Chris Hill, the Summit's founder and continuing guiding light, I had the pleasure of e-interviewing a number of past Ralph winners who have each been Creative Summit presenters, speakers and jurors as well. They represent the full circle that the Summit offers. Now successful professionals in the early part of their careers, their insights, like a message from the future, are gold to any design student looking for the keys to a successful career. Brian Flynn and Dora Drimalas, brilliant design partners and new parents, are founders of San Francisco's Hybrid Design. Their work is both smartly contemporary and at times nostalgic of perfect fifties modernism. It comes from wicked talent and knowing design history like the backs of their hands. I was able to catch up with Brian for the interview. Heather Amuny-Dey is Creative Director at Nike. Her career demonstrates that with the right combination of uncompromising design talent, communication and organization skills, a young designer need not over-pay their dues and can, relatively quickly, go to where the action is for world-class lifestyle branding. Christian Helms actually moved to Texas as a result of the Summit experience, and founded Austin-based The Decoder Ring. One trip to thedecoderring.com will not only get you laughing, but longing to export some of that Texas attitude to your hometown.

What do you wish you would have known as a student that you now understand as a professional?

Brian Flynn focused on the portfolio, "No one cares what school you went to, or if the work is for a real client, school or yourself. It only matters if the work is good or bad. Show me your best work, the work that you wish that you were doing, not what you think I should see." He pressed the point further, "If you had to make crappy projects in school to make your professors happy, then by all means, make new projects to replace those. The portfolio is not sacred, it is supposed to be a direct reflection of you as a designer, and not a mixed bag of half-baked ideas you don't believe in. If you don't show the work you want to be doing, you will end up doing the work you are showing. No one can read your mind that you can do something better than what you are showing. You need to show them that you can, and if that means staying up late to make fictional projects of your own, then do it. I would rather see five amazing pieces for someone's personal satisfaction than 15 finished, mediocre pieces for real clients. If you don't believe in the work you do, why should anyone else?"

Heather Amuny-Dey says that the most valuable thing she has learned as a professional is, "how to work as a team and how to manage client expectations. It is very easy, and somewhat expected of you as a student, to work in isolation and focus solely on your own creative ideas. As a professional, I find that collaborations and team projects are some of the most rewarding. It is inspiring to work with others and to be able to come to the best solution, together." Another deeply insightful lesson: "The ability to distance personal emotion from client presentation and critique allows me to take client feedback and manage their expectations." Many firms separate the junior from the senior designers based on that criteria alone.

Christian Helms considers writing and having a vision as essential. "Being creative is only part of the job," he says. "Writing and communication skills will get you a long way as a designer."

"One of the most important things to understand is that after school, there is no longer a defined checklist for achievement. YOU set your own criteria for success. If you don't have a strong vision of that in your head and heart, it's much less likely that you're going to end up in a place where you're happy, creative and healthy."

I couldn't resist asking a question intended to send a message back to their teachers. If you could change design education in any way, what one thing would you change or new rule would you institute?

Again, Brian focused on the portfolio. "Most schools seem to approach them as checklists to accomplish. 'Here is one book cover, one annual report, two magazines, one packaging concept, one poster and three logos. Congratulations, you graduate.' Every student's portfolio looks the same, and they think they have to show all of it, as they have had that concept beaten into their head... You begin to wonder if it is the influence of the teacher. Does the student know the difference between good and bad? "The schools should have a better understanding of their individual students, and help them tailor their books to their strengths as designers, not a lowest common denominator that works for the group."

Heather would change the pace in school to better prepare students for the real world. "It is difficult to go from doing a couple of projects a semester to doing that in a week." She continues, "There are so many things to balance in a design education, but it could be helpful for students to have some experience in a faster-paced environment. Professional internships definitely help this agenda."

And Christian agrees with the need for more professional contact while still in school. "I would institute some sort of mentoring program. It's been talked about a lot recently, but that's because it really is important." He adds, "I've been fortunate enough to have a number of really amazing folks who've shared their advice, suggestions and even failures with me, and that's been an education in itself. It's helped me a lot in The Decoder Ring."

What do you perceive is the primary difference between the design world that your design heroes inhabited and the one you work in today?

Brian got down to the brass tacks after mentioning some of his older design heroes, like Otl Aicher, Saul Bass, Paul

"If you don't believe in the work you do, why should anyone else?"

Brian Flynn, *Hybrid Design founder and former Ralph winner*

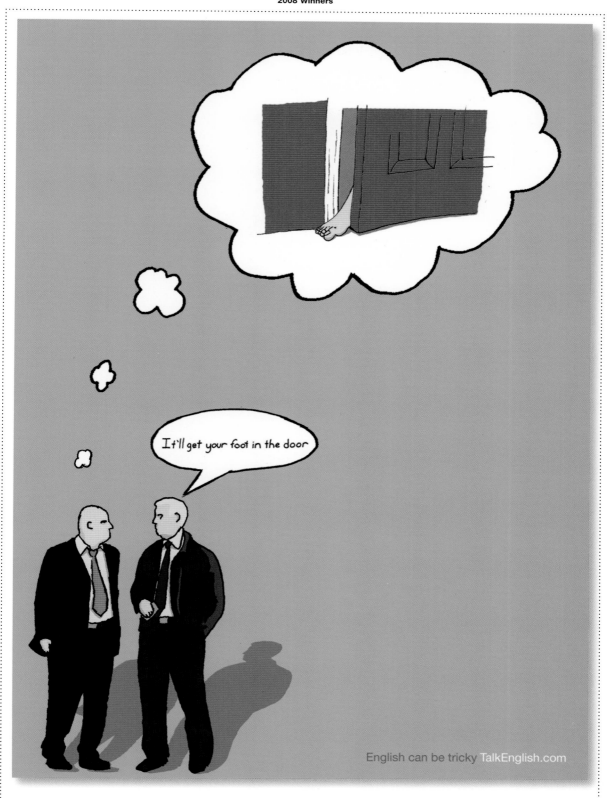

Nathan Trafford/Texas State University

Nathan Trafford/Texas State University

Herlinda Reyna / Texas A&M University

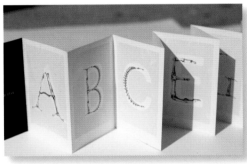

Brian Wood/Texas State University

Aline Forastieri/Texas State University

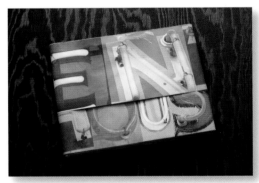

Katy McCauley/Texas State University

Brandon L. McCain/The Art Institute of Houston

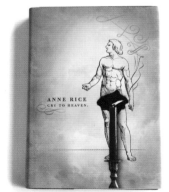

Christopher King/The University of North Texas

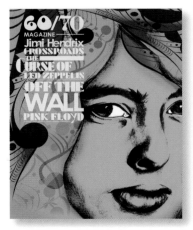
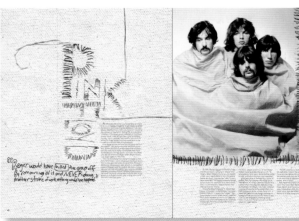

Ashley Ayres/The Art Institute of Houston

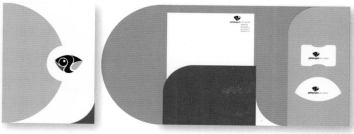

Cody Matheson/Texas State University

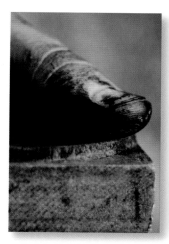

Jared Chadwick/Texas State University

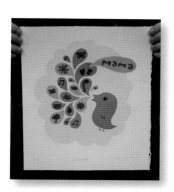

Chris Jones / Texas State University *Lauri Johnston/ Texas State University* *Shaun Fox/Texas State University*

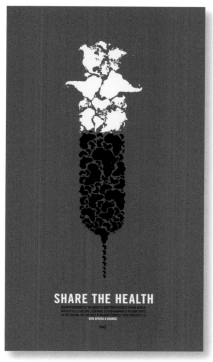
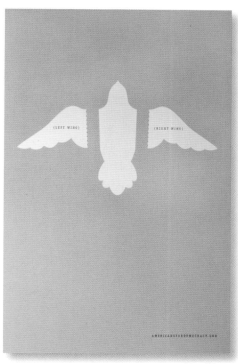

Ryan Bailey/The University of North Texas *Britta Fuller/Texas State University*

"The portfolio is supposed to be a direct reflection of you as a designer, not a mixed bag of half-baked ideas you don't believe in."

Brian Flynn, *Hybrid Design founder and former Ralph winner*

Rand, and Milton Glaser, and younger design stars, like Mark Farrow, Tomato and Designer's Republic. "Now, you can have a studio in your garage, finishing work for clients around the world, and have 20 projects under your belt in a year after graduating from school. The barrier of opportunity has been almost completely eliminated; so young, hungry designers can go straight to actively working without having to toil in the dungeon of an ad agency for years before getting their first shot."

That lack of hierarchy is a double-edged sword, he cautions. "We have more crap to wade through now, but we have so many more unique ideas now, which I think is far more valuable." A big shift in pre-press will mean that the heroes of yesterday may not be heroes tomorrow, as "the pre-press revolution has made it so that anyone can make a book, and there are design monographs everywhere. Even the most obscure designers can get the word out. So when you ask students who their heroes are, it is usually someone close to being a peer, someone they can relate directly to, and usually much less about the pantheon of design history."

Heather grew up in the design world. She has some of the same design heroes, but with one very important extra. "My design heroes were, and still are, Saul Bass, Paul Rand, Josef Müller-Brockmann and my father, Jack Amuny. Growing up as the child of a designer, I was raised to have an appreciation of design." As a parent of an industrial designer and a sculptor, I can attest to the advantage. Heather points to a fundamental shift from the design world of yesterday. "Today, consumers have a different relationship with design. Design used to be something that a very few did. Now, consumers are asked to be their own designers through many avenues of customization and self-expression. I think good design is good design, in the past or today. And the constant is the enjoyment that people get out of a beautifully designed piece."

Christian's point of view is more basic and has its own solid logic. "The world we work in has better coffee, a worse president and a hell of a lot more to distract us from doing our jobs. I've started turning the computer off for one hour a workday, and it's amazing how productive I am in that hour." This is an unassailably useful idea that the entire design planet would benefit by.

Over the years, Chris and the designers who have stayed connected to this Spring ritual have seen the fruit from Creative Summit ripen and return to seed a fresh crop of students. It has become a kind of a recursive design dance, an elegant feedback loop that affirms something magical and yet natural about design and the people who engage in its process. Ever changing, design is a human response to human needs, and a life in design is a terrific thing.
Michael Cronan portrait by Terry Lorant

Michael Patrick Cronan: Imaginative perception and innovation are the hallmarks of Mr. Cronan's accomplished design career. For over 30 years, Cronan created game-changing corporate communications, identities, graphics, packaging, and product development for clients including Apple, Estée Lauder, Levi Strauss & Co, and SFMOMA. Cronan and partner Karin Hibma focus on creating names and brands, to name a few: TiVo, GoodBelly, and Amazon's Kindle, and help companies create, transform and reinvent themselves. Awarded by national and international design organizations and publications, Cronan's work is represented in the collections of the Library of Congress, the Smithsonian Institute, London's Victoria & Albert Museum and the permanent Design Collection of San Francisco Museum of Modern Art and was featured in the Venice, Italy, Museo Fortuny exhibition "Pacific Wave," the first graphic design exhibition at SFMOMA "In the Public Eye," and the Denver Art Museum's "American Graphic Design." Born in San Francisco, he studied Fine Arts at CCA and CSU, served as an adjunct professor of graphic design at the CCA from 1982-1999, is a founding member and former president of the AIGA San Francisco and served on the national AIGA board. He is an artist and writes occasionally on design.

Creative Summit Facts:
Started in 1985 by Chris Hill while teaching on weekends at Texas State University. The Creative Summit is a 501c3 non-profit organization and is not affiliated with any organization or university.
Location: Texas State University, San Marcos (30 min South of Austin)
Attendees: 500 students, professors, professionals and past speakers
Students: From 20 universities of 6 different states
Auction: Speaker & past speaker silent auction of art, photographs, posters, books, etc.
Presentations: 12 guest speakers

Creative Summit Student Show:
Entries: Over 250 portfolios with a total of over 2,000 entered each year
The Judging: 12 to 20 speakers and past speakers jury the show.
Show: Approximately 110 entries are selected into the show.
Best in Show awards: 25 coveted Memorial Ralph Awards
Student Cash Scholarships: All entries selected for the show receive a cash award as well as the Best in Show awards up to $3,000.
History: This is the Summit's 23rd year. Over the last 4 years, cash prizes have totaled $110,000.

Awards:		*Speakers:*	
Coveted Memorial Ralph Award	*Certificates of Excellence*	*Brian Flynn and Dora Drimalas*	*Brian Singer*
The Singing Cow Scholarship Award	*Cash Awards*	*Jimm Lasser*	*Murray Tinkelman*
The Honorary Hoffman Award	*Speakers:*	*Michael O'Brien*	*Sharon Werner*
	Heather Amuny-Dey	*John Sabel*	*Scott Thares and Richard Boynton*

2008 Judges	*Jimm Lasser*	*Michael O'Brien*	*Murray Tinkelman*	*Karin Hibma*	*Gary Faye*	*Rex Peteet*	*Myers Raymer*
Heather	*Brian Flynn*	*John Sabel*	*Sharon Werner*	*Michael Doret*	*Christian Helms*	*Chris Hill*	*Sandro*
Amuny-Dey	*Dora Drimalas*	*Brian Singer*	*Michael Cronan*	*Laura Smith*	*Mike Hicks*	*Phil Hollenbeck*	*Jack Unruh*

Libby Morris/Texas State University

Justin Young/The University of Oklahoma

SADI (Samsung Art & Design Institute): South Korea's Premier Art School

The SADI Mission: To offer our students a specialized education program that provides strong professional experiences in harmony with a theoretical arts education. We consistently innovate to provide not only the best educational value for our students, but also to maintain a globally competitive educational model.

Q&A with Kim, Hyun-mee, Communication Design Faculty & Jeon, Jae-kyung, SADI's PR External Relations Manager

Tell us about the SADI curriculum, and what separates it from other art schools.

SADI was established in 1995, and is operated by Samsung Electronics. Our aim is to produce creative designers who will contribute to the development of the Korean design industry's competitiveness. SADI offers programs in Product, Communication, and Fashion Design. Our students come from a variety of backgrounds, and so our curriculum is flexible in order to better meet the needs of each of our students. SADI does not provide academic degrees; rather, we offer a SADI certificate at the completion of students' third year.

SADI's courses are structured to encourage a higher-quality learning process, based on critical review, rather than traditional lecture classes. Students are encouraged to participate in presentations and offer constructive criticism within small groups. Each course is aimed at helping students develop their capacities for analysis, criticism and creative expression via the exchange of views. The classes, consisting of small groups of students (less than 20), ensure in-depth teaching in a free atmosphere.

SADI operates various academy-industry cooperative projects and internship programs with Korea's leading design specialties—including Samsung affiliates such as Cheil Industries, Cheil Communications, and Samsung Electronics—which differentiate SADI from other Korean art schools. The school helps students acquire a thorough understanding of the entire process of production development and provides professional-level experience by offering multiple on-site tour opportunities.

Finally, SADI has established partnerships with nine prestigious design schools around the globe, including Parsons The New School for Design in New York. SADI's partnerships with other international design schools helps students experience global design trends. These classes are particularly effective for students, and no other educational institution in Korea offers similar courses.

How does the Samsung connection benefit SADI's students and faculty?

• Personal Exchange: SADI invites Korea's leading design professionals in as visiting professors.

• Professional Experience: SADI offers internships at Samsung Electronics for Communication Design and Product Design majors, at Cheil Worldwide (an advertising agency) for Communication Design majors, and at Cheil Mojic for Fashion Design majors. SADI also offers international internships through additional Samsung Group associated companies.

• Excellent Educational Facilities: The SADI campus is proud of its environment, which is armed with ultramodern facilities and was prepared with the ardent support of the Samsung Group. Students are able, for instance, to use custom-built high-spec PCs (one per student), as well as some of Korea's best research facilities built by Samsung Electronics, Cheil Industries, and Cheil Communications.

What do you look for when hiring faculty?

SADI faculty consists of professionals with degrees awarded by institutions in USA and Europe. They are also equipped with more than three years of distinguished working experience, and regarded as top professionals in their fields.

How would you describe the SADI student body?

SADI has a particularly different level of students from various backgrounds, which gives SADI a more interesting atmosphere than other art schools. If one considers our entire student body, 30-40% have a BFA degree, 30% have a highschool degree, and the rest are transfer students. Recently, more and more students are coming from famous Korean corporations, with the dream of becoming a designer. With this professional experience, they are excellent students in terms of strategy, planning and execution. SADI graduates have earned awards from numerous international competitions, including red dot, IDEA and Graphis for years. SADI's curriculum is intense, and our students have the vision, passion and dedication to match.

During their first year, SADI students are required to take a yearlong introductory course, in which they study theories of art, sculpture and design. How does this help prepare them for their remaining years at SADI?

SADI students are from various backgrounds, and most have academic degrees and work experience in fields as varied as literature, business, engineering, and fine art. The Foundation Courses at SADI are focused on educating our students on the basics of design, which they need to know before proceeding on to major projects. During these courses, students nurture their interests and potential and develop skills of creative expression. After acquiring a comprehensive understanding of design, students are better equipped to choose the major best suited to them in the following years.

How does SADI prepare its students – undergraduate and graduate – for the real world?

We prepare our students with:

• Professional industry-sponsored projects

• Lectures by top-level professional designers in every discipline offered during students' senior year

• A required internship program

• International workshops offered each year in every department allow students to experience global trends and provide priceless educational experiences

SADI Information

Address: 9th Floor, Bojeon Building, 70-13, Non hyeon-dong, Gangnam-gu, Seoul, Republic of Korea (zip: 135-010)

Telephone: 82-2-3438-0300
Departments of Study: Foundation, Communication Design, Fashion Design, Product Design

Number of Enrolled Students: 256
Number of Faculty: 20
Pupil-Teacher ratio: 11-1
Average Class Size: 15 persons

Tuition Cost: 4,000,000 Won/semester
Website: www.sadi.net

Notable SADI Alumni:

KyungSup Yeom, *Designer, Ogilvy New York*
YoungHa Park, *Graphic Designer, ZONA Design, New York*
JiEun Hwang, *Fashion Designer, DKNY Jeans, New York*
AhRa Yoon, *London College of Communication (LLC), UK*
HeeBock Lee, *Prologue Films Art Director, Kyle Cooper, LA*
Sook Lee, *Fashion Designer, Hansome, Korea*
JunHyun Oh, *U-Biz Research Lab, SK C&C, Korea*

SaeNal Kim, *Broadcasting Manager, CJ Media Olive Network, Korea*
MinJee Kim, *Fashion Designer, Seoul*
SunYoung Lee, *Graphic Artist, Web Developer, Kinetic Post Inc, Michigan*
SungIn Kim, *Fashion Designer, Owner, Old Army, Korea*
HyunJoo Lee, *Senior Interaction Designer, DIGITAS, New York*
NaIm Jun, *Creative Designer, Scandalous Cup, New York*
JongChul Yoon, *Instructor, LaSalle-DHU International College, Shanghai*
(According to the SADI SAYS/SADI DESIGN REPORT)

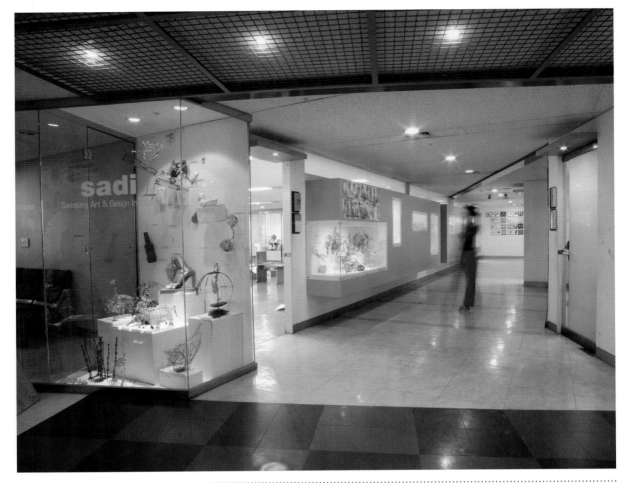

Foundation Department

Overview: The combined focus on practical studio projects and art theory in SADI's Foundation program gives students the practical and conceptual foundation to successfully approach any major. Students acquire a working knowledge of the basic concepts and fundamental principles that underlie and connect the theory and practice of many fields of art and design. Students develop visual sensitivity and perception, faculties of observation, creative expression skills and problem solving abilities.

Classes include: Drawing Fundamentals, Drawing Concepts, 3-Dimensional Design, 2-Dimensional Design, Visual Analysis, Typography, Introduction to Fashion Design, and the SADI Leadership Program. Outdoor classes in art museums and on-site class activities at relevant cultural events complement rigorous in-class activities. Guest lectures and international workshops also promote creative thinking. Students are encouraged to discover and explore their aptitudes in professional fields and develop their potential. They learn about the practical application and production of various materials, the step-by-step development of ideas, and presentation preparation and performance. All Foundation coursework—both practical and theoretical—is designed to promote creativity and an understanding of visual language. This core foundation forms the basis for students' remaining years at SADI and as long as life-long creative professional designers.

Communication Design Department

Overview: Communication Design enhances the aesthetics and effectiveness of communication and information exchange throughout visual language. Strategic communication is gaining greater importance in today's society. Meanwhile, as IT progress spawns increasing varieties of communication media, our society's demands for higher quality, more diverse visual communication grow too.

The purpose of SADI's Communication Design department is to foster creative communication designers with the capability to meaningfully contribute to the advancement of overall design in Korea. During the sophomore year, our program helps students gain basic design skills so that they can remain competitive, even while facing changing mediums and environments. In the senior year, students get an in-depth introduction to their respective fields of interest under the direction of our accomplished faculty members. The field and therefore our department are ever transforming, as we consider society's needs and demands and the evolving educational subjects within Communication Design: visual languages, strategic thinking, verbal and visual communication, visualization skills, resources, and business experiences.

"Our goal is to give students the tools and the confidence to become informed, inventive problem-solvers. We encourage students to ask why, to consider the fundamental principles at play, and to take risks. We help cultivate their technical and conceptual skills so they can approach work in novel, better ways. It is a process of exploration and discovery."
Lee, Yong Kyu, *Dean of Foundation Department*

"Even with appropriate business strategy and technology, knowledge of one's client and their audience is critical. Interaction & Communication design focuses on information exchange to promote business. Here, we try to create strategic and aesthetic forms to encourage interactions and maximize communication between our clients and their audiences."
Kim, Woo-jung, *Dean of Communication Design*

"Design harmonizes objectivity, intuitiveness and imagination."
Kim, Jeong-hee, *Instuctor of Design for Communication 2*

This page: SADI Foundation Department hallway photograph by Lee, Hyo-Bum I *Opposite page:* Fashion class photograph by Kim, Bien-hoon

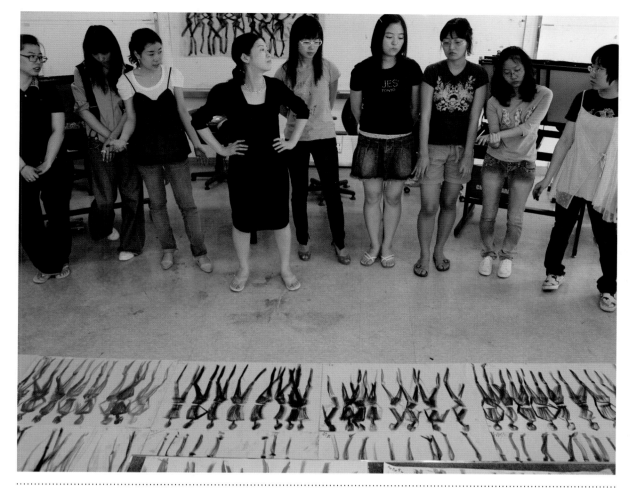

Fashion Design Department

Overview: The goal of this program is to provide students with the necessary education to lead a successful and creative career as a fashion designer. The learning emphasis is on arming students with design development abilities and problem-solving skills.

During the 2nd year, students receive basic training covering broad-ranging areas of fashion design, from design process, draping, model drawing, pattern making and illustration to textile and CAD.

During the 3rd year, students attend a critiquing program where they work on design projects under the direction and review of specially invited critics, each an eminent fashion designer. The program gives student designers the skills needed in real-world design environments so that they are prepared for professional challenges ahead. The fashion design curriculum at SADI closely corresponds to industry needs so that graduates are ready to contribute to real-world job environments.

Product Design Department

Overview: Based on strong support from Samsung Electronics, a global leader in the information and communications industry, this major provides students a world-class design education based on a powerful infrastructure and a specialized university-business cooperation program. The Product Design Department's goal is to create business-minded, creative design leaders.

The department produces globally competitive designers, armed with creativity and ability, by providing an education focused on systematic and intensive work-level projects. SADI is a world leader, offering one of the first IT product industry focused courses in the world. Educational focuses include design management, marketing, design methodology, and interaction design.

Classes include: basic modeling classes (design drawing and rendering, 3D modeling and prototyping, product color design, model making, materials and process, product semantics), theoretical and methodological classes (design research, design ethics, design history, and marketing) and practical studio classes. All students are also required to complete an industry-academic project and internship program prior to graduation.

Classes are led by visiting professionals. Programs require students to solve real-world design projects to better prepare them for the future. Most impressively, by the time Product Design students graduate, they already have 1-2 years of work experience and can immediately start working for any professional design agency.

"SADI's Fashion Design Department is dedicated to providing professional level practical environments so students develop into creative fashion professionals, effectively prepared with both design and communication skills. We give our students real-field experience, constructing creative and professional partnerships with leaders in the fashion industry."
Lee Myung-ohk, *Dean of Fashion Design*

"It is important to consider the role of design and its consumption over time. The evolution of human beings is reflected through design's development and diversification. It is important to note not only the positive benefits of design, but also its negative and sometimes destructive nature. We should seek positive ways to take advantage of design for sustainable development. Human beings, as consumers, must consider the past to effectively plan for the future."

"SADI's Product Design is a very unique major. We focus on developing professionals whose skills span not only the design set, but also marketing and advanced technology. With the support of Samsung Electronics, we offer IT focused Product Design classes as well, a course of study unlike any other in the world. We expect our students to be at the head of business, design service and design management in the future."
Park, Yeong-chun, *Dean of Product Design*

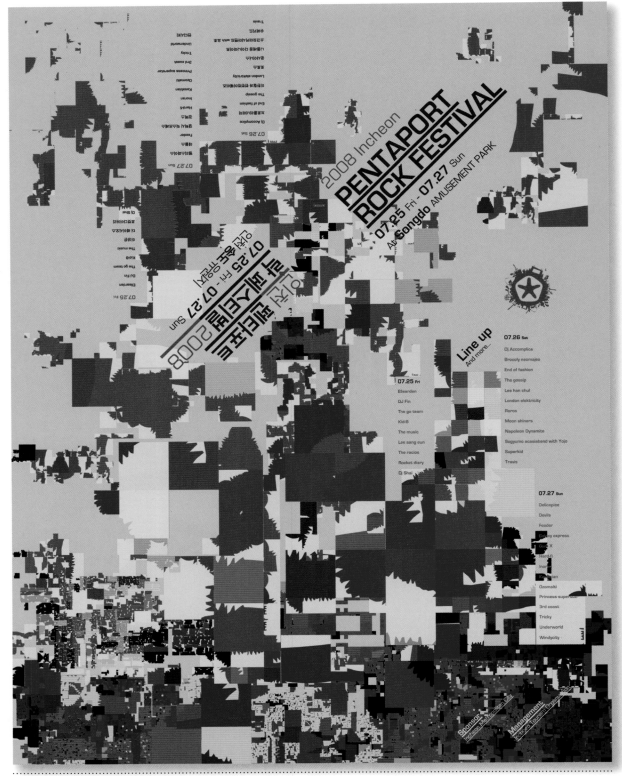

(this page) Grid poster by Chung, Yong-Chae / Project: Grid, Unit, Repetition / Department: Communication Department
(opposite page top) Butterfly Wings by Lee, Su-jin / Class: Digital Design / Department: Foundation Department

(opposite page middle) Worldhistory Calendar by Choi, Joo-young / Project: Information Design / Department: Communication Department
(opposite page bottom) Smart Clothing photograph by Kim, Bien-hoon / Class: Fashion Digital Studio / Department: Fashion Department

Lee, Yong Kyu
Dean of Foundation Department

Kim, Woo-jung
Dean of Communication Department

Kim, Jeong-hee
Faculty of Communication Department

Kim, Hyun-mee
Faculty of Communication Department

Lee Myung-ohk
Dean of Fashion Department

Park, Yeong-chun
Dean of Product Department

Jeon, Jae-kyung
PR External Relations Mamager

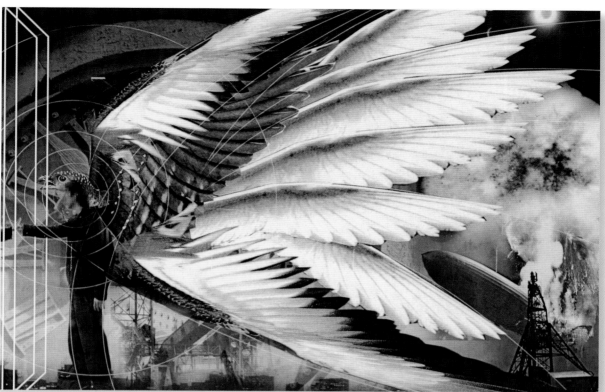

What happened Today?
World history in 365 days

Award photograph by Henry Leutwyler

Advertising

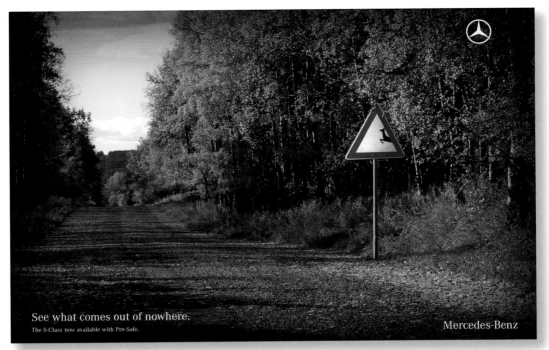

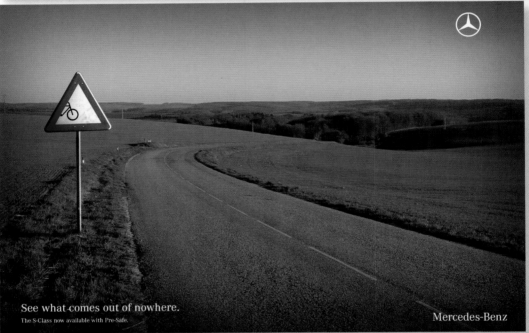

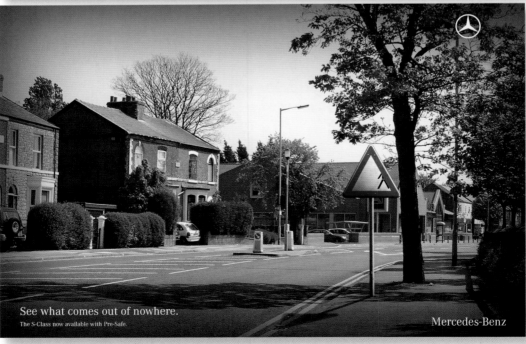

Jan Rexhausen, Niklas Frings-Rupp Miami Ad School, Europe
Nicolas Schmidt-Fitzner, Sascha Piltz, Tara Lawall

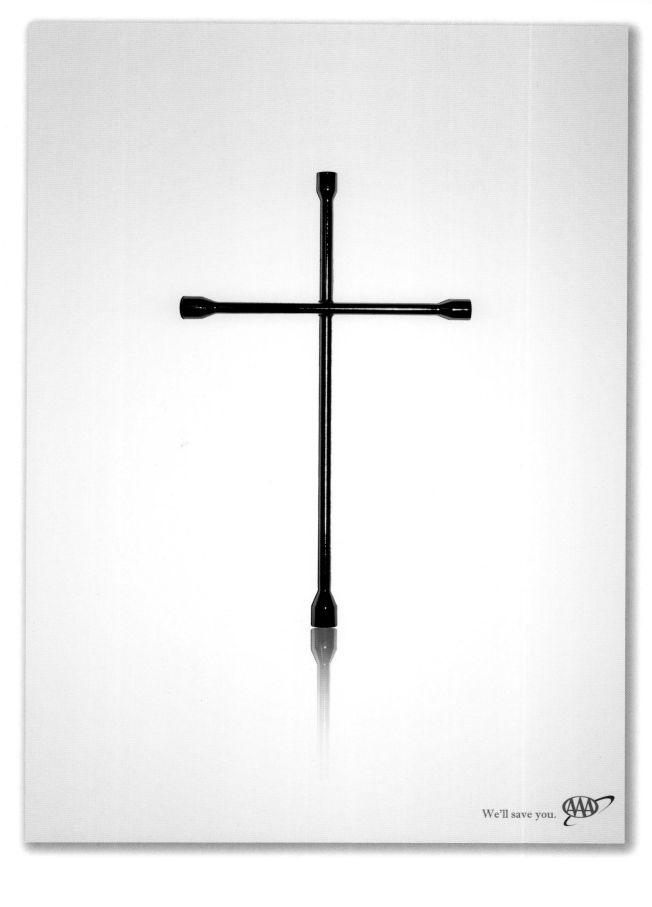

We'll save you.

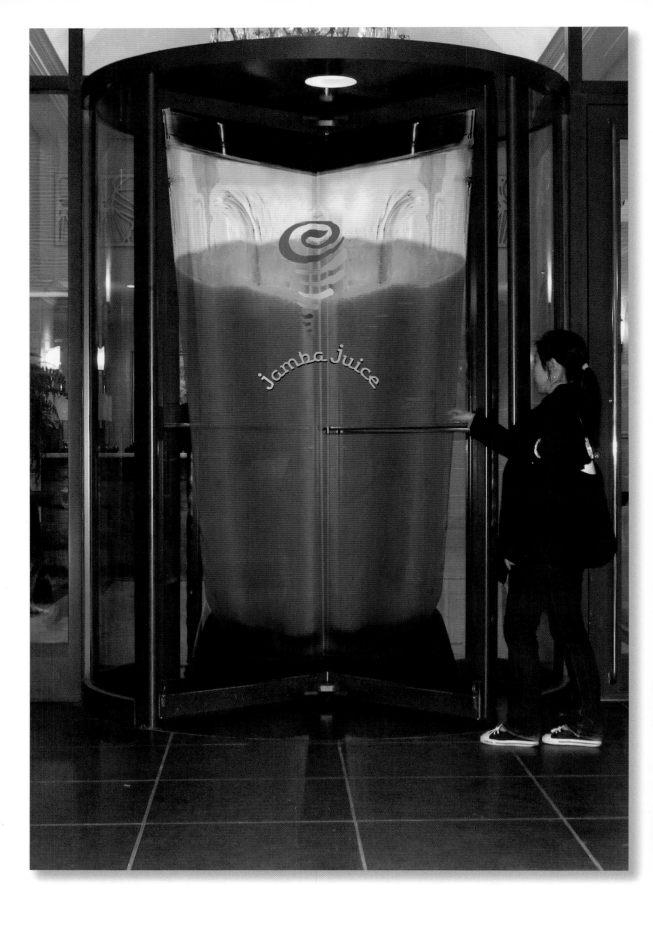

Frank Anselmo School of Visual Arts **Grace Eunhae Hwang**

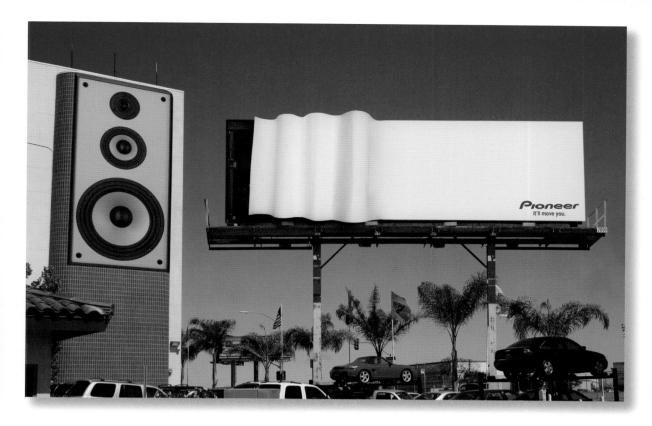

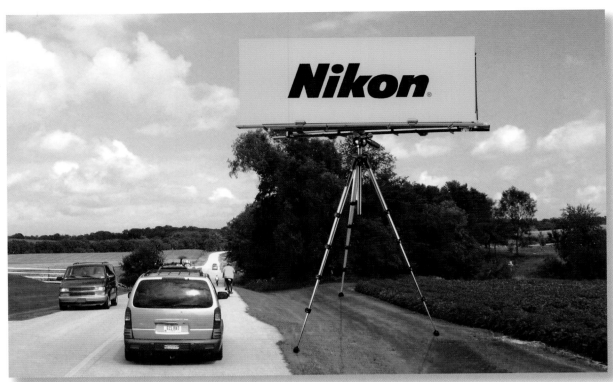

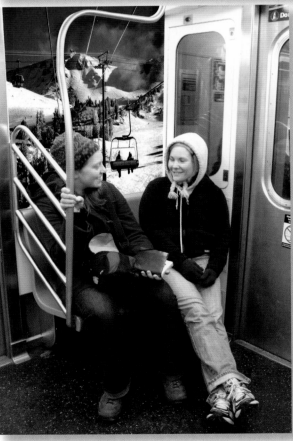

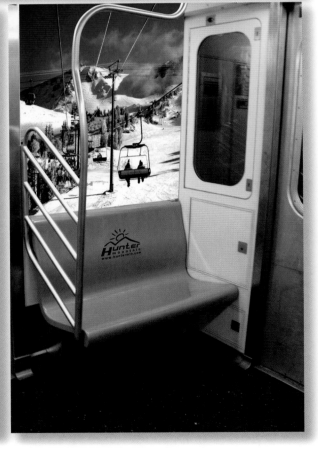

Frank Anselmo School of Visual Arts **Igor Josef Brodsky**
Frank Anselmo School of Visual Arts **Grace Eunhae Hwang**

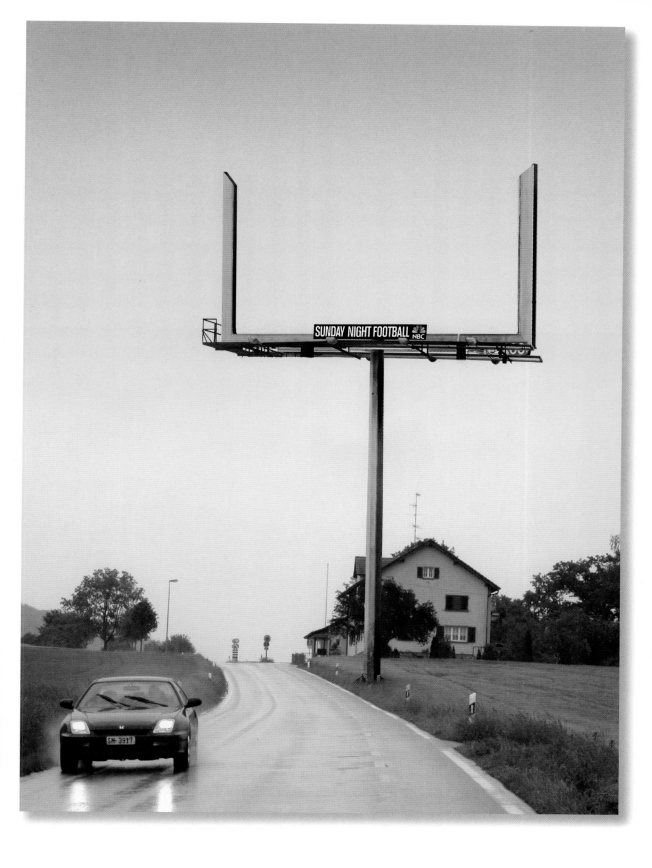

The billboard displays: SUNDAY NIGHT FOOTBALL NBC

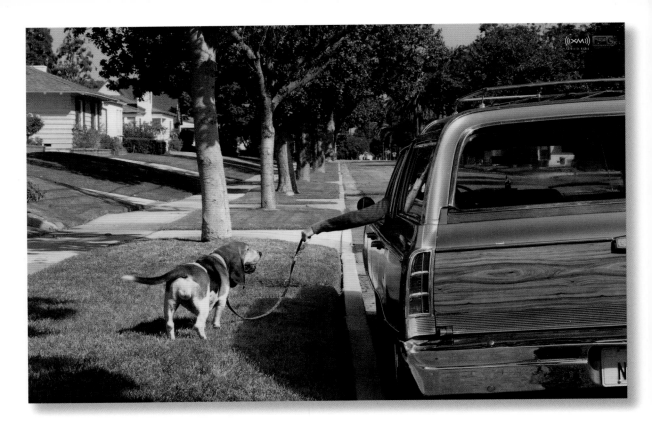

Frank Anselmo School of Visual Arts **Annie Chiu, Anna Echiverri**

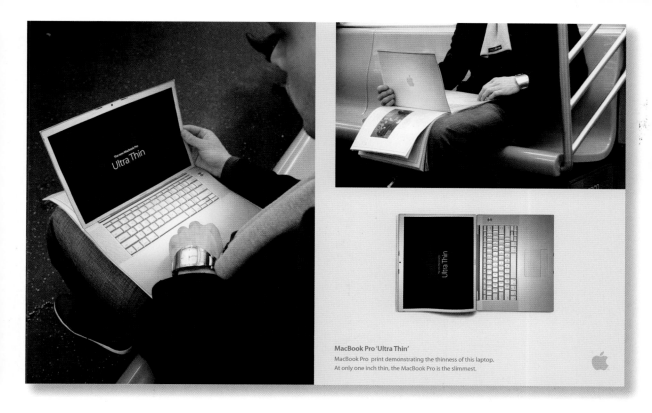

MacBook Pro 'Ultra Thin'
MacBook Pro print demonstrating the thinness of this laptop.
At only one inch thin, the MacBook Pro is the slimmest.

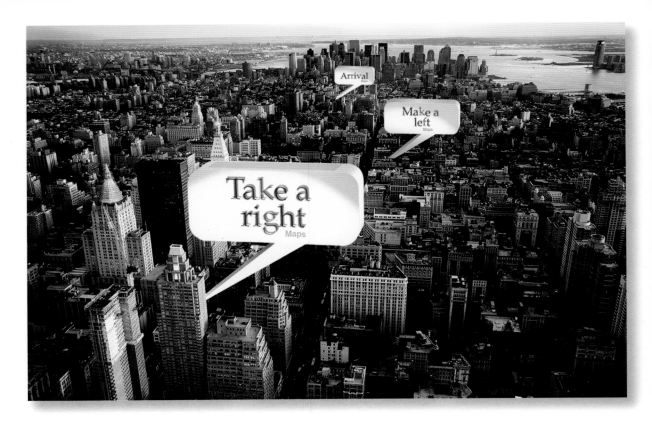

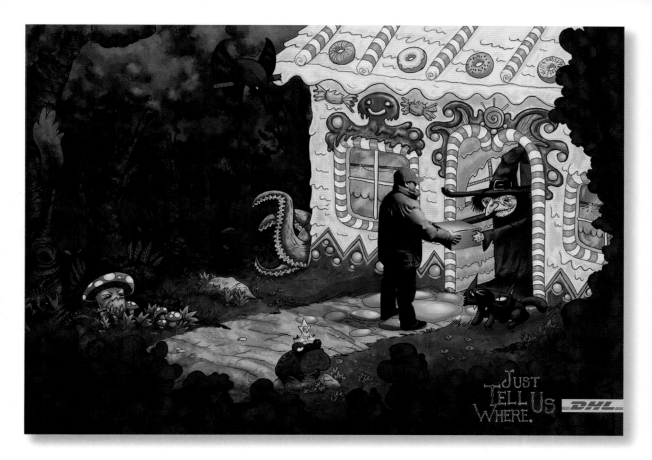

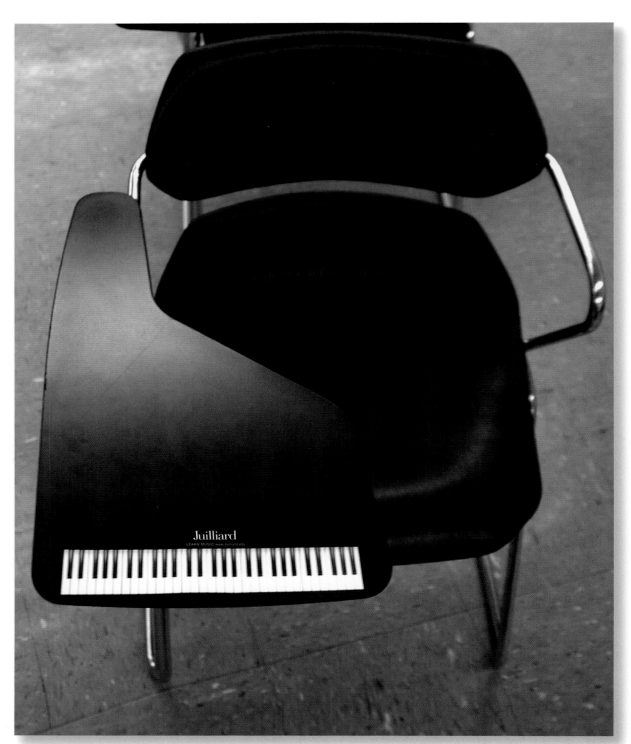

Frank Anselmo School of Visual Arts **Jeongjyn Yi**

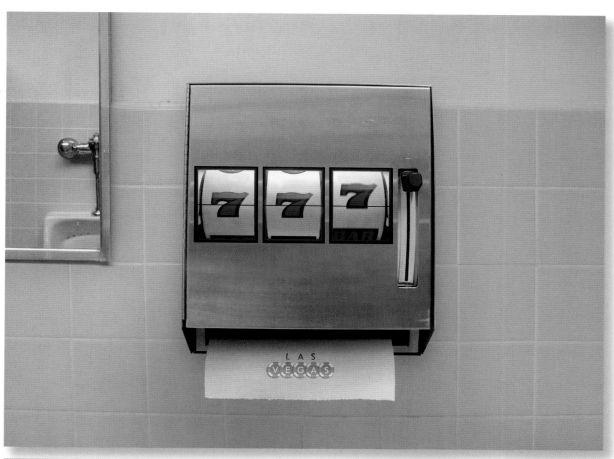

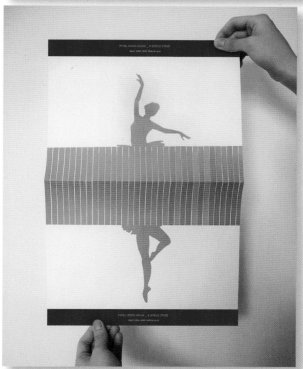

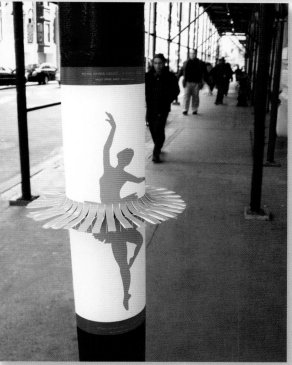

Frank Anselmo School of Visual Arts **Sungkwon Ha**
Frank Anselmo School of Visual Arts **Jeongjyn Yi**

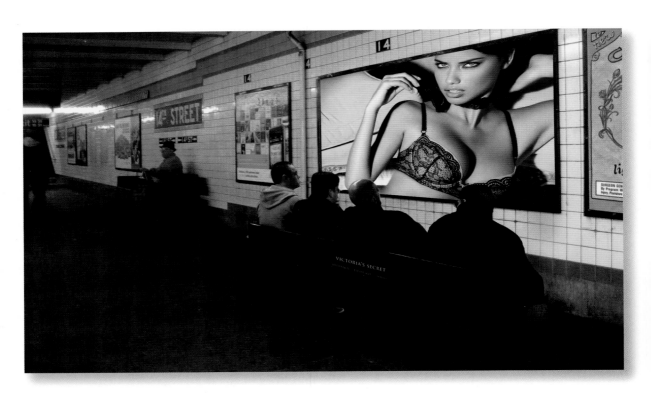

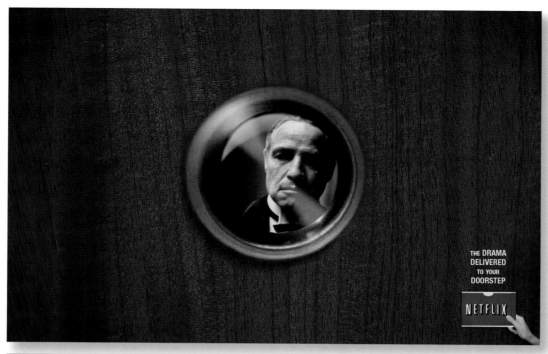

THE DRAMA
DELIVERED
TO YOUR
DOORSTEP

NETFLIX

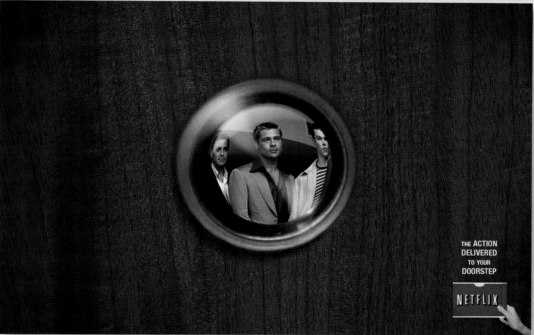

THE ACTION
DELIVERED
TO YOUR
DOORSTEP

NETFLIX

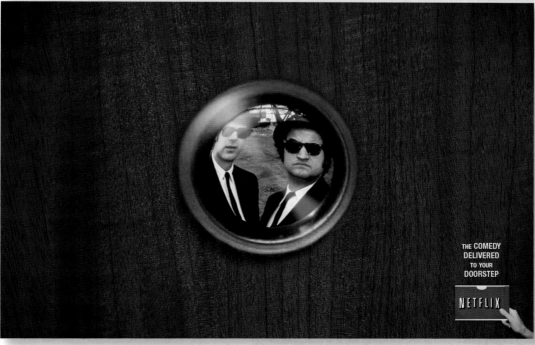

THE COMEDY
DELIVERED
TO YOUR
DOORSTEP

NETFLIX

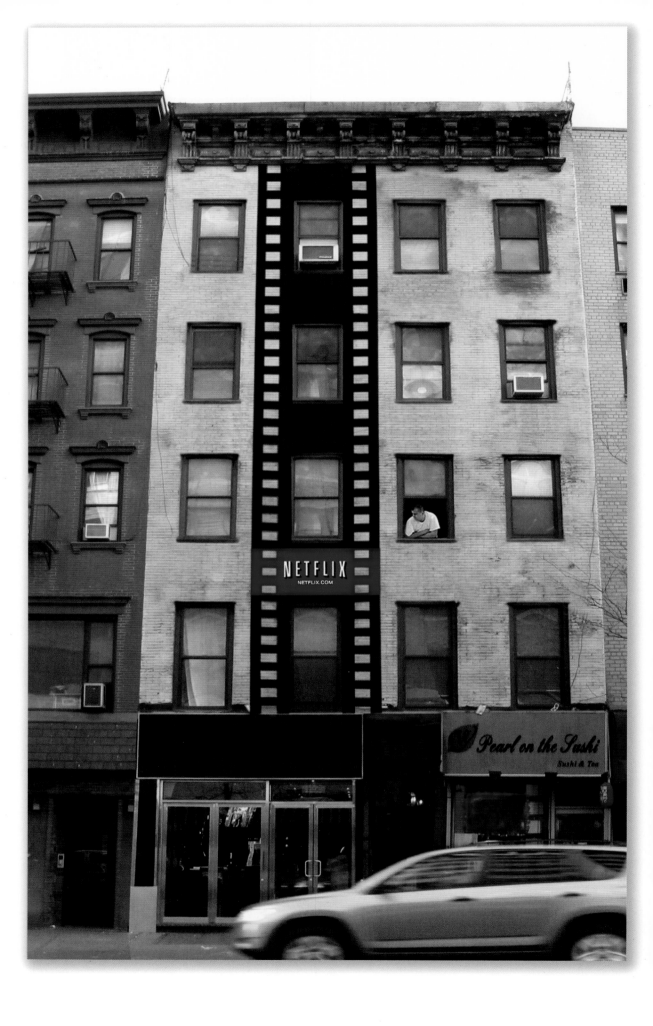

Frank Anselmo School of Visual Arts **Hee Kyung Helen Shin**

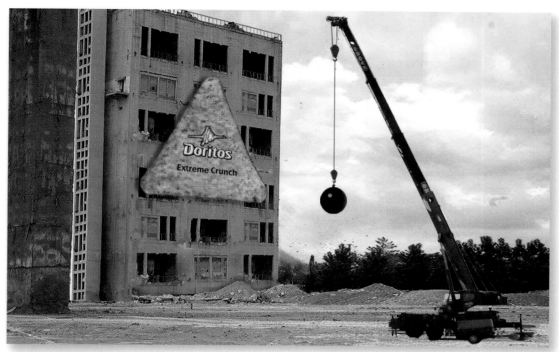

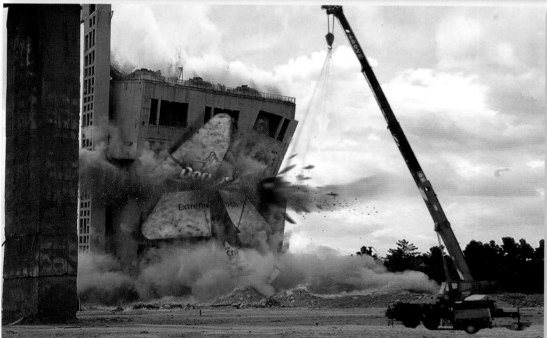

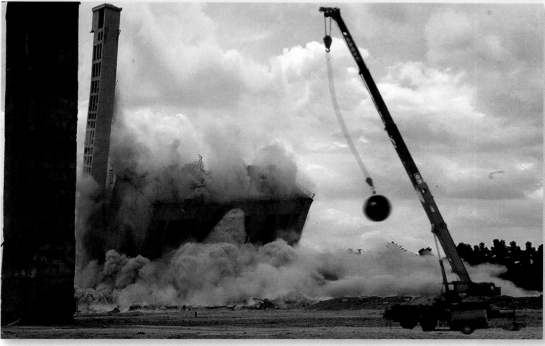

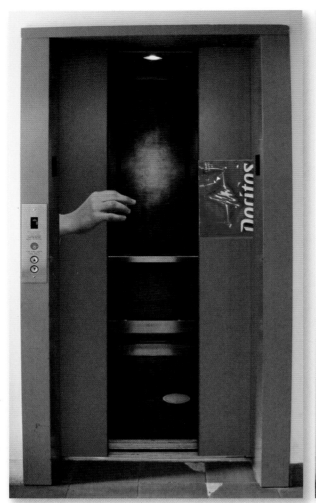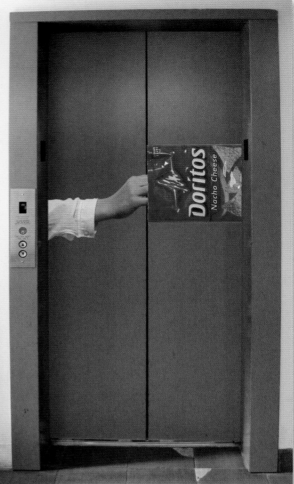

(this spread)

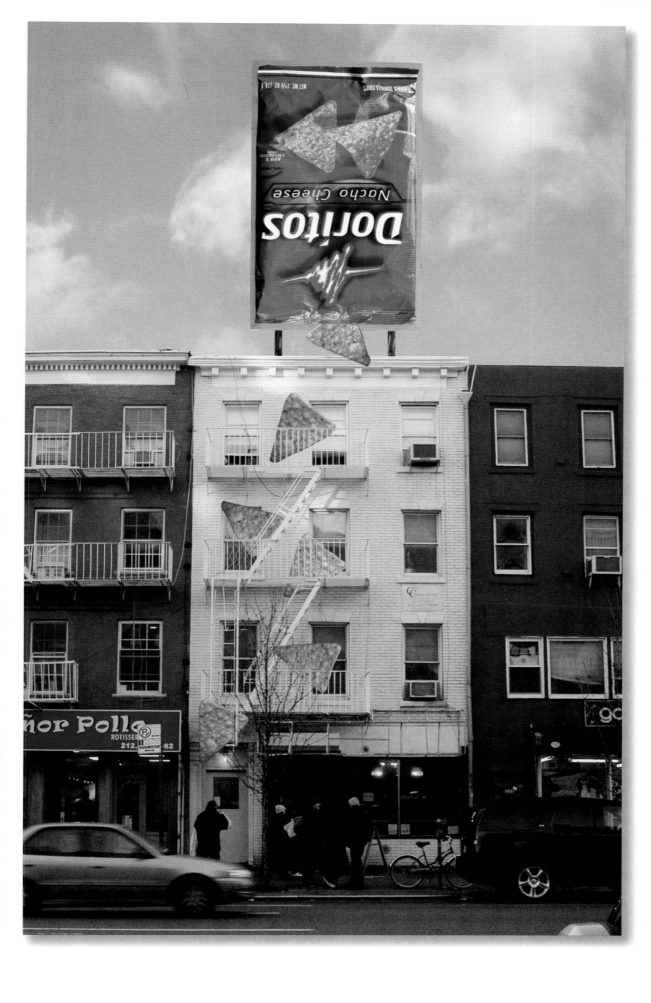

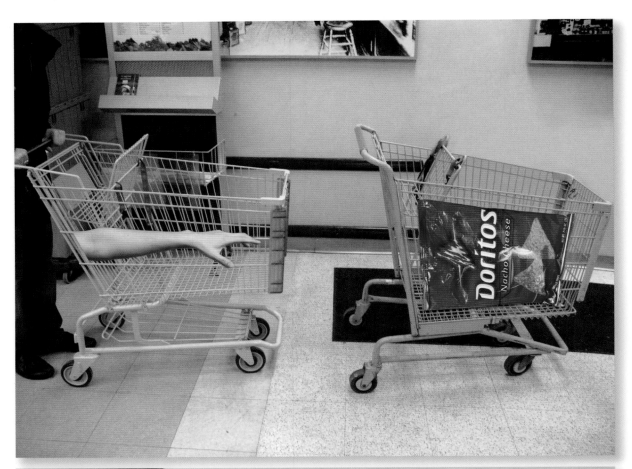

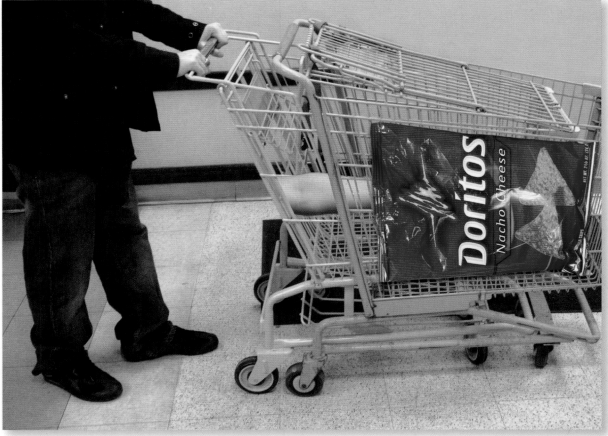

Frank Anselmo School of Visual Arts **Jelani Curtis, William Wang**

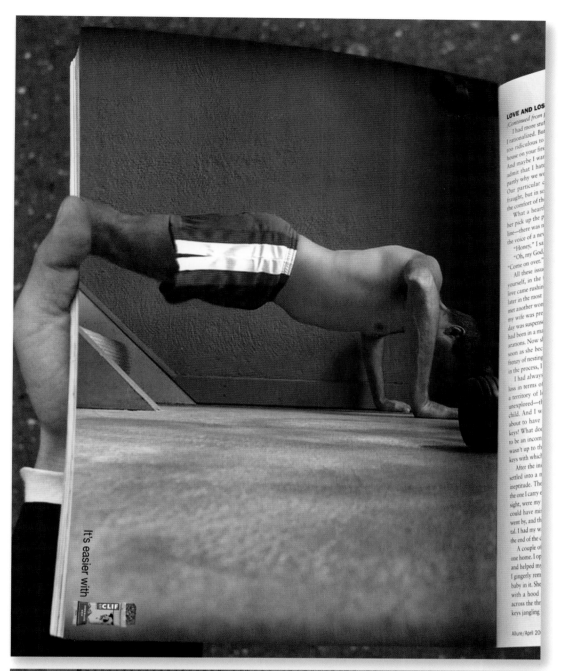

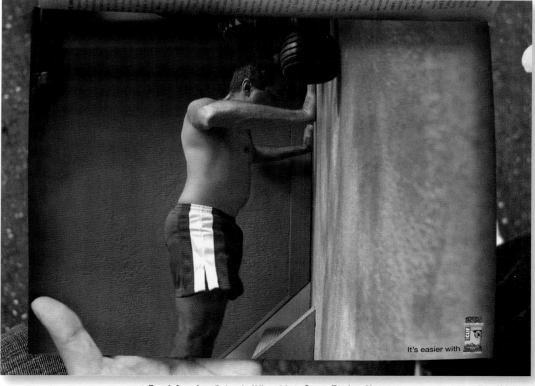

It's easier with

It's easier with

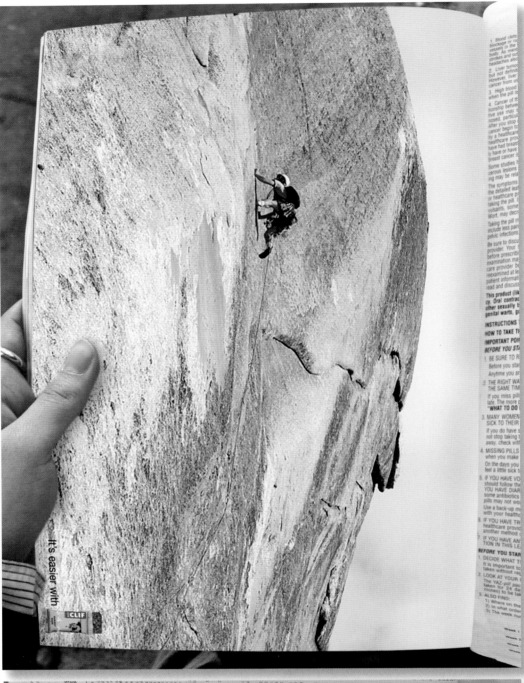

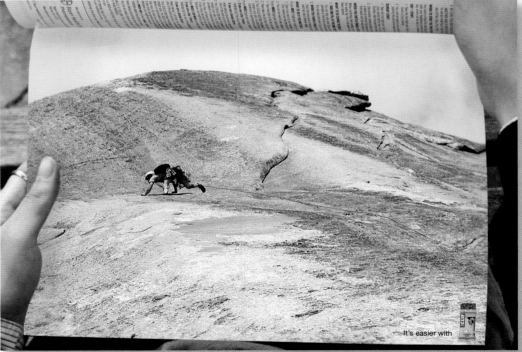

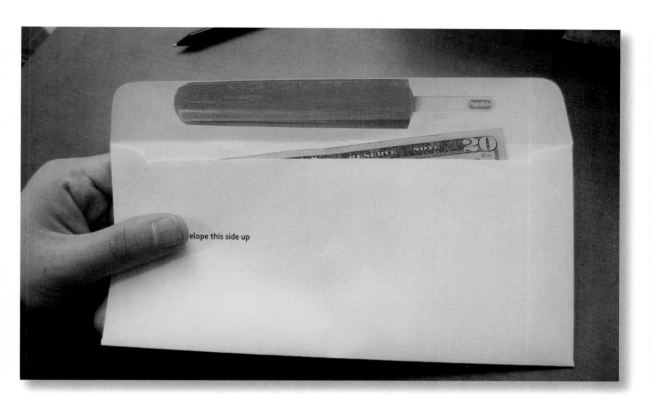

elope this side up

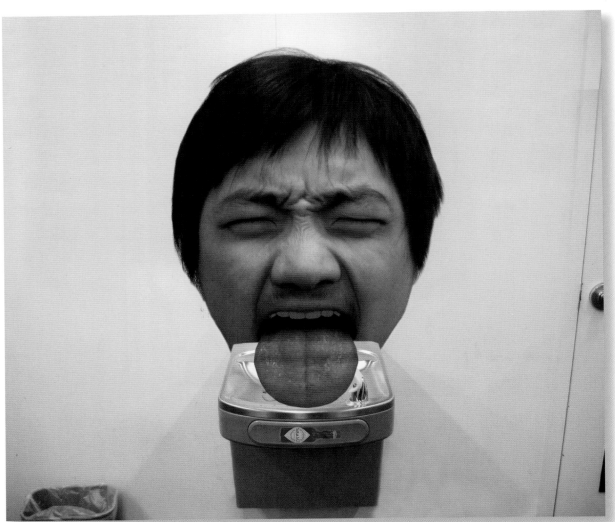

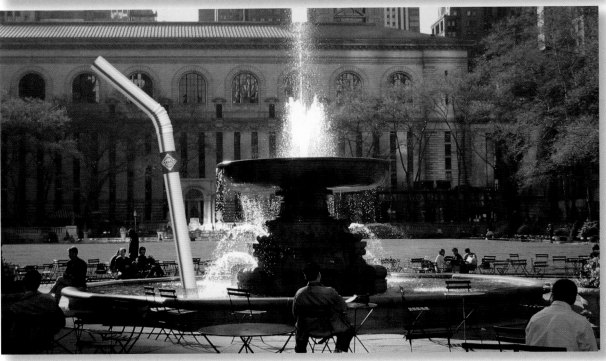

Frank Anselmo School of Visual Arts **Sungkwon Ha**
Frank Anselmo School of Visual Arts **Annie Chiu, Anna Echiverri**

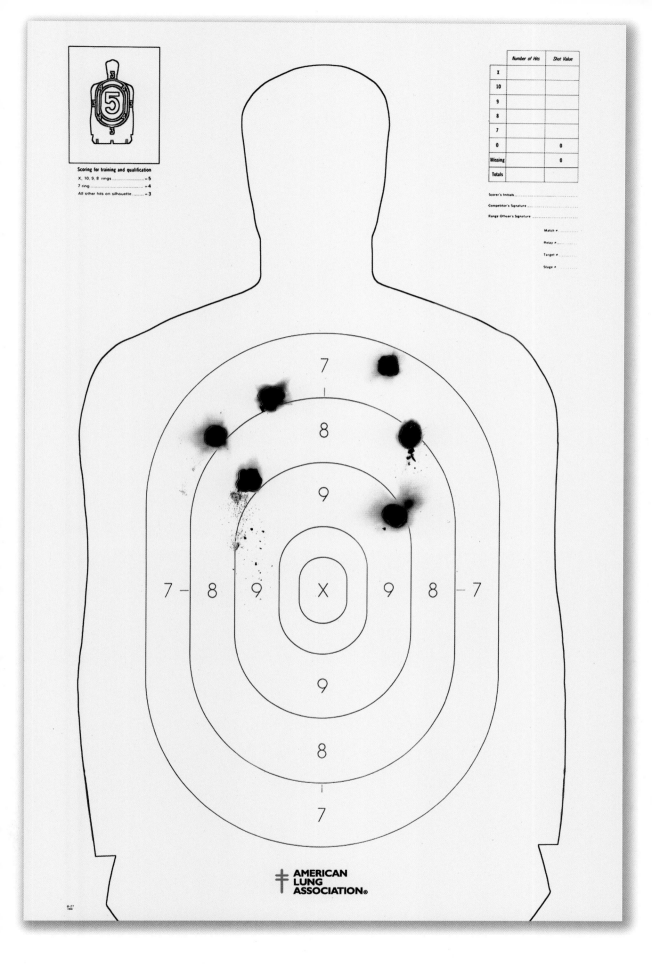

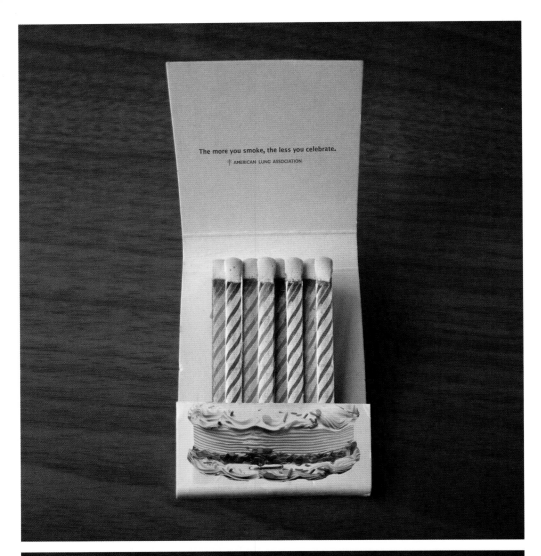

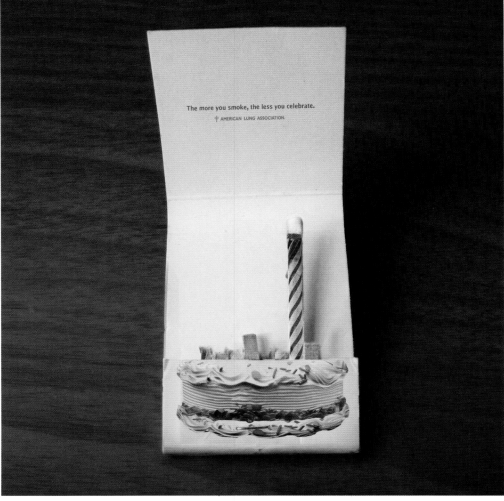

Frank Anselmo School of Visual Arts **Jeseok Yi**

To Emma Cohen, Alzheimer's has been a gift.

　　　　　　Henry Hikima The Art Institute of California, San Diego **Ray Dotterer**

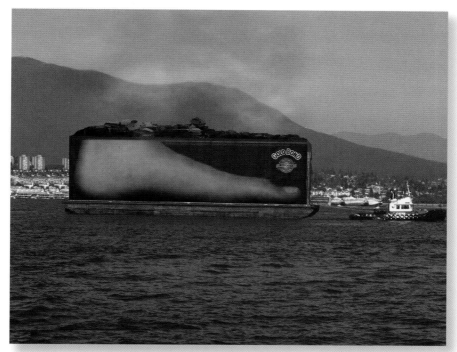

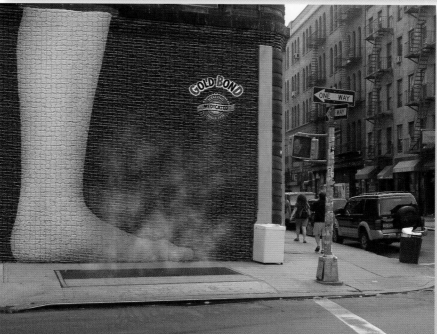

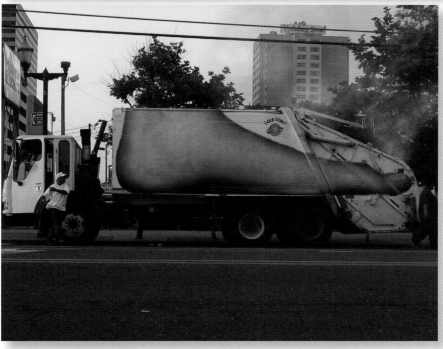

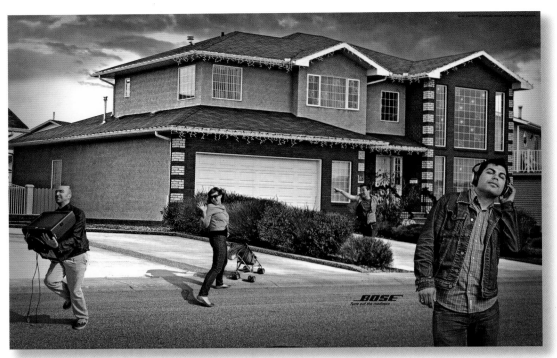

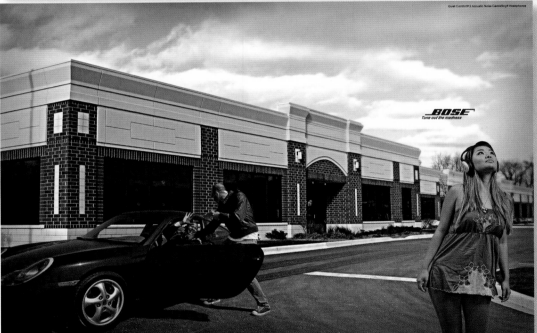

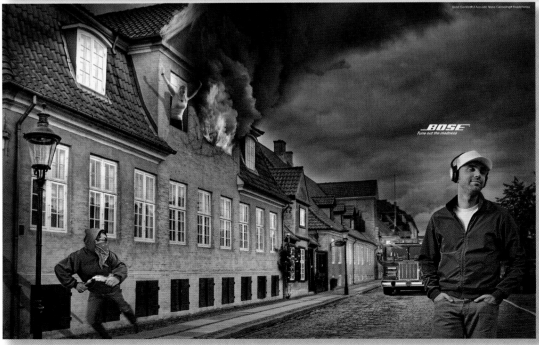

Reexe Hoverkamp, Brandon Sides Academy of Art University **Jang Soon Hwang**

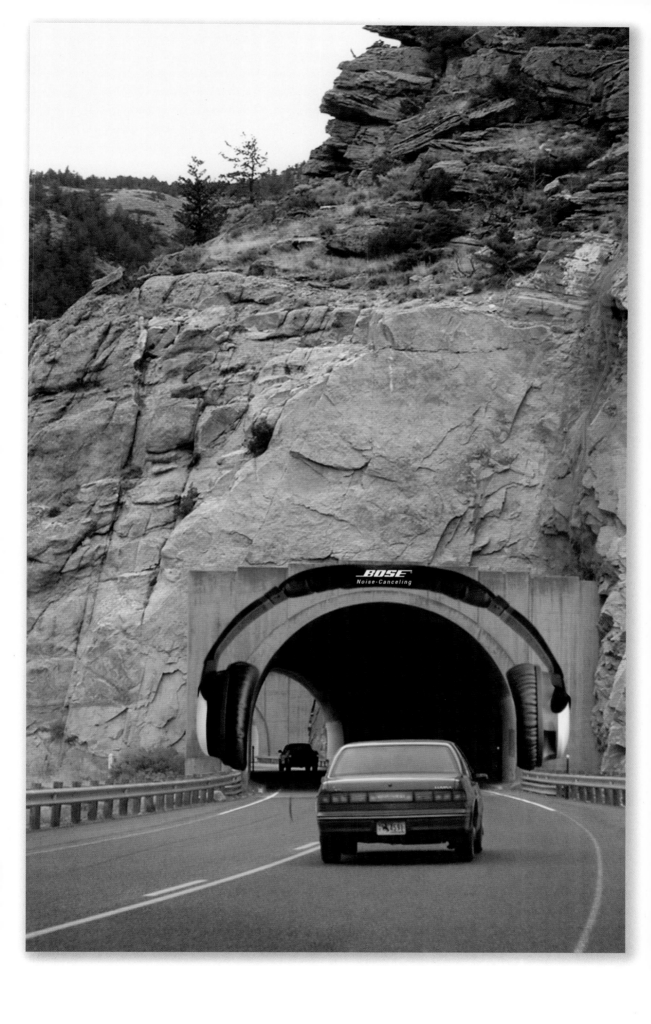

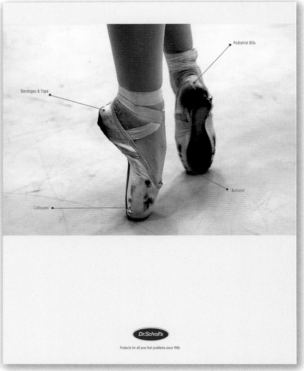

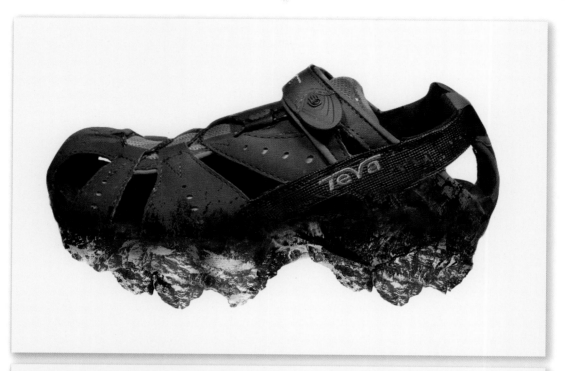

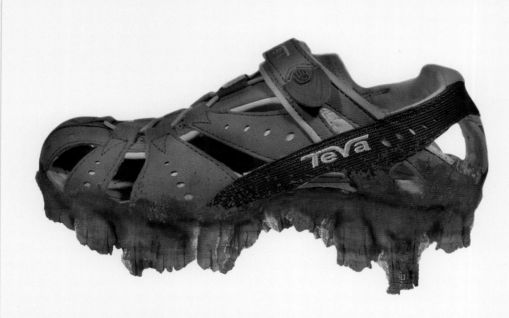

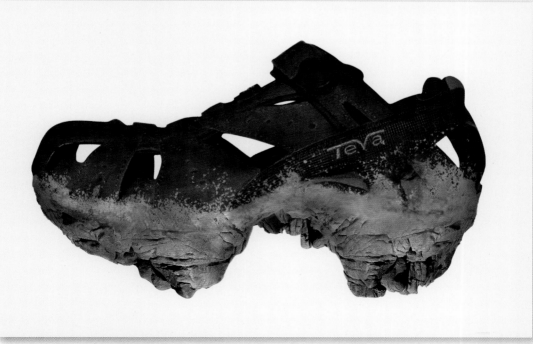

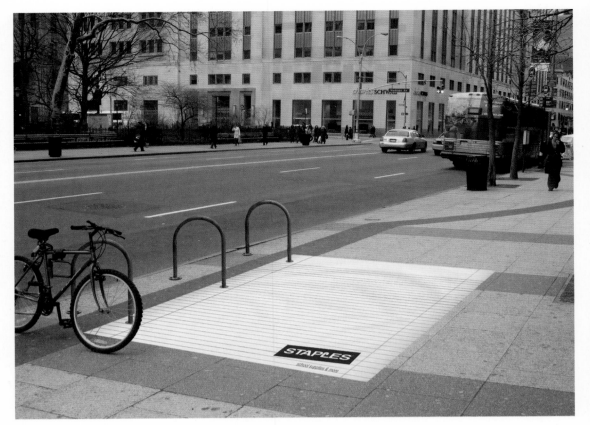

BIKE-RACKS THAT LOOK LIKE THREE-RING BINDERS, HOLD GIANT SHEETS OF LOOSE-LEAVE PAPER, WHICH ARE ACTUALLY GIANT STICKERS.

Frank Anselmo School of Visual Arts **Jelani Curtis, William Wang**

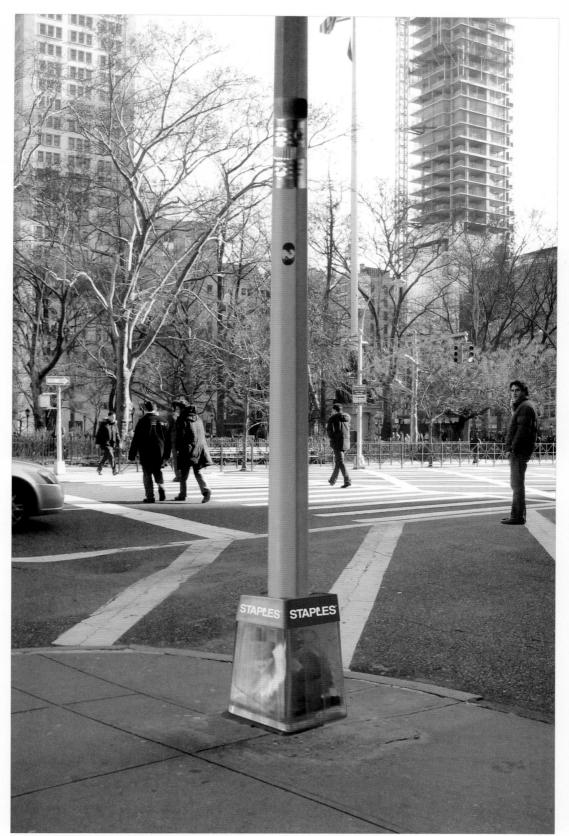

LIGHT POLES AND THE ACCOMPANYING BASES ARE CUSTOM-WRAPPED, CREATING THE ILLUSION OF A PENCIL & SHARPENER.

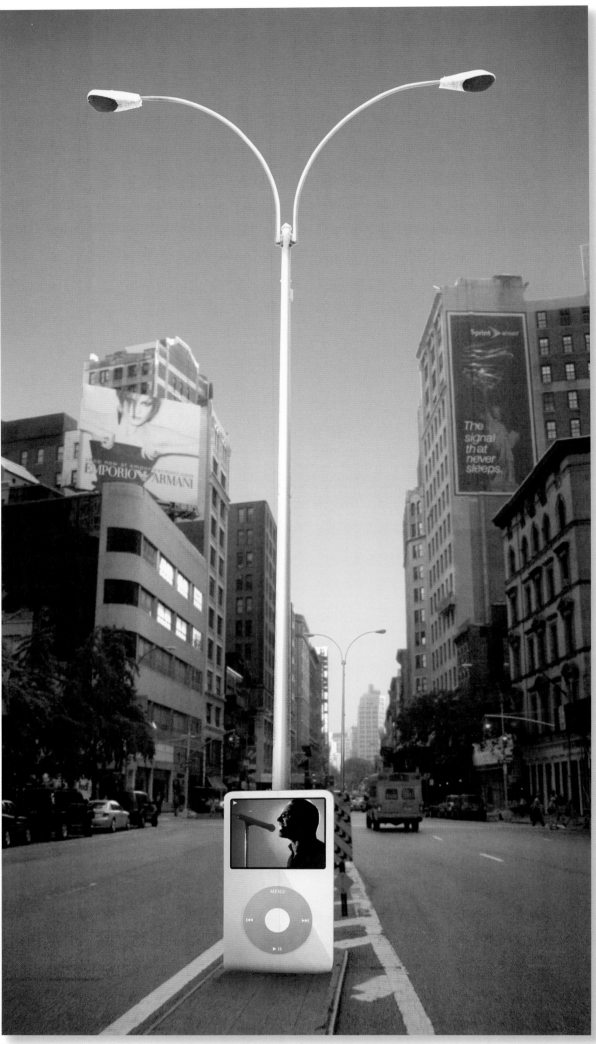

Frank Anselmo School of Visual Arts **Ronnie Jaspers, Nick Plomp**

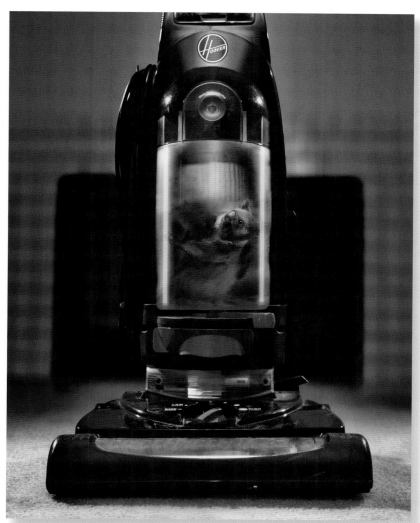

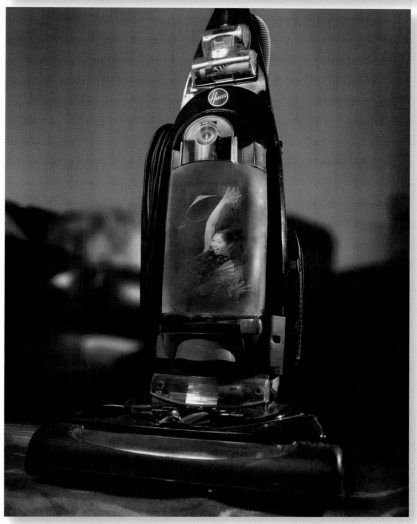

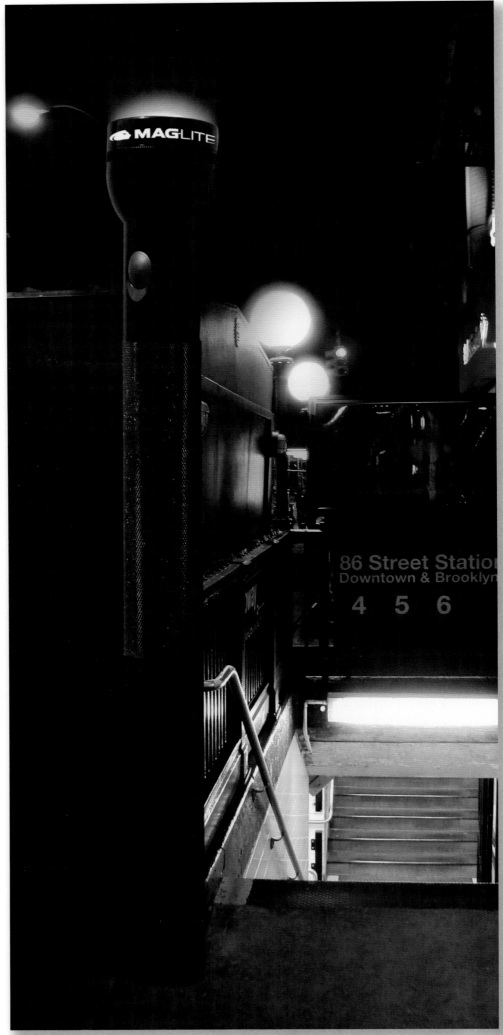

Frank Anselmo School of Visual Arts **Roy De Jong, Mylene De Knegt**

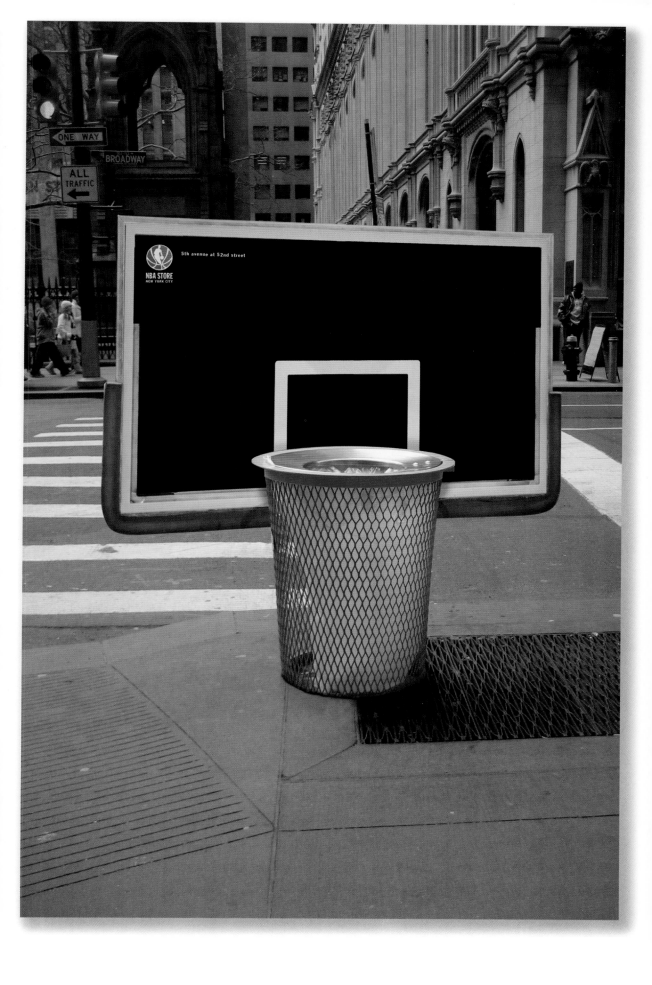

Frank Anselmo School of Visual Arts **Annie Chiu, Anna Echiverri**

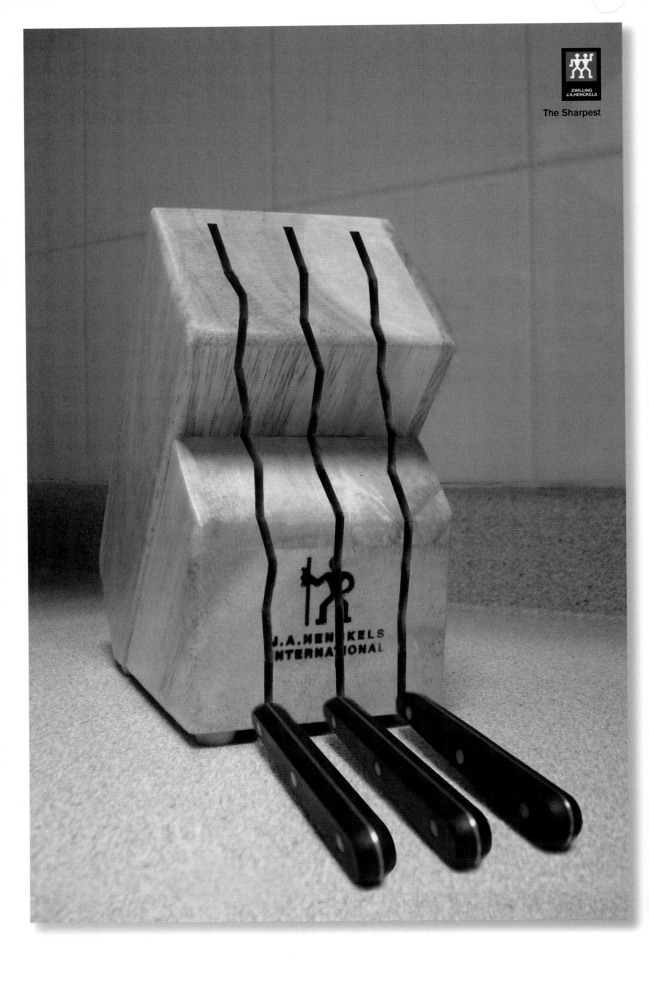

The Sharpest

Vincent Tully School of Visual Arts **Stella Shi**

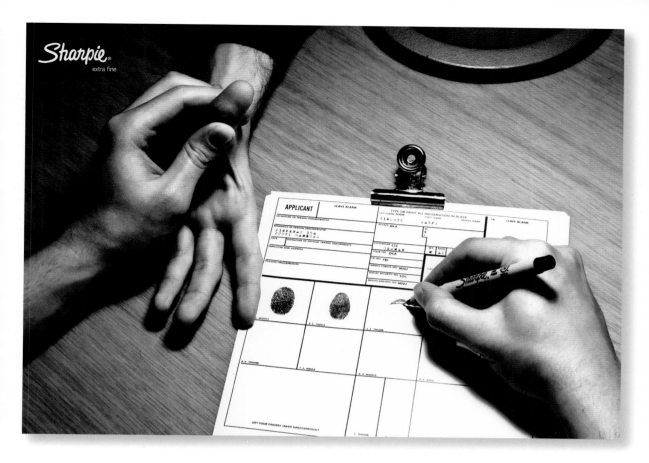

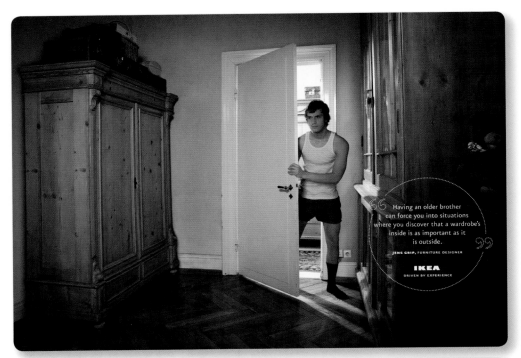

Having an older brother can force you into situations where you discover that a wardrobe's inside is as important as it is outside.

JENS GRIP, FURNITURE DESIGNER

IKEA
DRIVEN BY EXPERIENCE

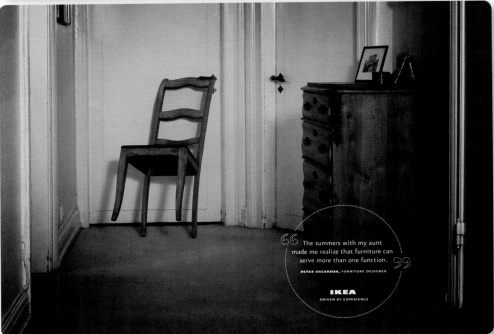

The summers with my aunt made me realize that furniture can serve more than one function.

PETER OSCARSON, FURNITURE DESIGNER

IKEA
DRIVEN BY EXPERIENCE

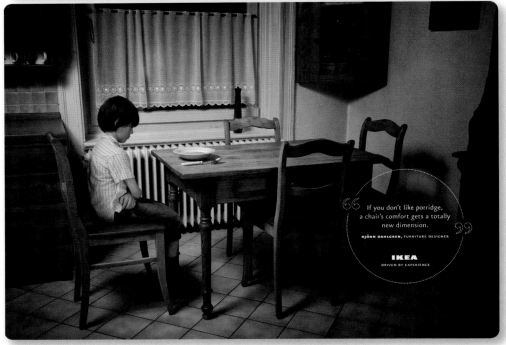

If you don't like porridge, a chair's comfort gets a totally new dimension.

BJÖRN DAHLGREN, FURNITURE DESIGNER

IKEA
DRIVEN BY EXPERIENCE

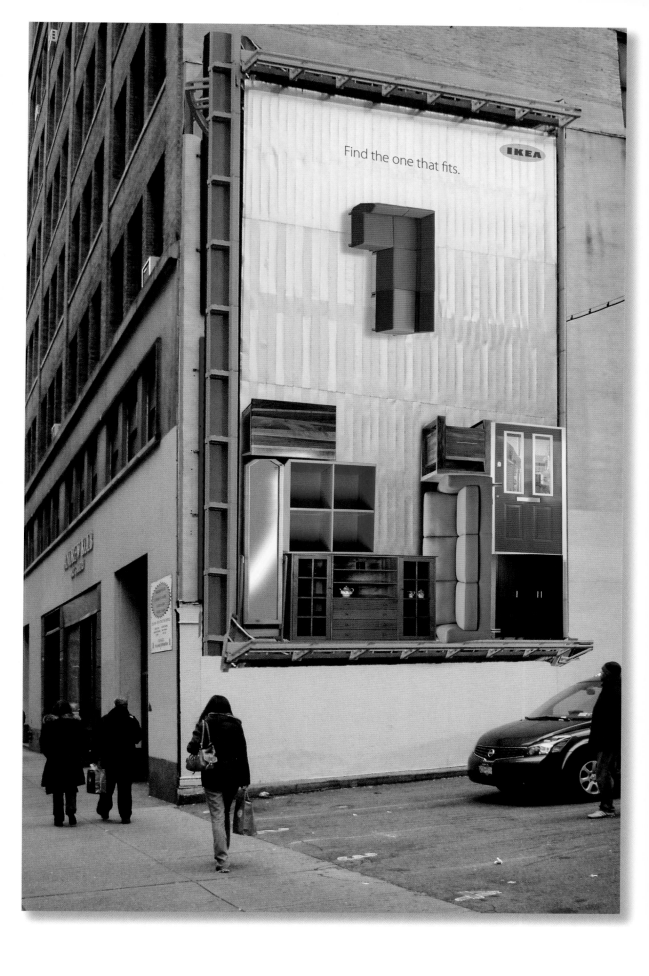

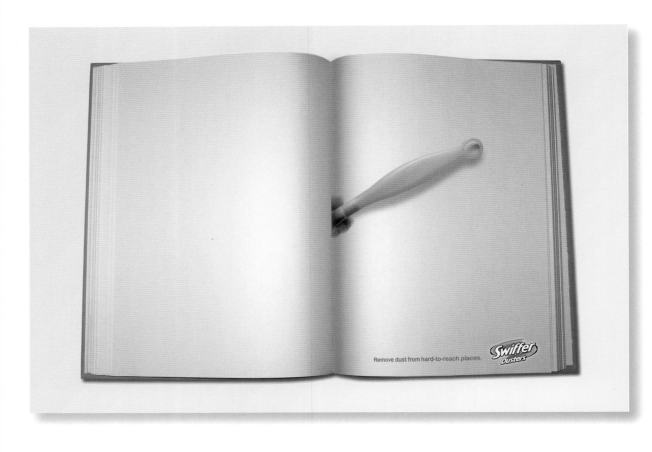

Remove dust from hard-to-reach places.

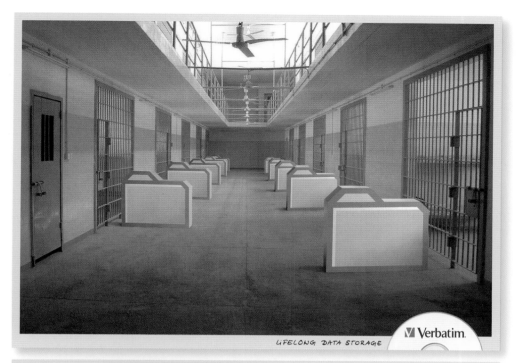

LIFELONG DATA STORAGE

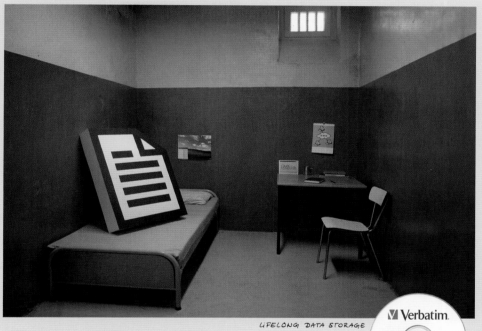

LIFELONG DATA STORAGE

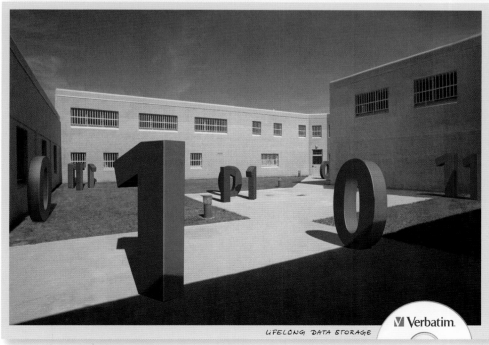

LIFELONG DATA STORAGE

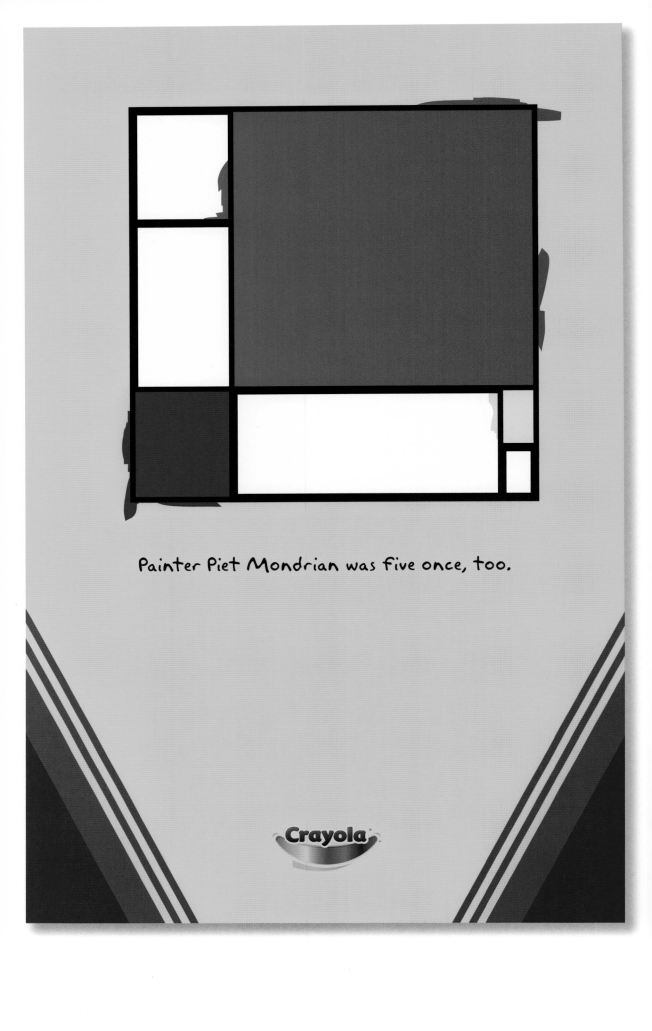

Painter Piet Mondrian was five once, too.

Crayola

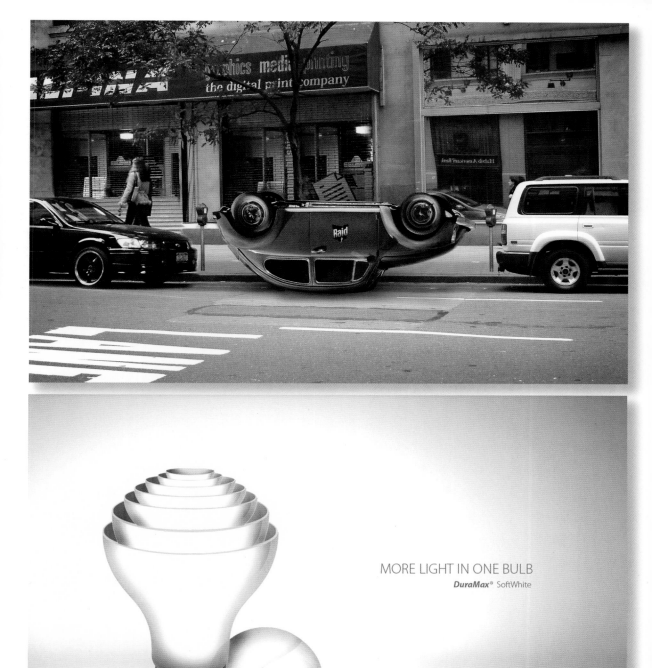

MORE LIGHT IN ONE BULB

DuraMax® SoftWhite

Frank Anselmo School of Visual Arts **Jeseok Yi**
Frank Anselmo School of Visual Arts **Ronnie Jaspers, Nick Plomp**

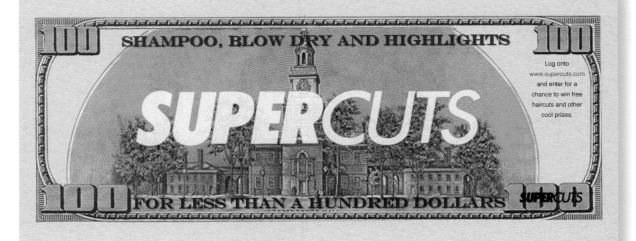

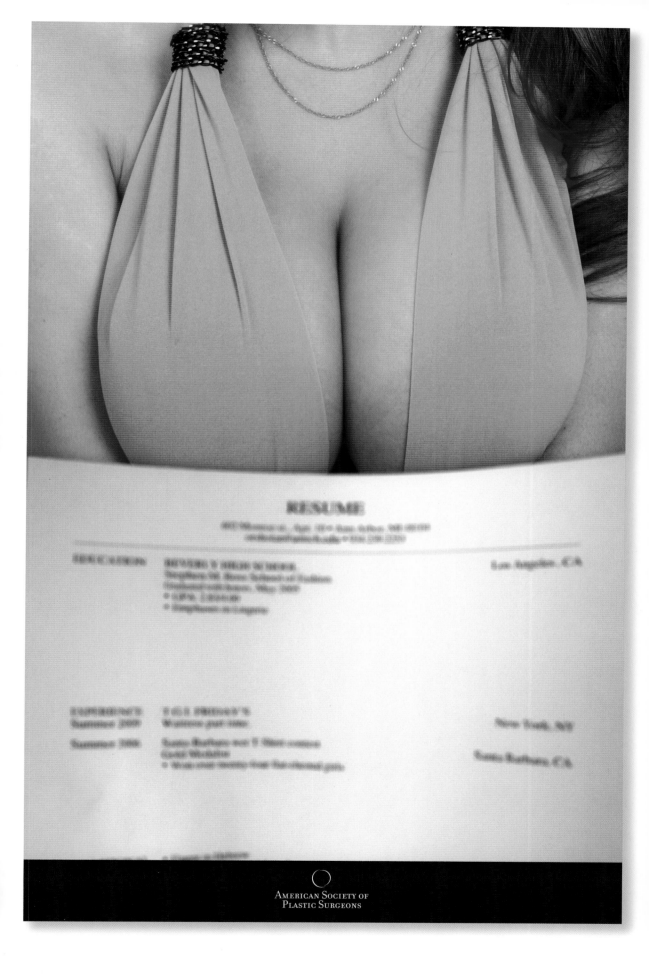

RESUME

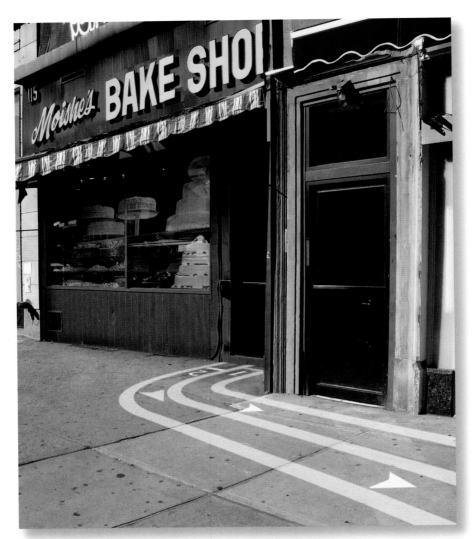

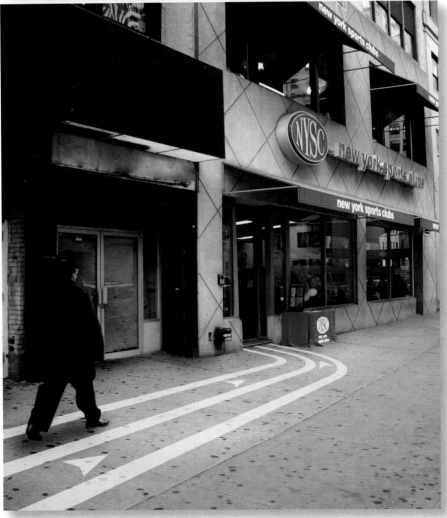

Frank Anselmo School of Visual Arts Jeongjyn Yi

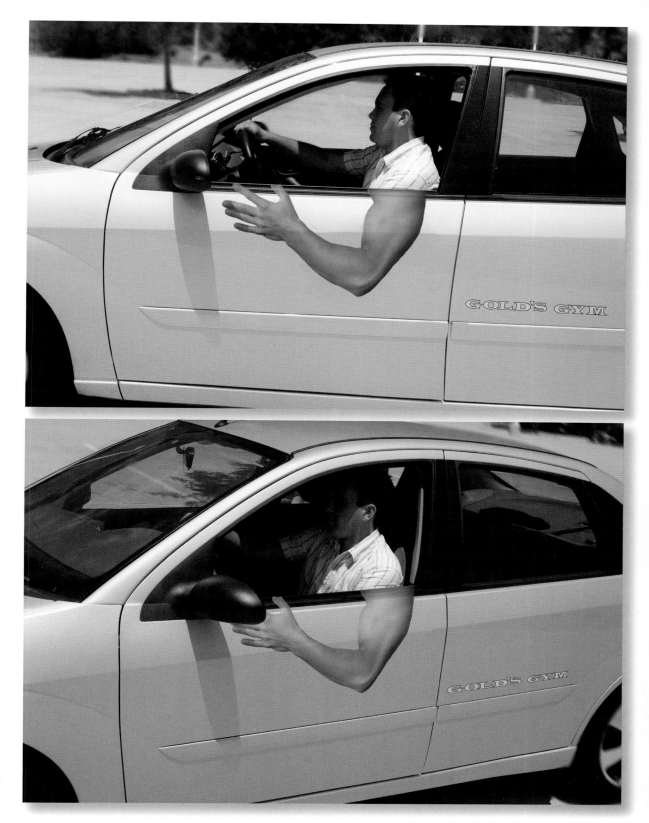

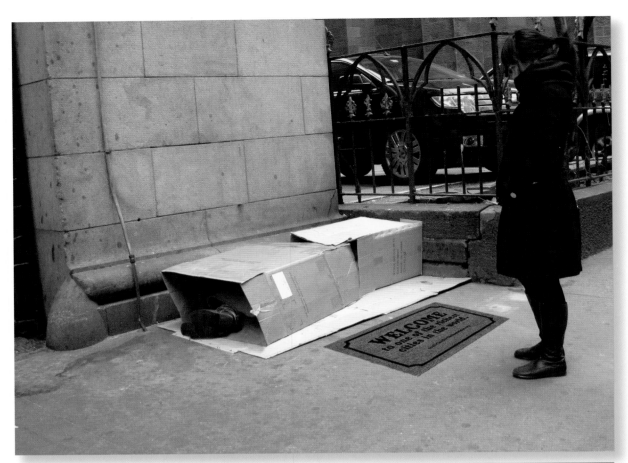

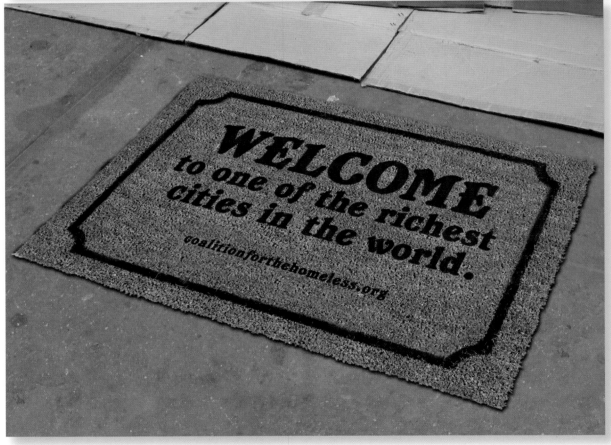

Frank Anselmo School of Visual Arts
Annie Chiu, Ana Echiverri, Hee Kyung Helen Shin

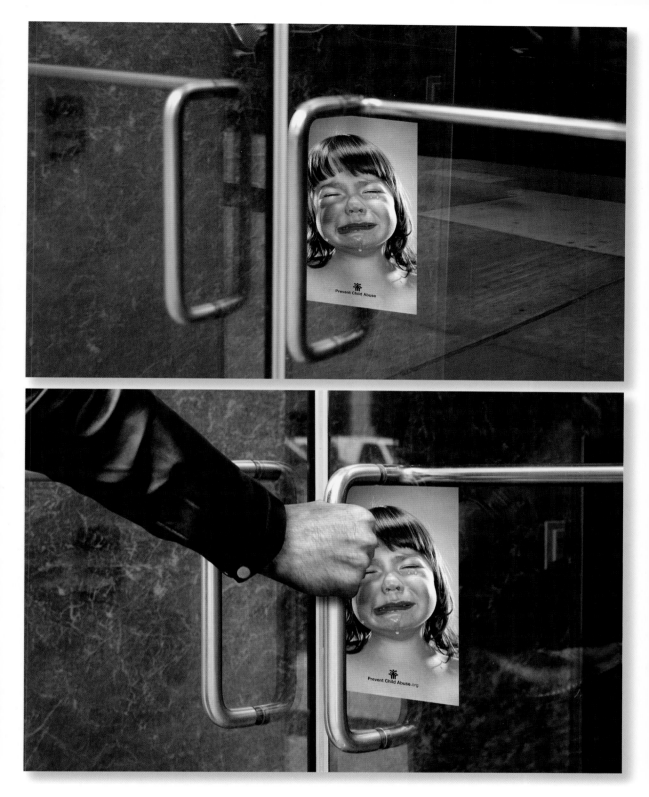

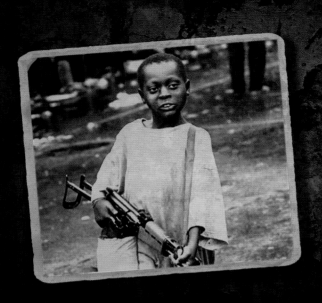

SOMETHING'S WRONG WHEN BASIC TRAINING
COMES RIGHT AFTER POTTY TRAINING.

 Amnesty International There are over 300,000 child soldiers around the world. Help ban the use of children in armed conflicts.

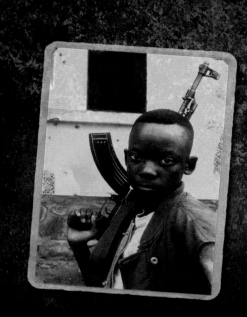

SOME CHILDREN DREAM OF JOINING THE ARMY ONE DAY.
OTHERS DREAM OF LEAVING IT.

 Amnesty International There are over 300,000 child soldiers around the world. Help ban the use of children in armed conflicts.

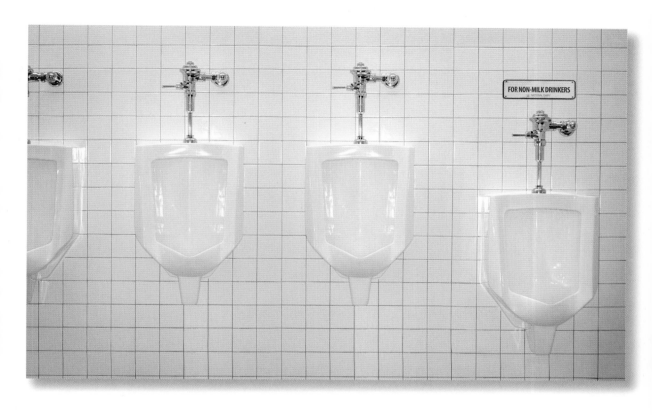

The image contains a sign reading "FOR NON-MILK DRINKERS"

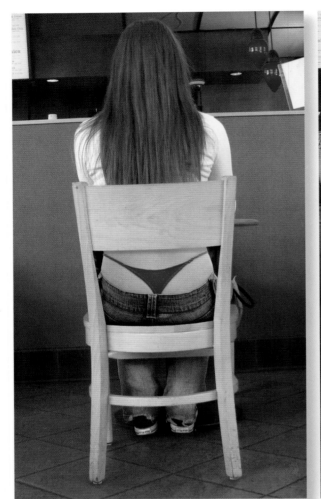 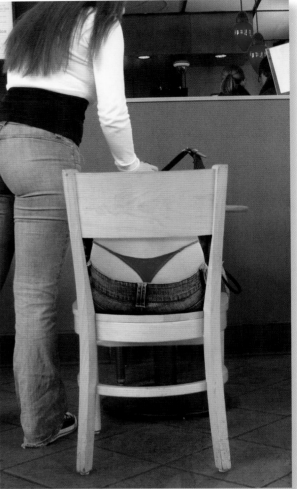

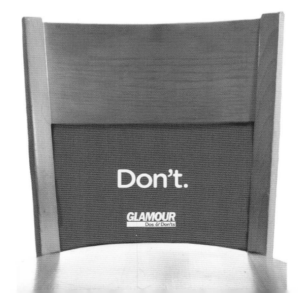

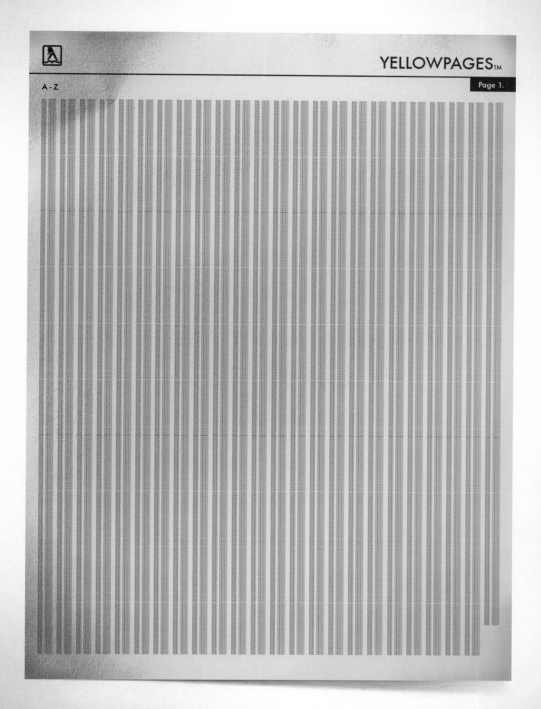

NOW ALL ON ONE PAGE.

YELLOWPAGES.COM

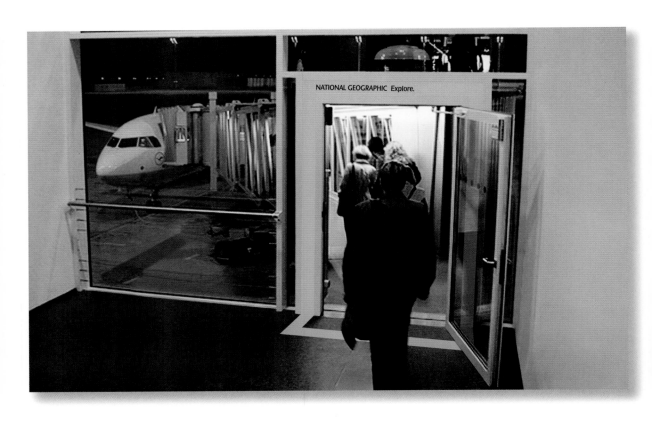

NATIONAL GEOGRAPHIC Explore.

Library Cafe

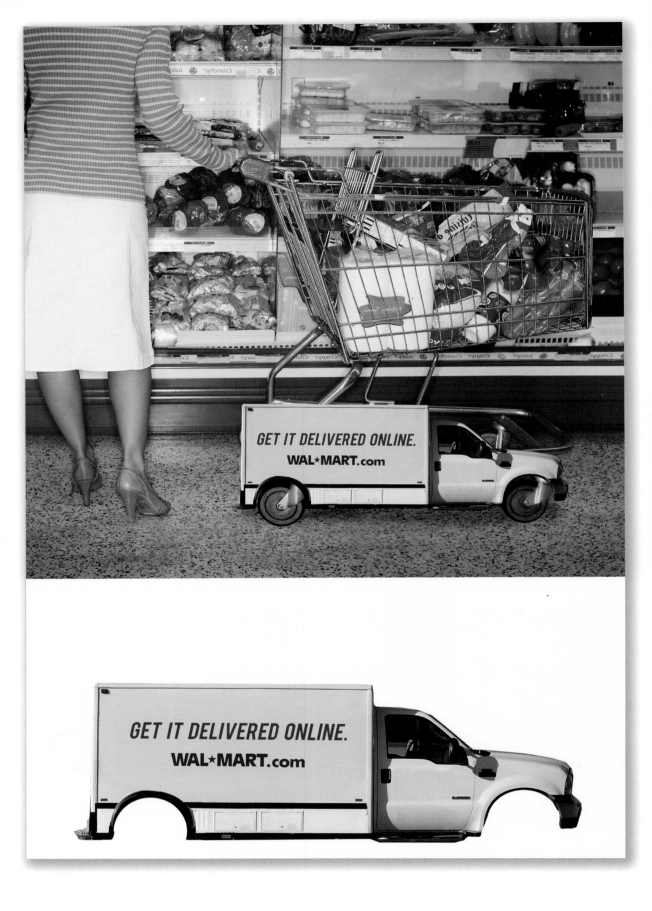

GET IT DELIVERED ONLINE.
WAL★MART.com

GET IT DELIVERED ONLINE.
WAL★MART.com

Frank Anselmo School of Visual Arts **Jeseok Yi**

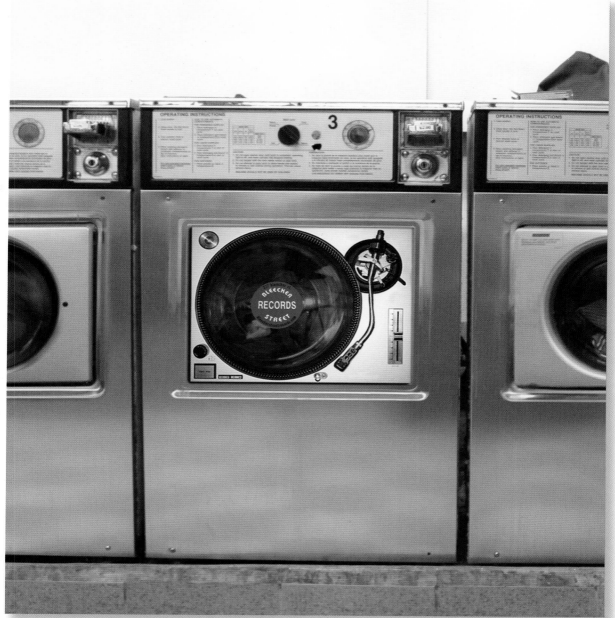

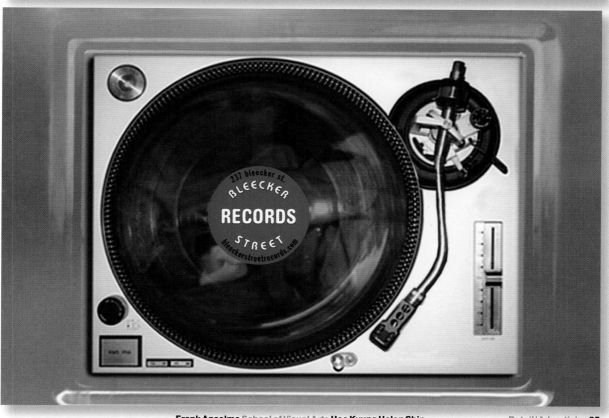

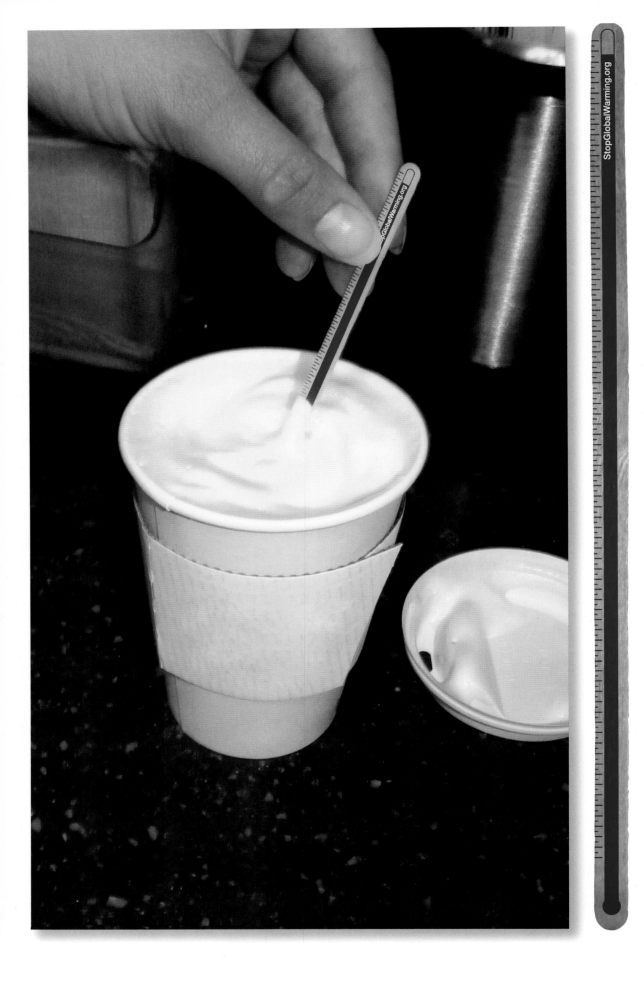

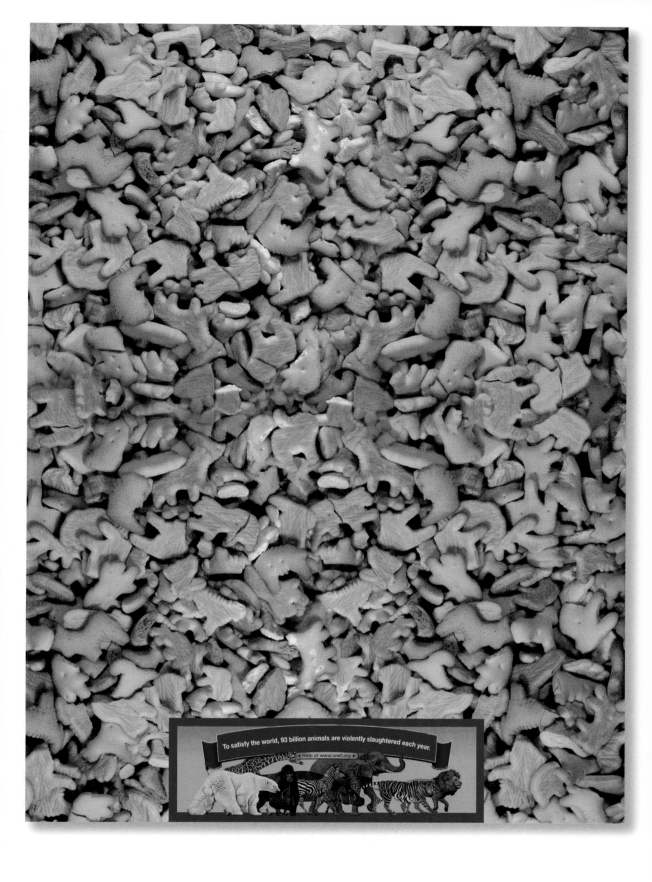

To satisfy the world, 93 billion animals are violently slaughtered each year.
★ Help at www.wwf.org ★

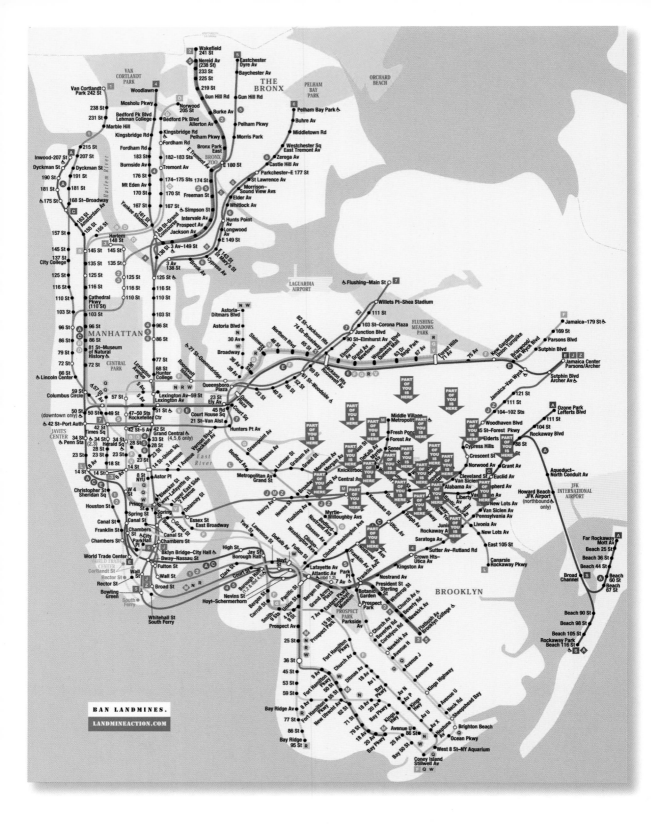

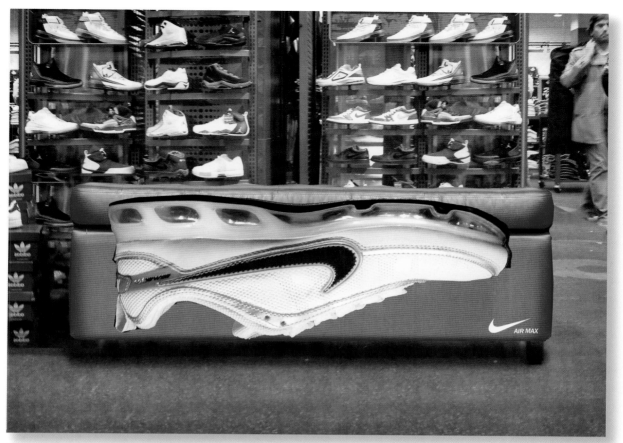
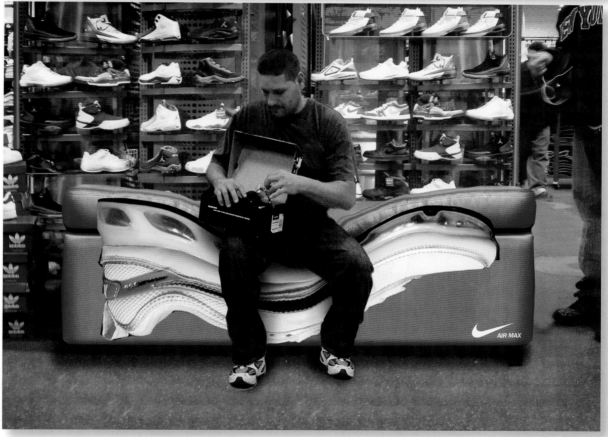

WHEN YOUR SON PLAYS THE TUBA NO ONE WINS

RAISE A CHAMPION.

kids

Jan Rexhausen, Niklas Frings-Rupp Miami Ad School, Europe
Nicolas Schmidt-Fitzner, Tara Lawall

It's okay to LICK THE LAST DROP

A Letter from the Chairman

David Bennett The Art Institute of Houston **Ashley Ayres**

IT WAS AN ACCIDENT.

WHAT A TRAGEDY.

THE ACCIDENT

A NOVEL

GAO XINGJIAN

MOVE ON. ALL OF YOU MOVE ON.

Lanny Sommese, Kristen Sommese Penn State University **Thomas Wilder**

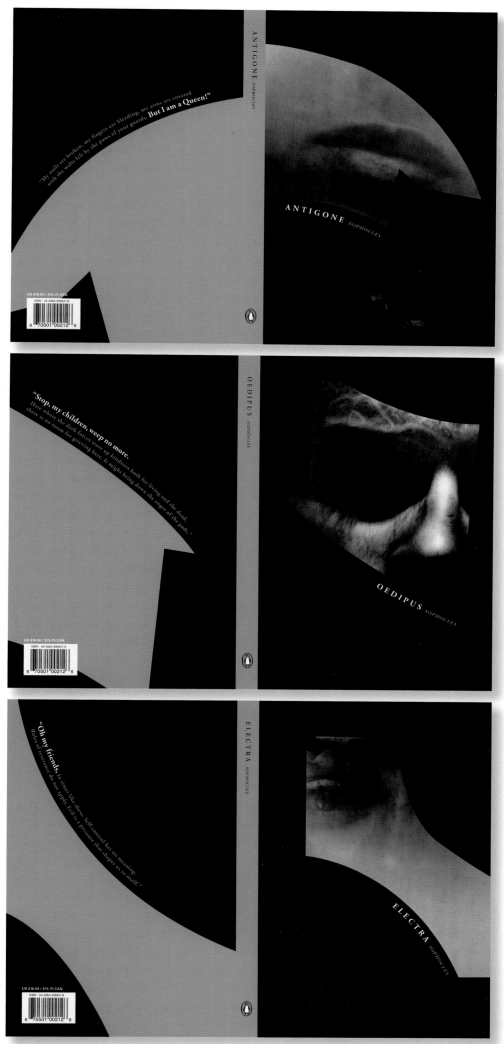

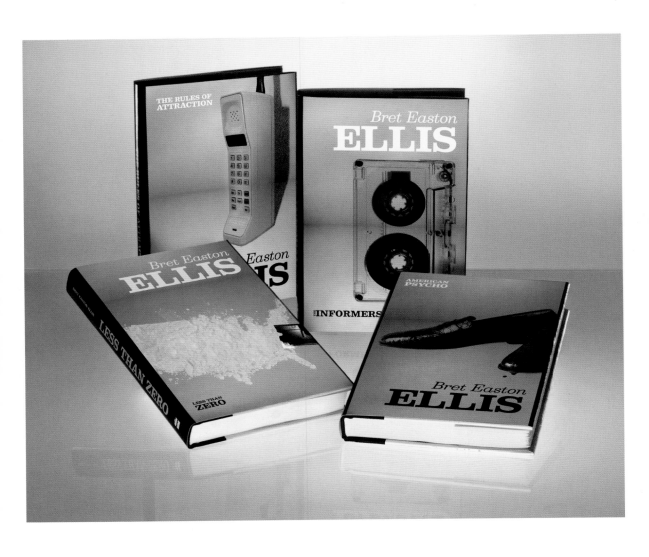

HarperCollins

10004 ISBN-13: 989-0-378-05738-9 6-89667

BRET EASTON ELLIS

THE INFORMERS

Bret Easton
ELLIS

THE INFORMERS

THE RULES OF ATTRACTION (second cover)

HarperCollins

10004 ISBN-13: 989-0-378-05738-9 6-89667

BRET EASTON ELLIS

THE RULES OF ATTRACTION

THE RULES OF ATTRACTION

Bret Easton
ELLIS

AMERICAN PSYCHO (third cover)

HarperCollins

10004 ISBN-13: 989-0-378-05738-9 6-89667

BRET EASTON ELLIS

AMERICAN PSYCHO

AMERICAN PSYCHO

Bret Easton
ELLIS

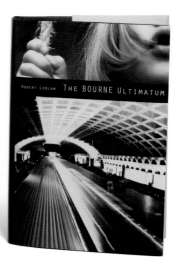

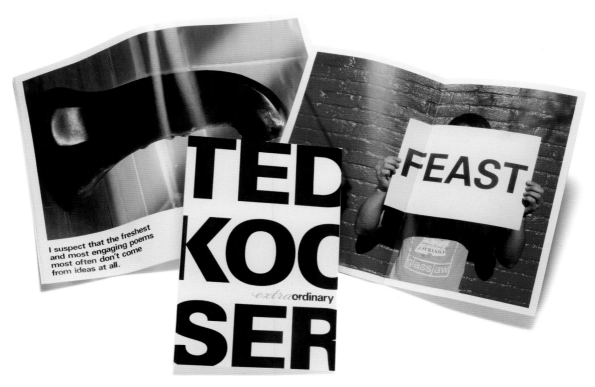

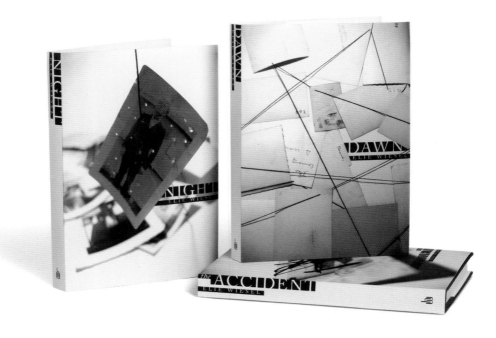

Melissa Kuperminc Portfolio Center **Jennifer Peake**
Nicole Riekki Portfolio Center **Dave Whitling**
Melissa Kuperminc Portfolio Center **Audrey Gould**

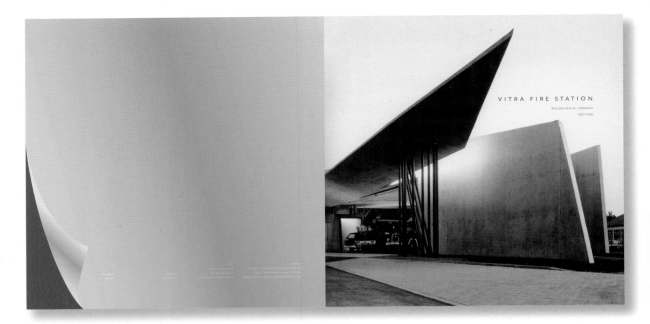

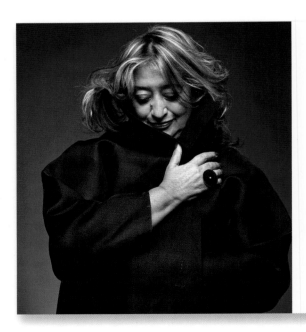

Richard Poulin School of Visual Arts **Laura Pocius**

MARK HELPRIN

a

vermont

tale

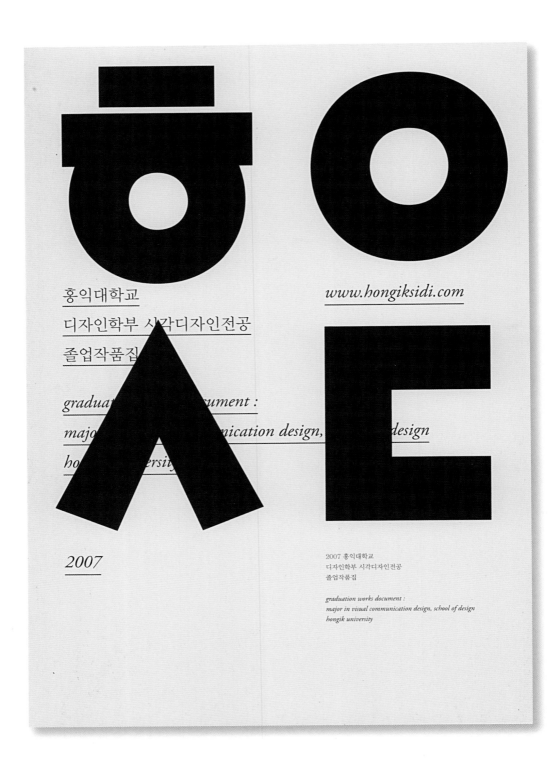

홍익대학교
디자인학부 시각디자인전공
졸업작품집

www.hongiksidi.com

graduat ument :
majo nication design, design
ho ersity

2007

2007 홍익대학교
디자인학부 시각디자인전공
졸업작품집

graduation works document :
major in visual communication design, school of design
hongik university

Ahn, Sang-Soo Hongik University **Hyemi Choi**

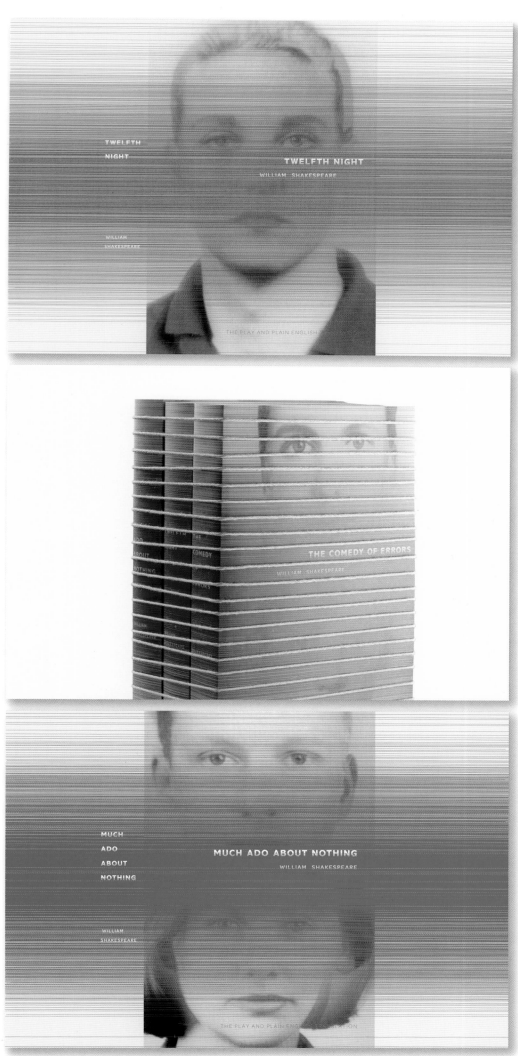

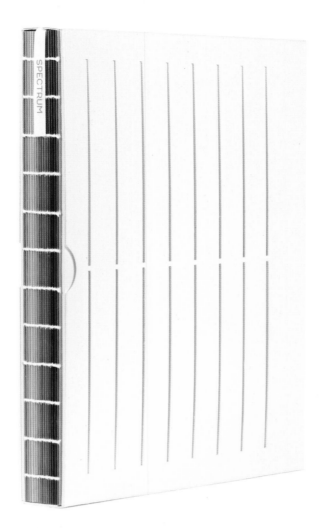

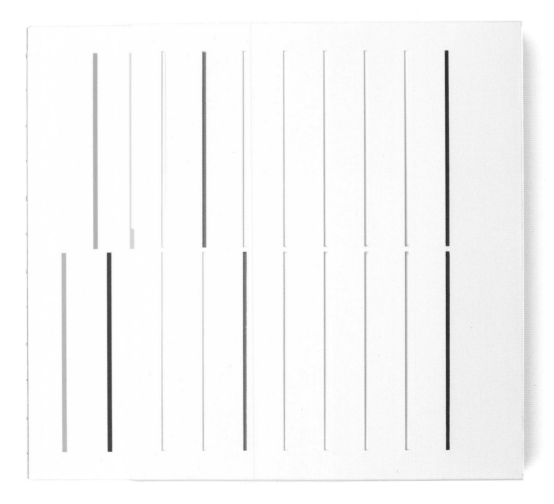

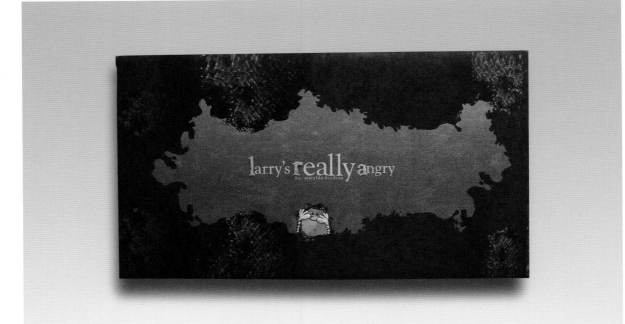

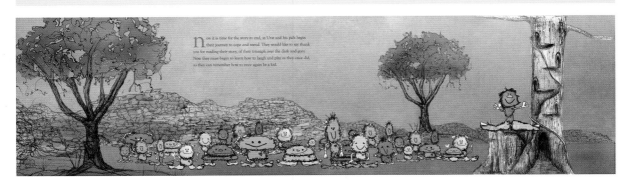

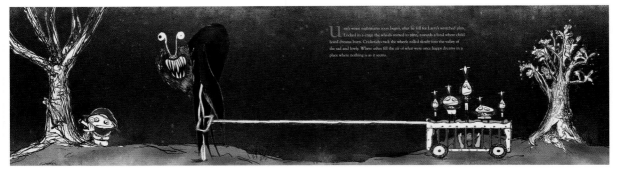

Scott Laserow Tyler School of Art, Temple University **Matylda Bierdron**

THEY WERE JUST SO MEAN TO ME.

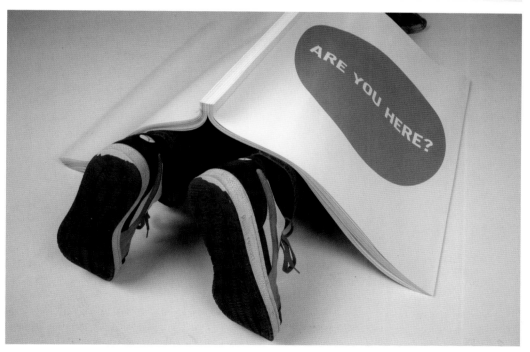

ARE YOU HERE?

LO SE R.

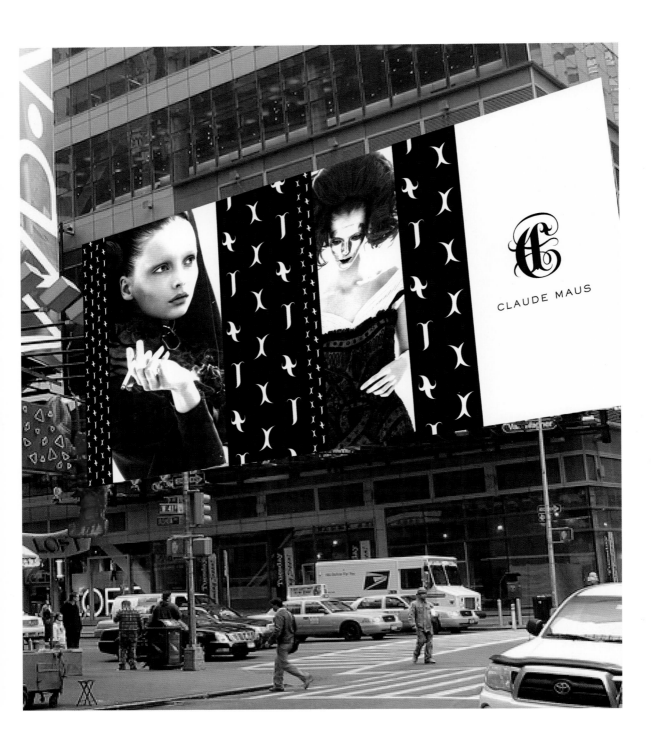

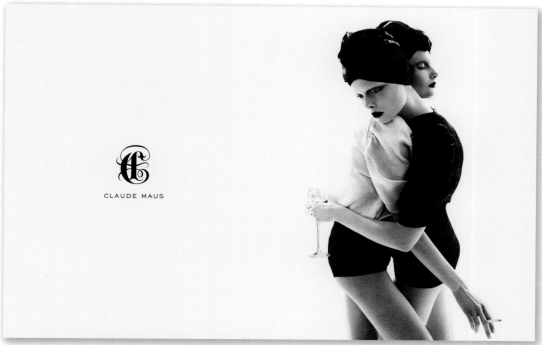

CLAUDE MAUS

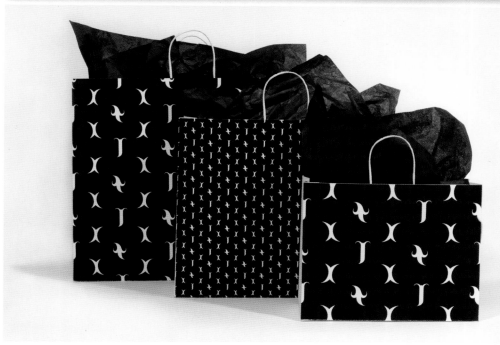

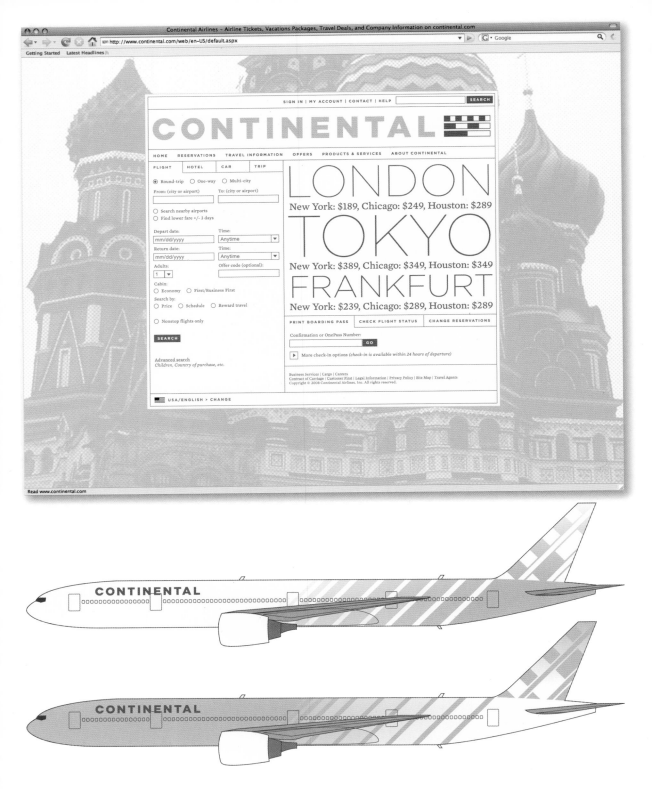

Adrian Pulfer Brigham Young University **Austin Taylor**

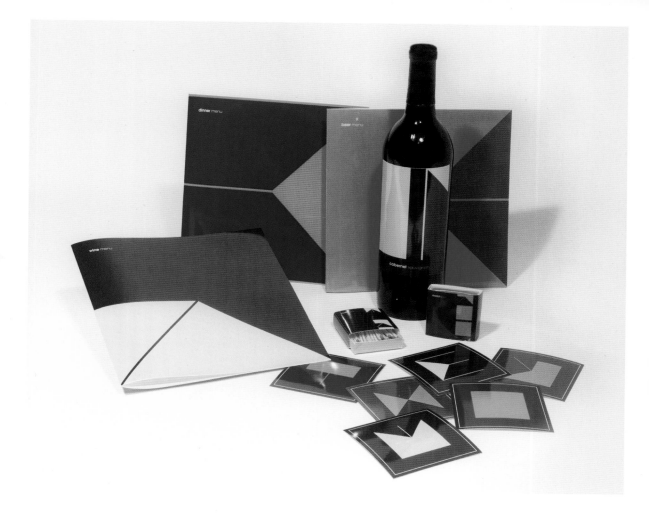

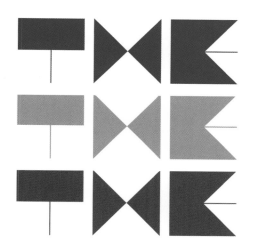

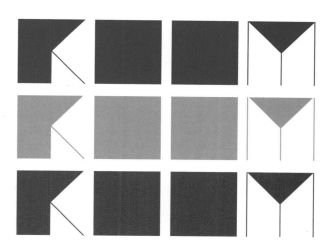

Michael Ian Kaye School of Visual Arts **Takashi Kasui**

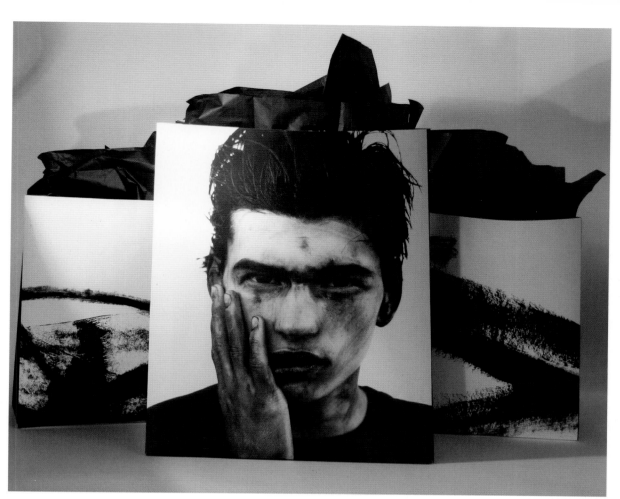

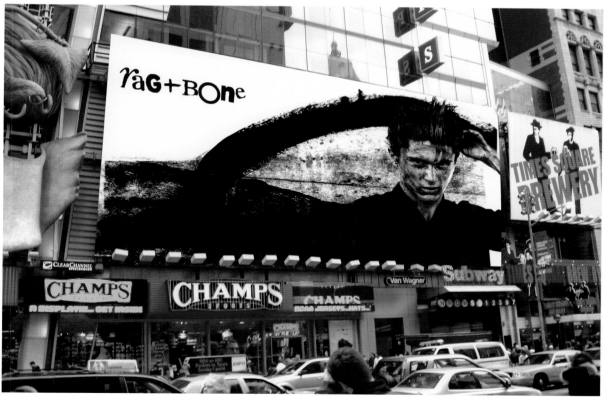

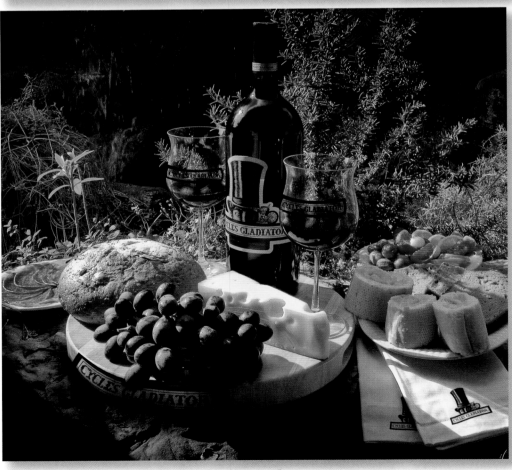

(this spread)

Helvetica Wonder Book

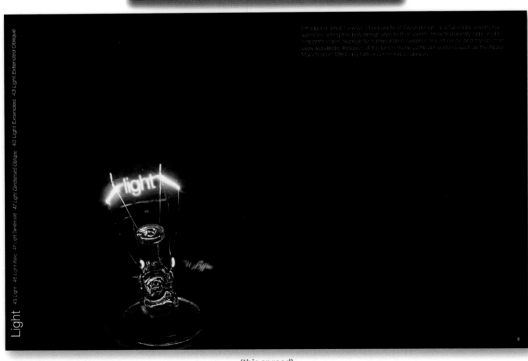

a

The first thing to look for when identifying Helvetica is the lowercase a. It is a two-storied letter; the top of the bowl curves to meet the stem; the stem ends in a hooked tail almost like a serif that curves parallel to the baseline.

R

Next look for an uppercase R. Helvetica is one of the only san serifs that has a curved leg on the uppercase R.

12

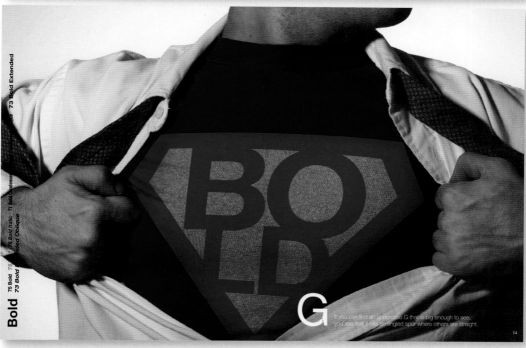

Bold 75 Bold 76 Bold Italic 77 Bold Condensed
73 Bold 77 Bold Condensed Oblique

G If you can find an uppercase G that is big enough to see, you see that it has an angled spur where others are straight.

14

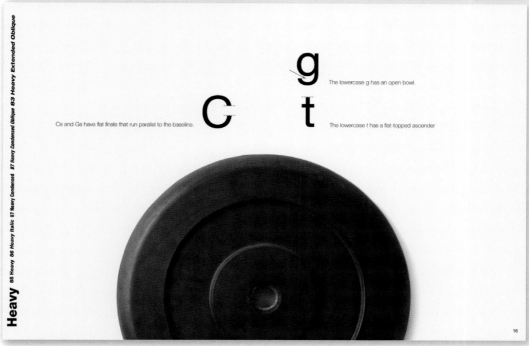

g The lowercase g has an open bowl.

C

t The lowercase t has a flat-topped ascender

Cs and Gs have flat finals that run parallel to the baseline.

16

01

02

03

04

05

06

07

08

09

10

11

12

(this spread)

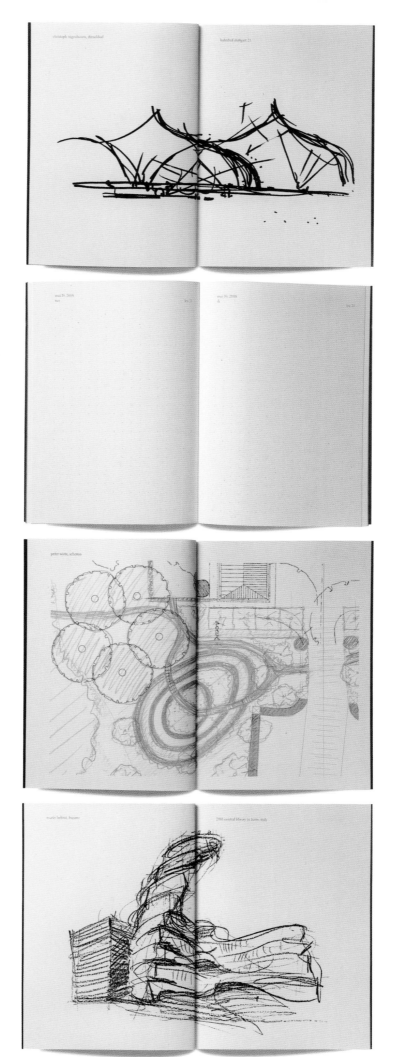

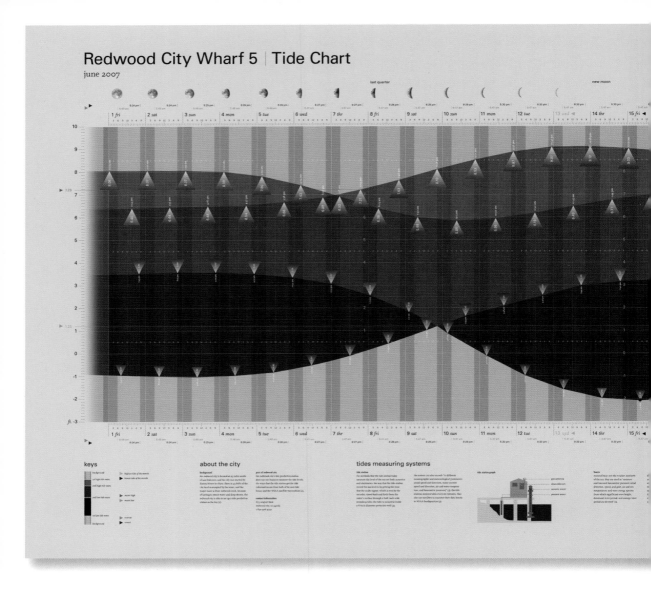

Redwood City Wharf 5 | Tide Chart

june 2007

Randall Sexton San Jose State University **Kevin Tzu-Shuan Lu** (top)

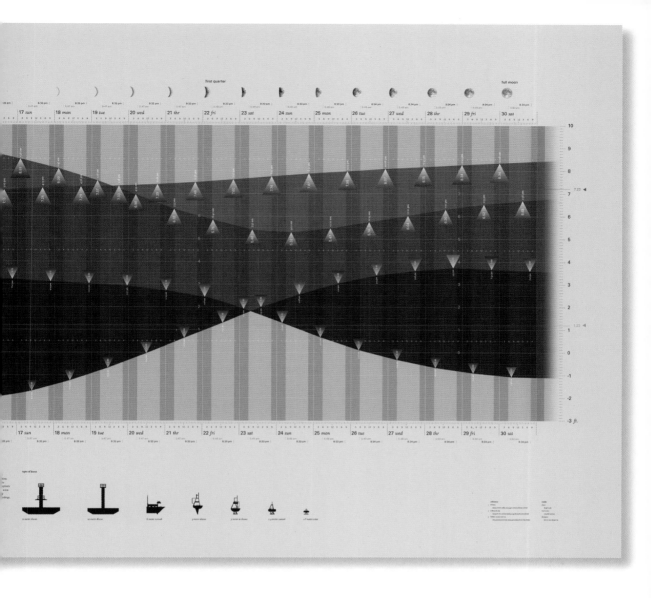

Kristin Sommese Penn State University **Jillian Haney** (bottom)

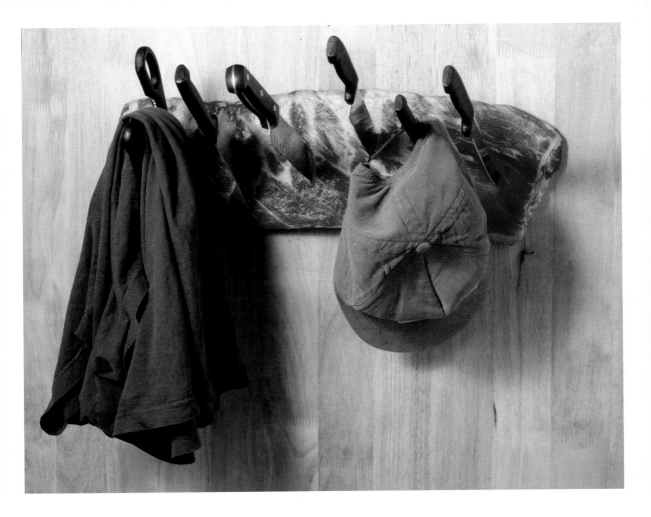

Kevin O'Callaghan School of Visual Arts **Alexis Shields**

● Style ● Beauty ● Object ● Food ● Culture

summer 2009 **#17**

i
icons

THE NEW GREEN BUILDING ●
ALL ABOUT NEW SUSTAINABLE BUILDINGS

STUTTGART ●
FROM 2 PHOTOGRAPHER'S PERSPECTIVE

BEYOND THE FOOD ●
PIERRE GAGNAIRE

ALEX KATZ ●
A 2D LOOK REAVEALS HIS VOICE

IRVING PENN
STRANGE SIGHT, ANOTHER WORLD

iconsmagazine.com

04>

0 71486 02051 6

$ 9.95 US $ 10.95 CAN

(this spread)

● Style ● Beauty ● Object ● Food ● Culture

summer 2009 **#17**

i
icons

● **THE NEW GREEN BUILDING**
ALL ABOUT NEW SUSTAINABLE BUILDINGS

● **STUTTGART**
FROM 2 PHOTOGRAPHER'S PERSPECTIVE

● **BEYOND THE FOOD**
PIERRE GAGNAIRE

● **ALEX KATZ**
A 2D LOOK REAVEALS HIS VOICE

● **IRVING PENN**
STRANGE SIGHT, ANOTHER WORLD

iconsmagazine.com

0 71486 02051 6 04>

$9.95 US $10.95 CAN

FALL WINTER 2007-08
Volume 4 Number 2 $14.95

Jennifer Gunji, Daniel Goscha University of Illinois at Urbana-Champaign School of Art and Design
Travis Austin, Aditya Bhargava, Samuel Copeland, Kelly Cree, Lauren Emerson, Sarah Esgro, Lauren
Ferguson, Adam Fotos, Mark Hauge, Sarah Kowalis, Jonathan Lopez, Elise McAuley,
Jessica Mullen, Archana Shekara, Brett Talbot, Ho-Mui Wong

anthem

august/2008

US $5.95 / CAN $8.95

no. 30 **BANKSY** UNMASKED **HEIDI WILLIAMS** A REAL BOMBSHELL
JOHN MITCHELL ESCAPES FROM NEW YORK **CILLIAN MURPHY** FAR
AND AWAY **JASON LEE** SHOOTS AMERICA

1 28016 69167 5

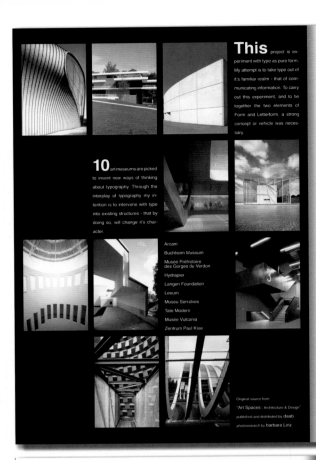

This project is experiment with type as pure form. My attempt is to take type out of it's familiar realm - that of communicating information. To carry out this experiment, and to be together the two elements of Form and Letterform, a strong concept or vehicle was necessary.

10 art museums are picked to invent new ways of thinking about typography. Through the interplay of typography my intention is to intervene with type into existing structures - that by doing so, will change it's character.

Arcam
Buchheim Museum
Musée Préhistoire
des Gorges du Verdon
Hydrapier
Langen Foundation
Leeum
Museu Serralves
Tate Modern
Musée Vulcania
Zentrum Paul Klee

Original source from
"Art Spaces : Architecture & Design"
published and distributed by daab
photoresearch by barbara linz

INTER VENTIONS
FORM&LETTERFORM

The success of Herzog & de Meuron's Tate Modern set off a boom for this architect team which has continued on into the new millenium, especially in the field of museum building. This project might well be regarded as the acid test for the architects, as they didn't have the option here of erecting a new building. Instead, they were asked to transform a pre-existing structure with a completely different function - a former power plant - into London's first museum for modern art. The capable designers did not attempt to conceal the brick building erected by G. G. Scott (inventor of Britain's red telephone booth), but rather underlinded its industrial character and contrasted it in a highly aesthetic fashion with modern glass insertions and additions. Perhaps the team's most important decision in architectonic terms was to lay open the turbine hall, which can now unfold its full power as a gigantic space soaring 35 metres upward, comparable in feeling only to a church nave.

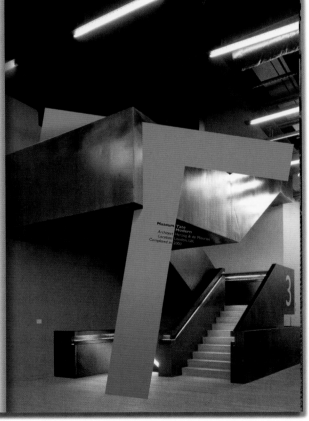

Museum **Tate Modern**
Architect Herzog & de Meuron
Location London, UK
Completed in 2000

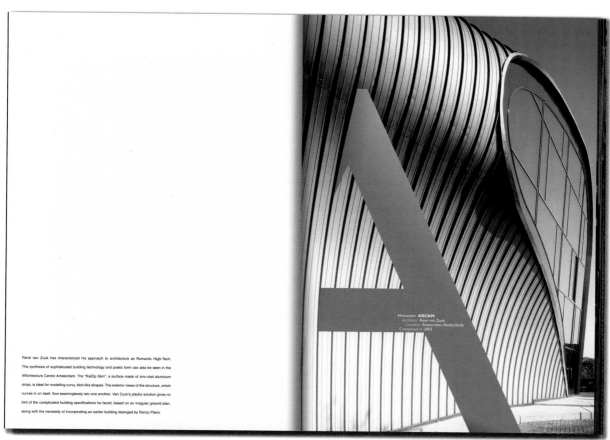

René van Zuuk has characterized his approach to architecture as Romantic High-Tech. The synthesis of sophisticated building technology and poetic form can also be seen in the ARchitecture Centre Amsterdam. The "KalZip Skin", a surface made of zinc-clad aluminium strips, is ideal for modelling curvy, blob-like shapes. The exterior views of the structure, which curves in on itself, flow seamlessly into one another. Van Zuuk's playful solution gives no hint of the complicated building specifications he faced, based on an irregular ground plan, along with the necessity of incorporating an earlier building designed by Renzo Piano.

Museum **ARCAM**
Architect René van Zuuk
Location Amsterdam, Netherlands
Completed in 2003

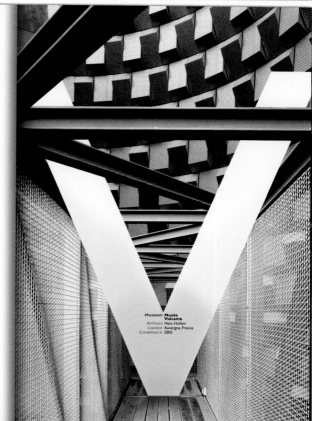

This museum, part of a European centre for volcano research, is situated at an altitude of 1,000 metres in the middle of an extinguished volcano in the Massif Central. The striking focal point of the complex, which can be seen far and wide, is a 37-metre-high cone composed of two offset conical half-shells. The cone forms an artificial crater set over an actual solidified lava stream. It is fittingly sheathed in basalt, a ligneous, or volcanic, rock. The spectacular iridescent interior is coated in gold-coloured stainless steel, promoting associations with a smouldering volcano. The actual museum itself is underground, with light pouring down from the crater. To enter the museum, visitors undertake a dramatic descent into the imposing mouth of the volcano.

Museum **Musée Vulcania**
Architect Hans Hollein
Location Auvergne, France
Completed in 2002

life/love
Face
magazine

issue
01

£ 9.50

0108

AR·NA

(this spread)

LINES ARE NOT BOUNDARIES
THEY'RE INVITATIONS

S

Dacra has created the start of a revolution in the use of line and space by crossing boundaries previously unapproached. In the late 1980s, Dacra played an instrumental role in the revitalization and restoration of a number of nice Art Deco landmarks—and helping transform the area from a shabby backwater complex into the international architectural phenomenon it is today in a world.

For the past seven years, Dacra has led the redevelopment of the Design District, and has worked with architects like teams Craig Konyken, Alison Spears, Walter Chatham, Enrique Norten, John Keenan, and the a Terence Riley to revamp the rundown areas and bring a new life in the beautiful spaces in the an architecture of space and form. One of Robins' most recent projects is also perhaps his boldest: Aqua, a community of 151 townhouses in and mid-rise condominium units on an 8.5-acre island near Miami Beach.

The urban-planning firm of the Duany Plater-Zyberk—noted proponents of New Urbanism—created the site's master plan. But while New Urbanism is often associated with traditional design, Robins wanted Aqua to "reconcile the rift between New Urbanism and Modernism," and he invited 10 different architects, all known for their contemporary vocabulary, to design the island's homes. Robins' intense interest in design extends beyond his role as a real estate developer. He is the principal of Design Miami and Design Miami/Basel, highly successful fairs for ultra-high-end design. A major collector of contemporary art and design, Robins also serves on a number of museum boards, including the big Miami Art Museum, the Hirshhorn Museum and Sculpture Garden, and the Wolfsonian–Florida International University Museum. He is also a member of the Yale School of Architecture Dean's Council. In 2006, he won the Design Patron Award from the Smithsonian Institution's on Cooper-Hewitt National Design Museum that carried significant promotion.

You played an important role in not one but two rather remarkable urban transformations: South Beach in the and of early 1990s, and, more recently, the Miami Design District. What's your formula for the successful revitalization (or creation) of an urban community? Craig Robins: Most developers and also most an architects are

AUGUST 師師 93

Text by Arlo Vance. Photographs by Edward Mencher

BEST LAID PLANS

MODA TEXTURA

text by james soda vance photography by hassan nieluno

ascilby in look with texture as a a key element in an industry of change

Adrian Pulfer Brigham Young University **Arlo Vance** Editorial | Design **135**

ISSUE
04
2007
US & INTL

INTERIORS // FASHION // DESIGN

ISSUE
04
2007
US & INTL

INTERIORS // FASHION // DESIGN

LIGHT FARE

FORM-FITTING AND GAUZY FABRICS THAT CREATE A SWEET
SILHOUETTE ARE COMING BACK SO START PRAYING FOR
WARMER WEATHER BY FRANK ZAPPA PHOTOS BY MOON UNIT

aided by the civil unrest caused by the Great Depression, took power in Germany and eliminated its democratic government, the Weimar Republic. These two leaders began to re-militarise their countries and became increasingly hostile. Mussolini first conquered the African nation of Abyssinia and then seized Albania, with both Italy and Germany actively supporting Francisco Franco's fascist Falange party in the Spanish Civil War against the Second Spanish Republic (which was supported by the Soviet Union). Hitler then broke the Treaty of Versailles by increasing the size of the Germany's military, and remilitarized the Rhineland. He started his own expansion of Germany by annexing Austria and also the German-speaking regions (Sudetenland) of Czechoslovakia. The British government under Neville Chamberlain saw the Soviet Union as a greater threat to Europe and he pursued a policy of appeasement towards Germany, hoping to maintain a strong, anti-communist Germany to block Soviet expansion. This policy culminated in the Munich Agreement in 1938, which gave the Sudetenland to Germany.[6][7] In March 1939, Germany occupied the remainder of Czechoslovakia. Mussolini also invaded and annexed Albania in April. These events caused the United Kingdom and France to prepare for war against Germany. France and Poland

Kevin Brainard , Darren Cox School of Visual Art **Minhee Park**

DANCE

FEBRUARY 2008

HERZOG & DE MEURON | Laban Center, London
THE CREATIVE PROCESS | Chris Elam's Misnomer
CHANCE PROCEDURES | Cunningham & Lewitt
SLOW DANCING | Shen Wei Dance Arts, New York

DOCUMENTA
12 KASSEL, GERMANY

DANCE

MARCH 2008

DTW | New Architecture, New Performances
JACOB'S PILLOW | Intense Summer Programs
THE 5 SENSES | Touch and Improvisation
YOGA VS. PILATES | Uniting Body and Soul

RITE
OF SPRING
DOUG VARONE AT THE MET

Richard Poulin School of Visual Arts **Laura Pocius**

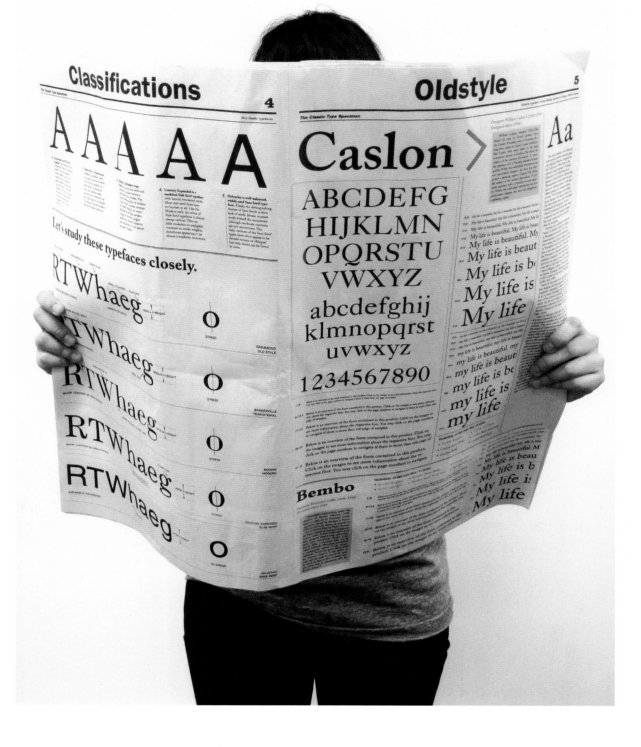

(this spread)

Font Reference Guide

Character Anatomy / Character Dimensions / Character Sets / Typeface Families · Weights, Widths, Styles & Numbers *The Classic Type Specimen* Character Sets / Typeface Classifications: Oldstyle, Transitional, Modern, Slab Serif, Sans Serif, Script Cursive Brush

Anatomy of a Character
By ILENE STRIZVER

Typestyles

Roman

Italic

Thin

Light

Regular

Semibold

Bold

Condensed

Extended

Light Condensed

Semibold Condensed

Bold Extended

Garamond Roman

Garamond Roman Italic

Garamond Semibold

Garamond Semibold Italic

Garamond Bold

Garamond Bold Italic

Type Families

Character Dimensions & Anatomy

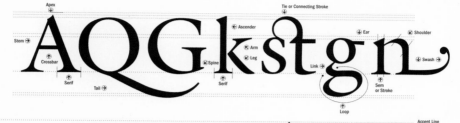

Apex · Stem · Crossbar · Serif · Tail · Ascender · Spine · Leg · Serif · Tie or Connecting Stroke · Ear · Shoulder · Link · Swash · Sem or Stroke · Loop

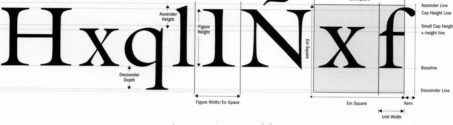

Ascender Height · Descender Depth · Figure Height · Figure Width/En Space · Accent Line (Uppercase) · Ascender Line · Cap Height Line · Small Cap Height Line · x-height line · Em Square · Baseline · Descender Line · Kern · Unit Width

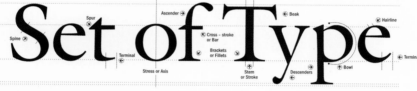

Spur · Spine · Terminal · Stress or Axis · Ascender · Cross-stroke or Bar · Brackets or Fillets · Stem or Stroke · Descenders · Beak · Hairline · Bowl · Terminal

hpx
GARAMOND

hpx
BASKERVILLE

hpx
BODONI

hpx
CENTURY EXPANDED

hpx
HELVETICA

Baskerville

Bodoni

Caslon

Caledonia

Helvetica

Futura

Eurostyle

Modern

Century

Lanny Sommese Penn State University **Jase Neapolitan**

RS Rolling Stone

WHERE WE ARE GOING. AFTER 7 YEARS OF FEAR AND CORRUPTION, THE TIME HAS COME FOR THE SWIFT AND RADICAL ACTION NECESSARY TO RESTORE HOPE AND COMMON SENSE.

by Jann Wenner

ART AND SEX
FROM ANTIQUITY
TO NOW

THE SPARKLING NATALIE PORTMAN HAS AMAZED US WITH HER BEAUTIFUL LOOKS. SHE IS THE TYPE OF WOMAN THAT SURELY TURNS HEADS WHEN ENTERING A ROOM.

by CHARLES MCGRATH
photograph by RICHARD BURBRIDGE

NATALIE PORTMAN

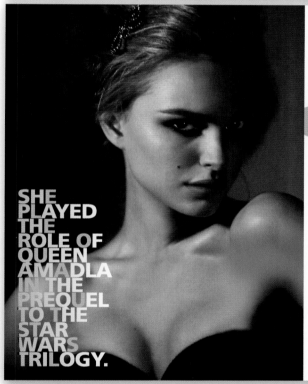

SHE PLAYED THE ROLE OF QUEEN AMADLA IN THE PREQUEL TO THE STAR WARS TRILOGY.

Effortlessly elegant even in a bright yellow bathrobe, Natalie Portman stands with Jason Schwartzman on a balcony in this scene from Hotel Chevalier, Wes Anderson's 12-minute short "prequel" that will play right before his feature film, The Darjeeling Limited (in which Portman also makes a brief appearance). Written by Anderson, Roman Coppola and Jason Schwartzman, (and featuring Schwartzman, Owen Wilson, Adrien Brody, The Darjeeling Limited follows three estranged brothers taking a train ride through India after the death of their father. The film is on schedule to hit theaters September 29, despite star Owen Wilson's recent difficultiesm Effortlessly elegant even in a bright yellow bathrobe, Natalie Portman stands with Jason Schwartzman on a balcony in this scene from Hotel Chevalier, Wes Anderson's 12-minute short "prequel" that will play right before his feature film, The Darjeeling Limited (in which Portman also makes a brief appearance). Written by Anderson, Roman Coppola and Jason Schwartzman, (and featuring Schwartzman, Owen Wilson, Adrien Brody, The Darjeeling Limited follows three estranged

BRIGHT YELLOW

FOLLOWING OTHER PEOPLE HAS NEVER BEEN HER STYLE

Duis fermentum turpis quis sem. Curabitur vitae turpis sed erat lacinia malesuada. Cras eu nulla. In mollis venenatis libero. Quisque vel ante in sem aliquam lobortis. Ut eleifend libero quis nunc. Etiam sed magna at eros viverra tristique. Curabitur convallis, quam commodo sollicitudin elementum, dolor elit elementum sapien, sit amet fringilla lectus magna at elit. Proin id felis.

SWEET SUZY Q WAS A REBEL

NO ANGEL WINGS, MORE LIKE THE

DEVIL, SHE WAS SO HOT SO COOL

AND NASTY

BELIEVE IT OR NOT, HERE'S WHAT SHE ASKED ME, IF YOU

WANT LOVE WITH NO CONDITION

LET ME PUT ON MY GLOVES SHUT UP AND LISTEN

CAUSE THE

DEVILS GOT A NEW

DISGUISE

Lanny Sommese Penn State University **Jennifer Way**
Kristin Sommese Penn State University **Nicole Angelica**

Kristin Sommese Penn State University **Kaleena Porter**
Kristin Sommese Penn State University **Madelyn Owens**

Editorial | Design **147**

Schweizer Spass
Spasseport suisse
Spassaporto svizzero
Spassaport svizzer
Swiss spassport

+

Only valid for
15 years Claus Koch™

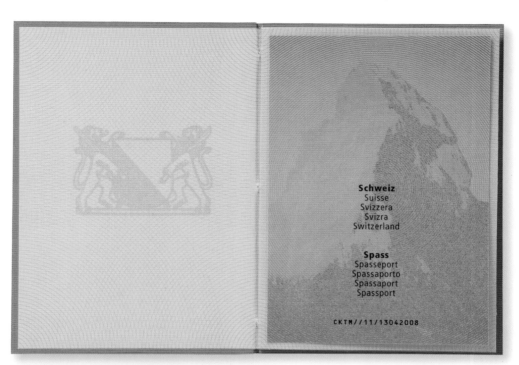

Schweiz
Suisse
Svizzera
Svizra
Switzerland

Spass
Spasseport
Spassaporto
Spassaport
Spassport

CKTM//11/13042008

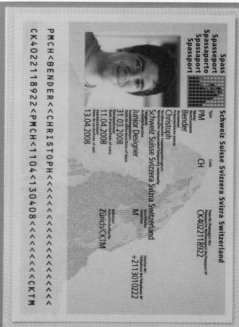

Spass
Spasseport
Spassaporto
Spassaport
Spassport

PMCH<BENDER<<CHRISTOPH<<<<<<<<<<<<<<<
CK4022118922<PMCH<1104<130408<<<<<<<<<<<<<CKTM

Schweiz Suisse Svizzera Svizra Switzerland

Type
PM

Code
CH

Pass Nr./Passeport No/
CK4022118922

Bender

Christoph

Junior Designer

31.03.2008

11.04.2008

13.04.2008

Schweiz Suisse Svizzera Svizra Switzerland

M

Zürich/CKTM

+211301 0222

Veranstalter / Organizer / Organisateur
TELEU, WALTRAUD / KOCH, CLAUS

Anlass / Occasion / Occasion
15 JAHRE CKTM

Teilnehmer / Participants / Participants
28

Ort / Location / Localité
ZÜRICH

Land / Country / Pays
SCHWEIZ

Dauer / Period / Durée
3 TAGE

CKTM//11/13042008

Reisegruppe / Tour group / Groupes de touristes

Name und Vornamen
Surname and given names
Nom et prénome

ADELT, NICOLE / BENDER, CHRISTOPH /
BERGER, TINA / BLOME, CAROLINE /
BRÜNING, HENDRIK / CRAIGIE, CORDELIA /
FINKE, CHRISTINA / FLÖTHMANN, TATJANA /
GEISLER, BIRGIT / GIESEN, NICOLE /
GRÜTTER, SIMONE / HOLLING, CAROLIN /
HOUBEN, ANTJE / HÜSEN, DIANA /
JANETZKY, SYLKE / KOCH, CLAUS /
KOCH, LIZA / KOCH, PATRICK /
KOCH, UTE / KOVAL, DANIEL /
MEHLER, MICHAEL / MEYER, SUSANNE /
RÖHR, SUSANNE / SACHERT, DANIELA /
TELEU, WALTRAUD / THIEME, DIRK /
TOEPSCH, ANDREA / WACKER, MARCUS

Amtliche Vermerke
Page reserved for issuing authorities
Page réservée aux autorités compétentes pour délivrer le passeport

APR 11, 08, DUS - ZRH
AB 8124
Abflug / Departure / Décollage 12:50
Ankunft / Arrival / Arrivée 14:05

APR 13, 08, ZRH - DUS
AB 8143
Abflug / Departure / Décollage 15:00,
Ankunft / Arrival / Arrivée 16:20

Hotel Greulich
Herman-Greulich-Strasse 56
8004 Zürich

Länder, für die dieser Pass gilt / Countries for which this passport is valid / Pays pour lesquels ce passeport est valable
Für die Schweiz / For Switzerland / Pour Suisse
Ausgestellt (Ort)/Issued at / Délivré à DÜSSELDORF

Datum / Date / Date
17.03.2008

Unterschrift / Signature / Signature

CKTM//11/13042008

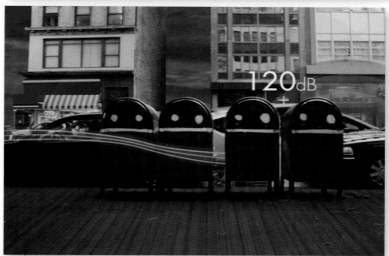

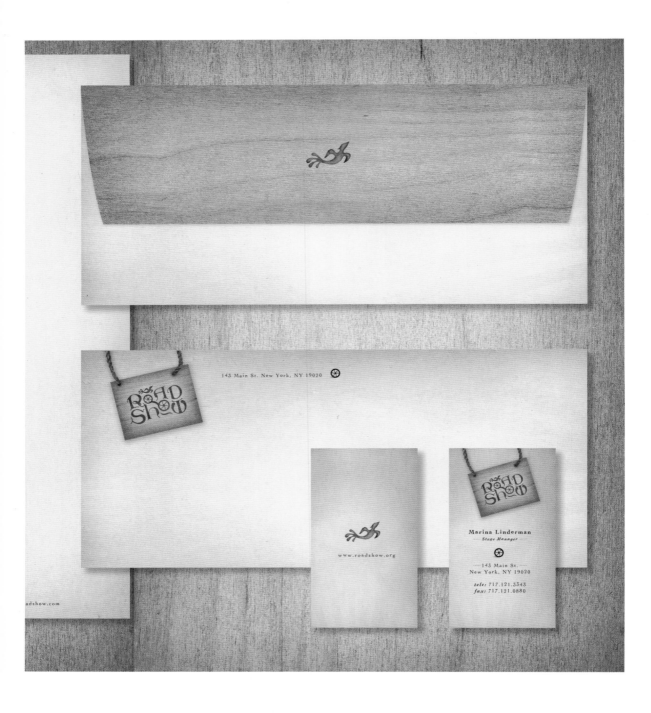

Alice Drueding Tyler School of Art , Temple University **Marina Linderman**

knee

ink tank
a world of ideas

Henry Hikima The Art Institute of California-San Diego **Inez Guevara**
Lanny Sommese Penn State University **Kelsey Walsh**
Richard Mehl School of Visual Arts **Drea Zlanabitnig**
Henry Hikima The Art Institute of California-San Diego **Daniela A. Ponce**
Lora Kueneman The Art Institute of California-San Diego **Jonis Perez,**
Peter Delgado, Gabriel Soria Meza, Luis Cazares

knyts

New York City

BLIND PIG PUB

VICTORIAN BONBONS VISUAL TREATS

PIRAHNA METALWORKS

RED ROCKET RECORDS

Richard Mehl School of Visual Arts **Jarrod Barretto**
Jeff Davis Texas State University at San Marcos **Steven Skadal**
Alice Drueding Tyler School of Art, Temple University **Andrea Pippins**
Henry Hikima The Art Institute of California-San Diego **Jonis Perez**
Henry Hikima The Art Institute of California-San Diego **David Gonsalves, Kyle Klemetsrud**

Henry Hikima The Art Institute of California-San Diego **Ana Galvez**
Alisa Zamir Pratt Institute **Li-Chuan Chiang**
Henry Hikima The Art Institute of California-San Diego **Peter Delgado**
Brian Brindisi School of Visual Arts **Isabelle Rancier**
Alice Drueding Tyler School of Art, Temple University **David Kusiak**

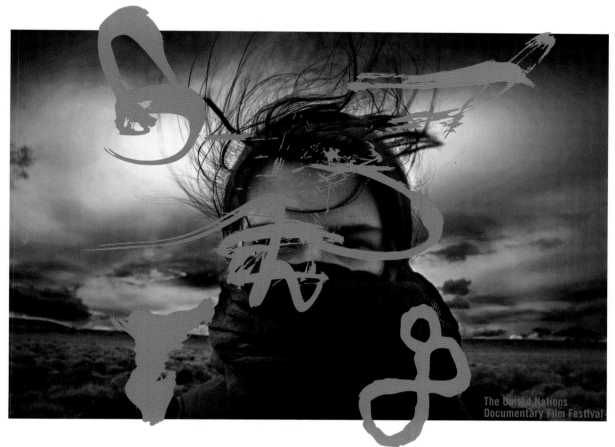

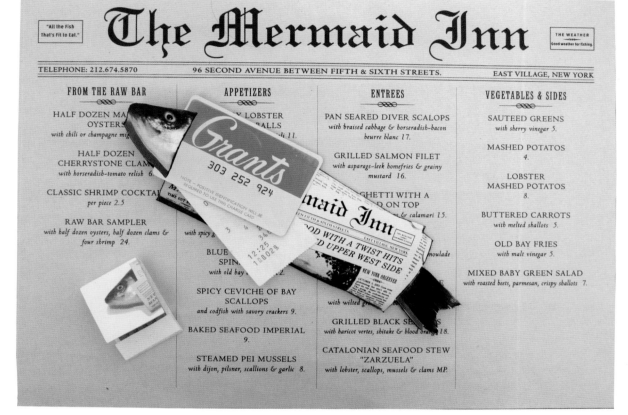

The Mermaid Inn

"All the Fish That's Fit to Eat."

THE WEATHER
Good weather for fishing.

TELEPHONE: 212.674.5870 96 SECOND AVENUE BETWEEN FIFTH & SIXTH STREETS. EAST VILLAGE, NEW YORK

FROM THE RAW BAR

HALF DOZEN MA...
OYSTERS...
with chili or champagne mig...

HALF DOZEN
CHERRYSTONE CLAM...
with horseradish-tomato relish 6.

CLASSIC SHRIMP COCKTAI...
per piece 2.5

RAW BAR SAMPLER
with half dozen oysters, half dozen clams &
four shrimp 24.

APPETIZERS

...Y LOBSTER
...ALLS
...li 11.

with spicy ...

BLUE
SPIN...
with old bay ... 2.

SPICY CEVICHE OF BAY
SCALLOPS
and codfish with savory crackers 9.

BAKED SEAFOOD IMPERIAL
9.

STEAMED PEI MUSSELS
with dijon, pilsner, scallions & garlic 8.

ENTREES

PAN SEARED DIVER SCALOPS
with braised cabbage & horseradish-bacon
beurre blanc 17.

GRILLED SALMON FILET
with asparags-leek homefries & grainy
mustard 16.

...GHETTI WITH A
...D ON TOP
...s & calamari 15.

...moulade

with wilted gr...

GRILLED BLACK SE...S
with haricot vertes, shitake & blood orange 18.

CATALONIAN SEAFOOD STEW
"ZARZUELA"
with lobster, scallops, mussels & clams MP.

VEGETABLES & SIDES

SAUTEED GREENS
with sherry vinegar 5.

MASHED POTATOS
4.

LOBSTER
MASHED POTATOS
8.

BUTTERED CARROTS
with melted shallots 5.

OLD BAY FRIES
with malt vinegar 5.

MIXED BABY GREEN SALAD
with roasted beets, parmesan, crispy shallots 7.

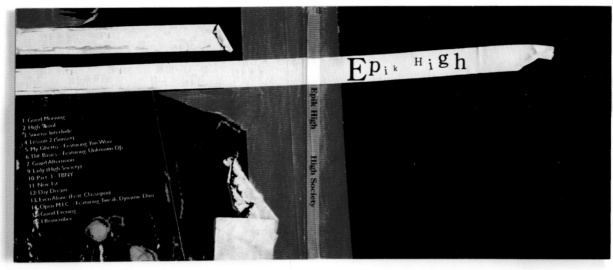

1. Good Morning
2. High Skool
3. Sunrise Interlude
4. Lesson 2 (Sunset)
5. My Ghetto - Featuring Yun Woo
6. The Basics - Featuring Unknown DJs
7. Good Afternoon
9. Lady (High Society)
10. Part 3 TBNY
11. Nov 1st
12. Day Dream
13. Even Alone (Feat. Clazziquai)
14. Open M.I.C - Featuring Tweak, Dynamic Duo
15. Good Evening
16. I Remember

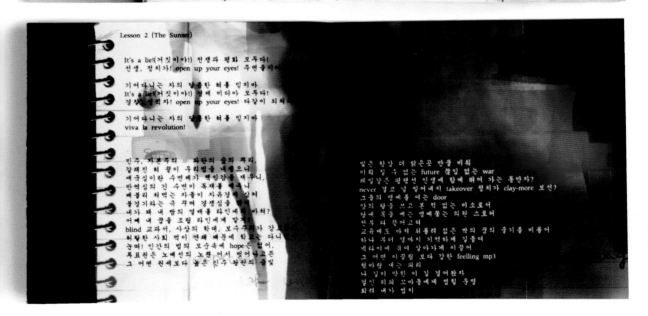

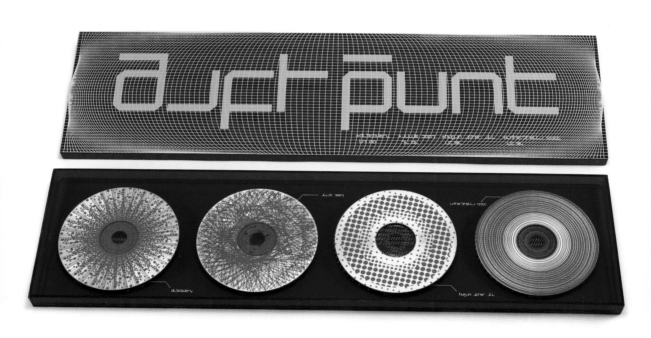

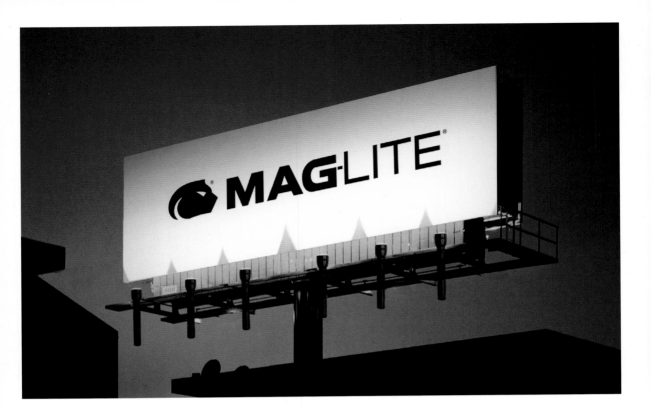

Sal DeVito School of Visual Arts **Annie Chiu**

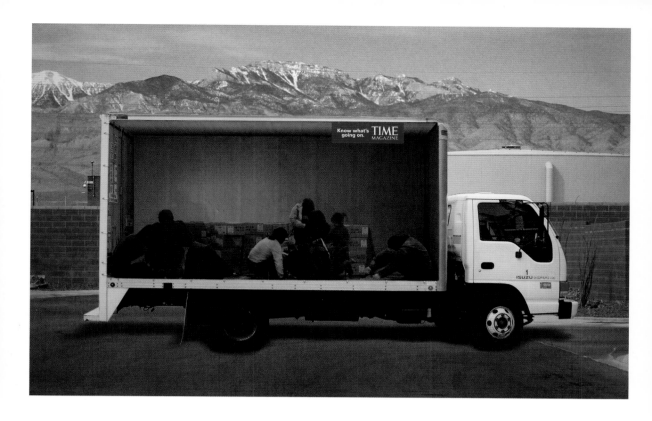

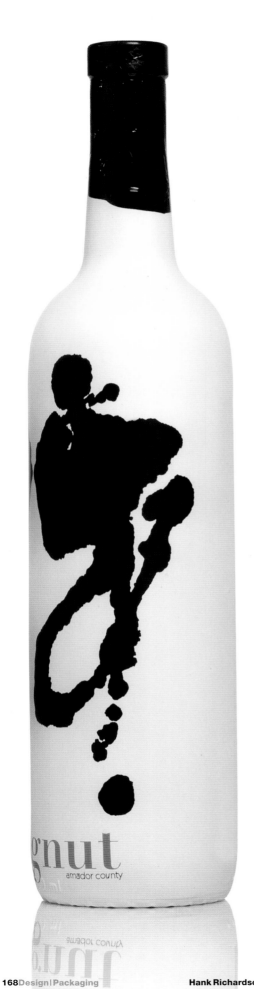

gnut
amador county

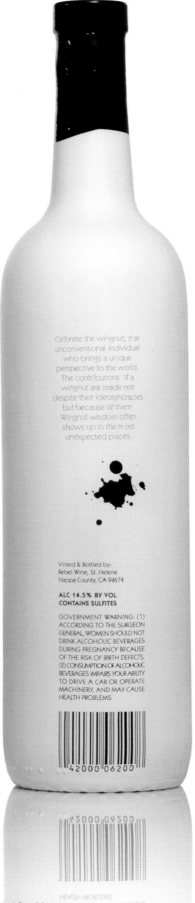

Celbrate the wingnut, that
unconventional individual
who brings a unique
perspective to the world.
The contributions of a
wingnut are made not
despite their ideosyncracies
but because of them.
Wingnut wisdom often
shows up in the most
unexpected places.

Vinted & Bottled by:
Rebel Wine, St. Helena
Nappa County, CA 94674

**ALC 14.5% BY VOL
CONTAINS SULFITES**

GOVERNMENT WARNING: (1)
ACCORDING TO THE SURGEON
GENERAL, WOMEN SHOULD NOT
DRINK ALCOHOLIC BEVERAGES
DURING PREGNANCY BECAUSE
OF THE RISK OF BIRTH DEFECTS.
(2) CONSUMPTION OF ALCOHOLIC
BEVERAGES IMPAIRS YOUR ABILITY
TO DRIVE A CAR OR OPERATE
MACHINERY, AND MAY CAUSE
HEALTH PROBLEMS.

42000 06200

FAT CAT

CHARDONNAY
2002 PRODUCT OF NEW ZEALAND

750ml 13%vol

Chava Ben Amos Pratt Institute **Eulie Lee**

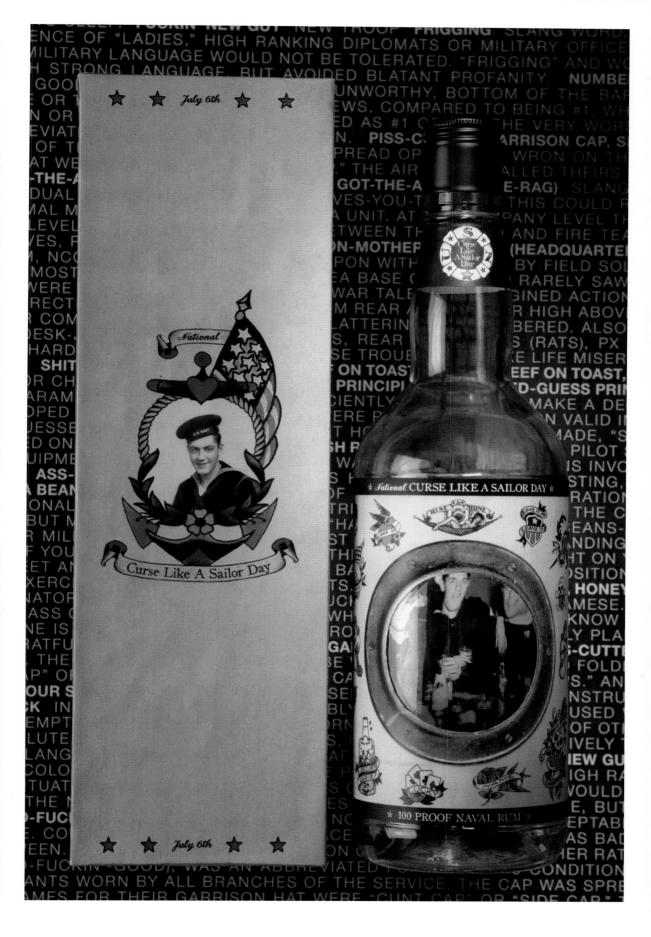

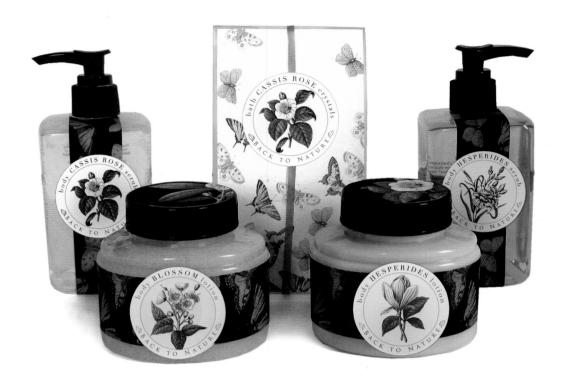

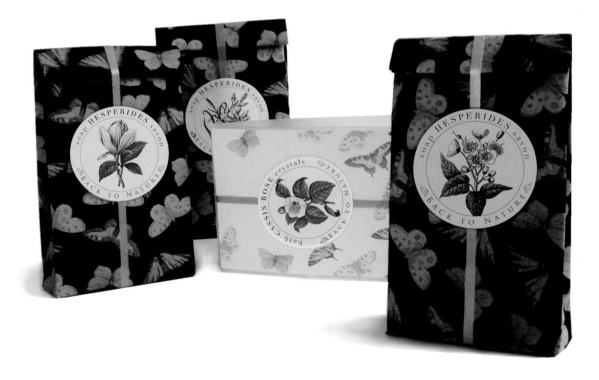

Steven Brower School of Visual Arts **Emily Kim**

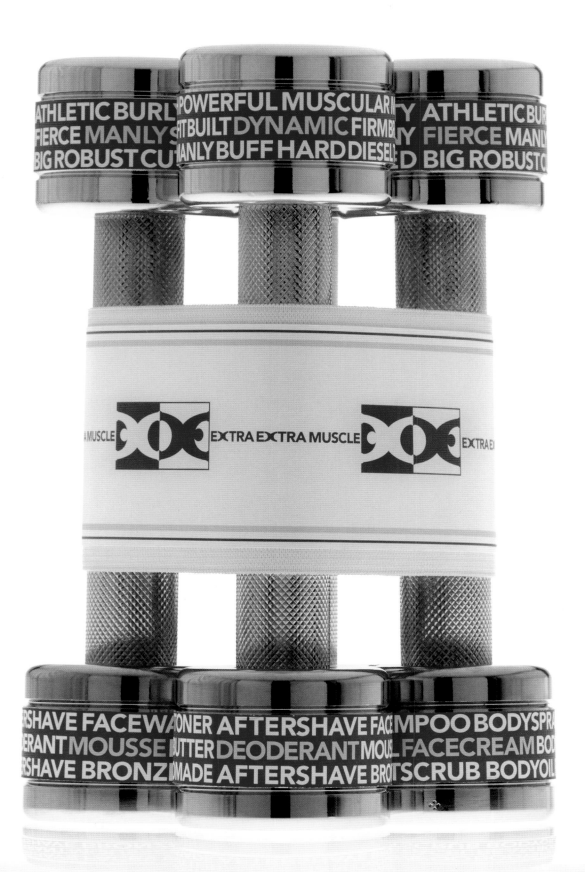

ATHLETIC BURLY
FIERCE MANLY
BIG ROBUST CU

POWERFUL MUSCULAR
BUILT DYNAMIC FIRMB
MANLY BUFF HARD DIESEL

ATHLETIC BURF
FIERCE MANLY
BIG ROBUST C

EXTRA MUSCLE EXTRA EXTRA MUSCLE EXTRA EX

RSHAVE FACEWA
DERANT MOUSSE
RSHAVE BRONZ

TONER AFTERSHAVE FACE
BUTTER DEODERANT MOUS
DMADE AFTERSHAVE BRO

MPOO BODYSPRA
FACECREAM BOD
SCRUB BODYOIL

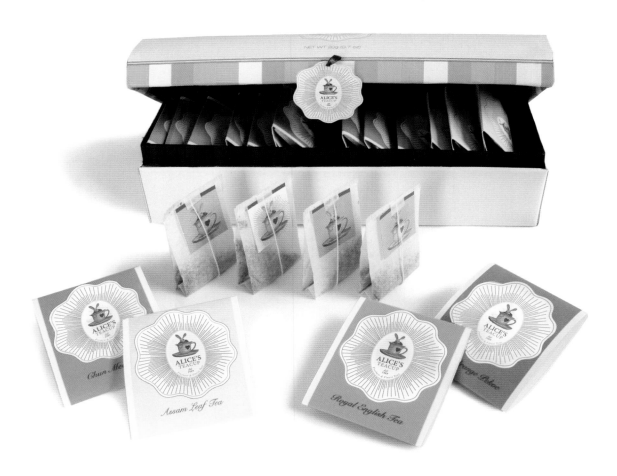

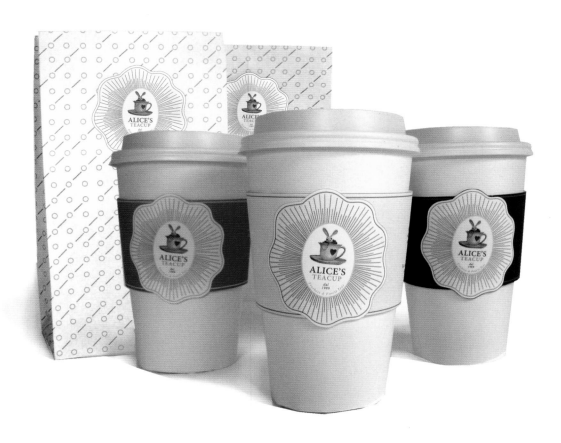

Genevieve Williams School of Visual Arts **Emily Kim**

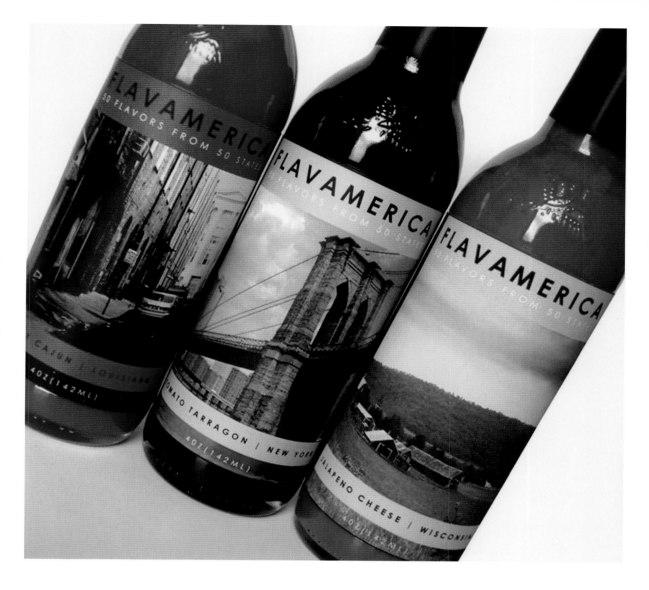

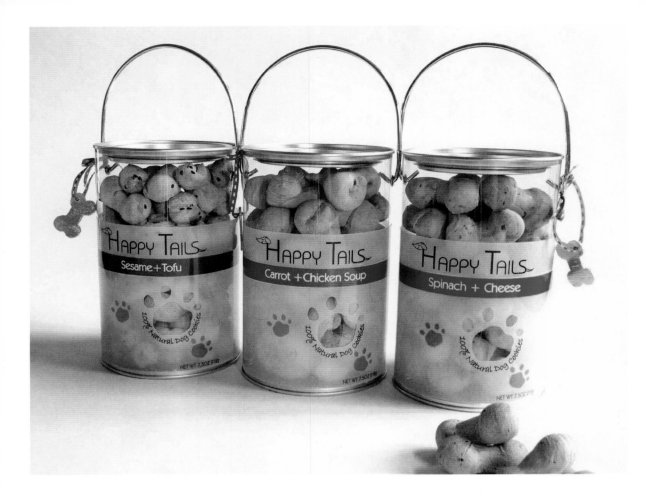

 James Lienhart Columbia College Chicago **Yuuka Yonemura**

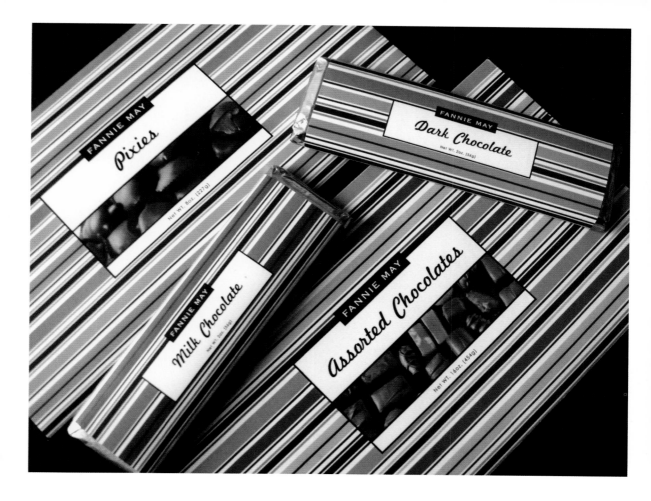

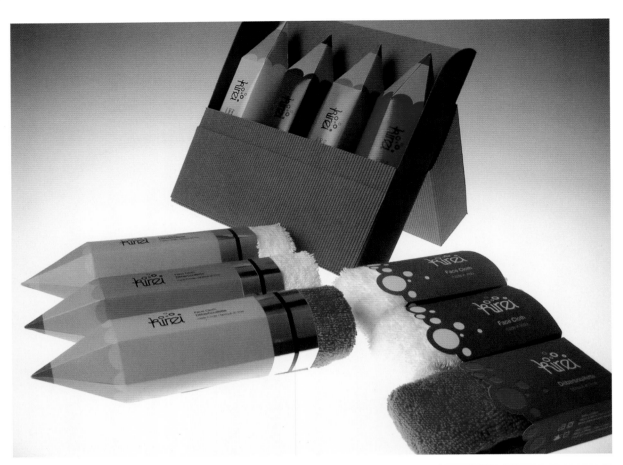

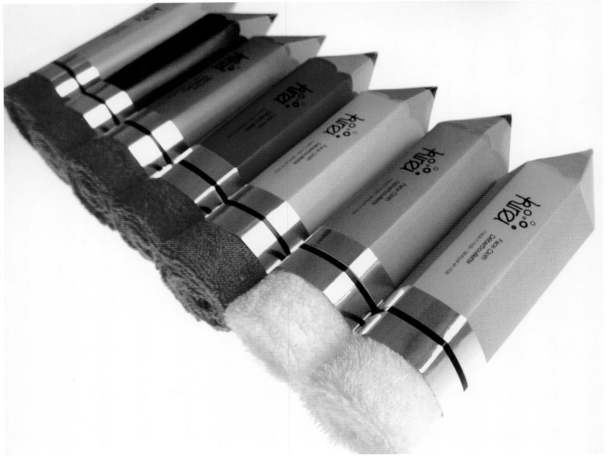

Albert Ng York University Hannah Jor

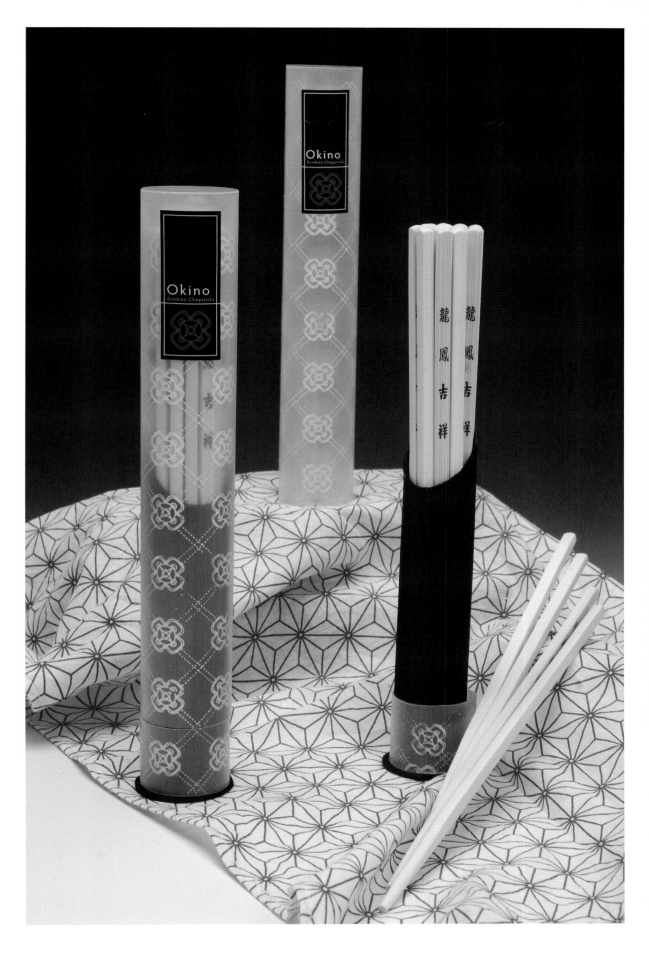

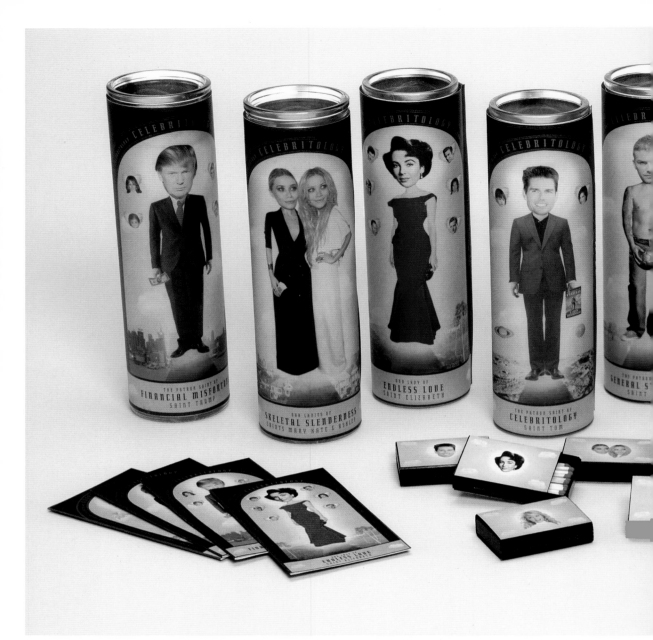

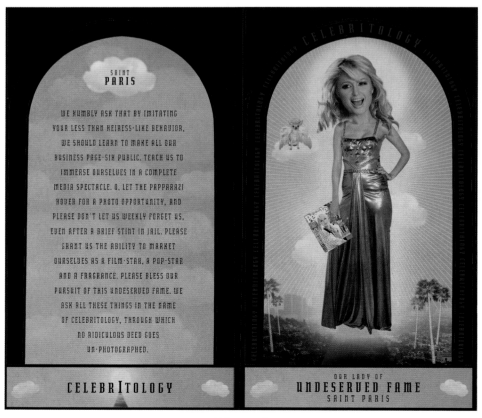

(this spread)

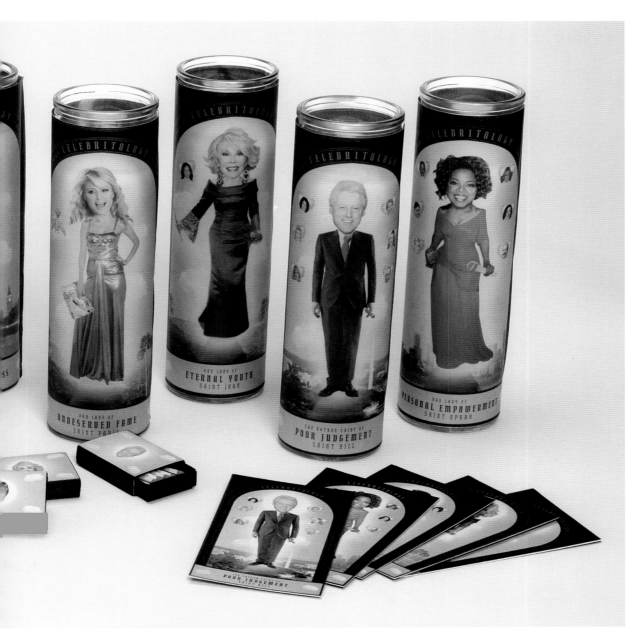

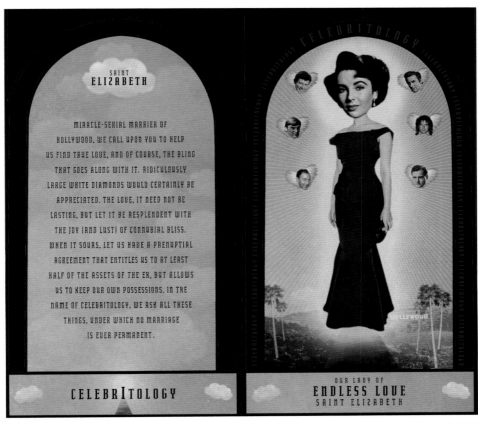

ARICEPT
(donepezil HCl)
10 mg | 28 tablets
see cautions and
usage instructions
at the bottom

exp
2/22/08

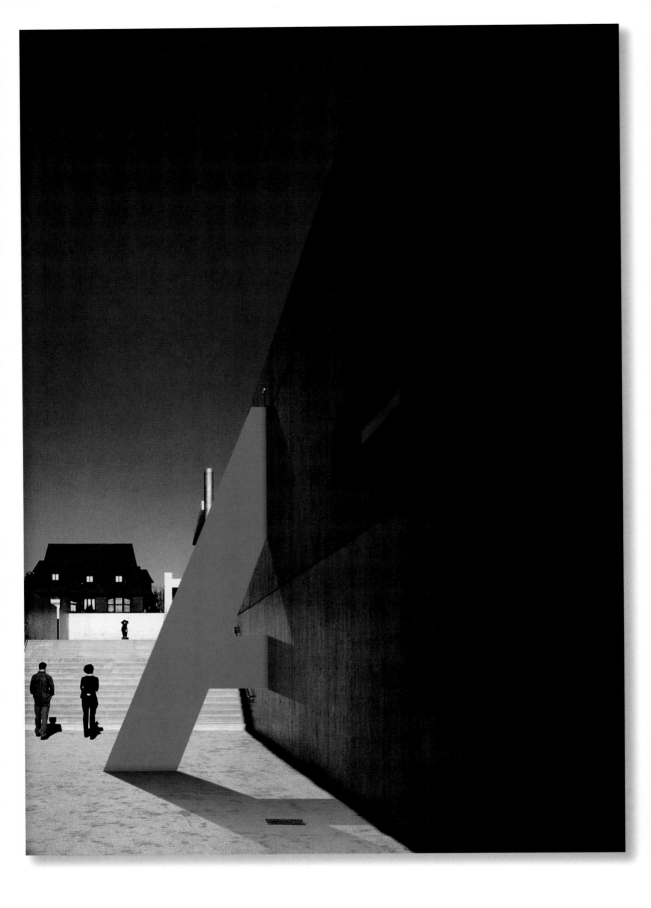

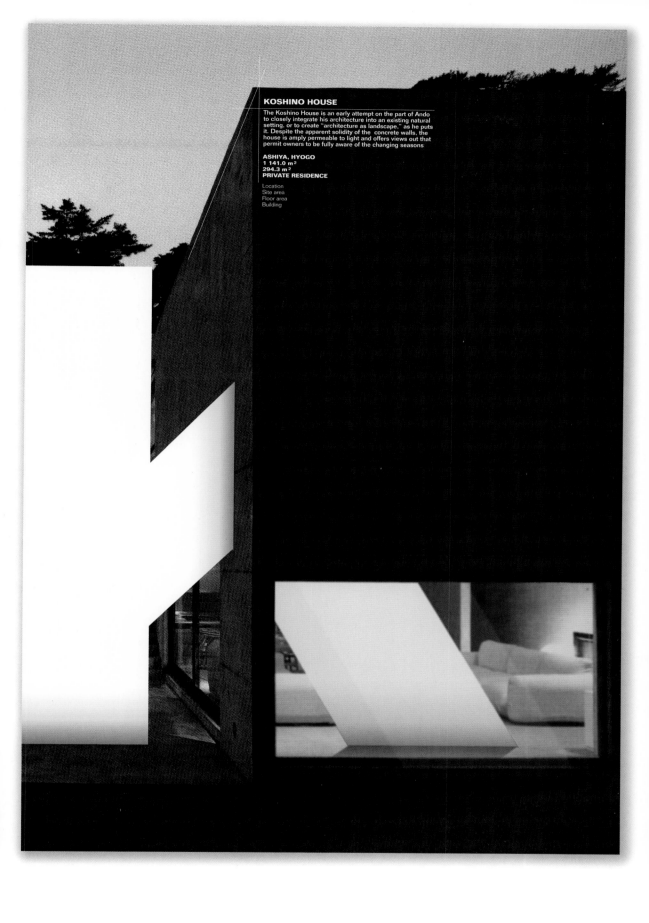

KOSHINO HOUSE

The Koshino House is an early attempt on the part of Ando to closely integrate his architecture into an existing natural setting, or to create "architecture as landscape," as he puts it. Despite the apparent solidity of the concrete walls, the house is amply permeable to light and offers views out that permit owners to be fully aware of the changing seasons

ASHIYA, HYOGO
1 141.0 m²
294.3 m²
PRIVATE RESIDENCE

Location
Site area
Floor area
Building

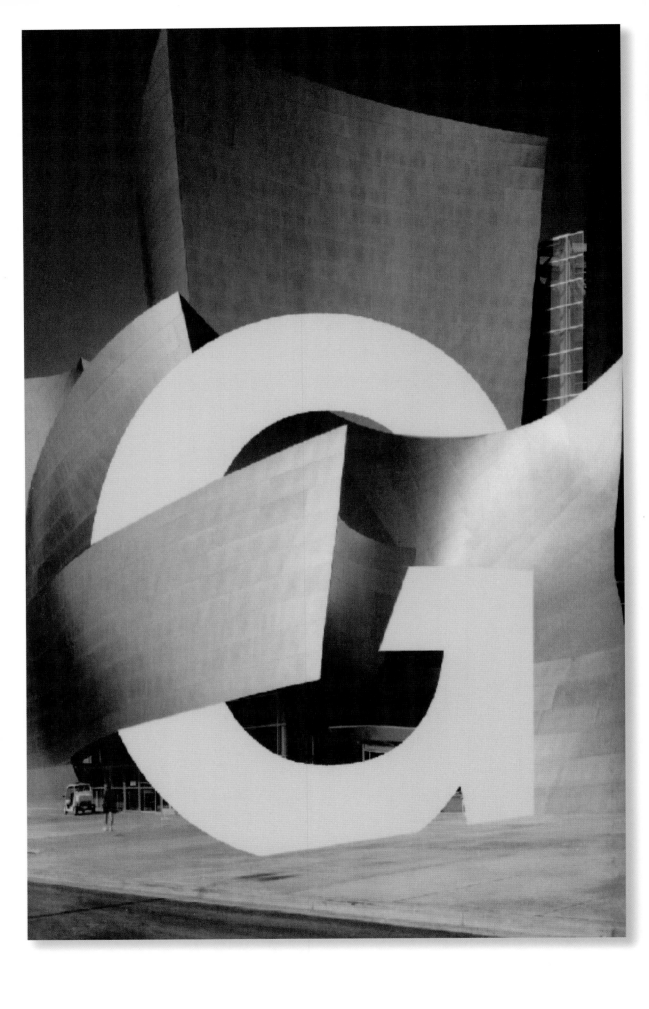

Henrita Condak School of Visual Arts **SunEun Kim**

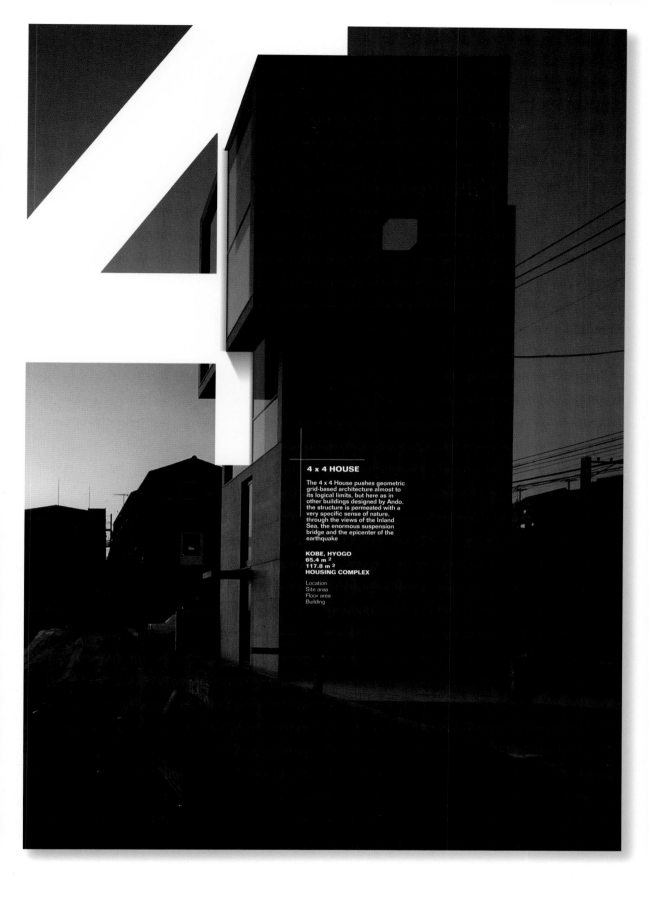

4 x 4 HOUSE

The 4 x 4 House pushes geometric
grid-based architecture almost to
its logical limits, but here as in
other buildings designed by Ando,
the structure is permeated with a
very specific sense of nature,
through the views of the Inland
Sea, the enormous suspension
bridge and the epicenter of the
earthquake

KOBE, HYOGO
65.4 m 2
117.8 m 2
HOUSING COMPLEX

Location
Site area
Floor area
Building

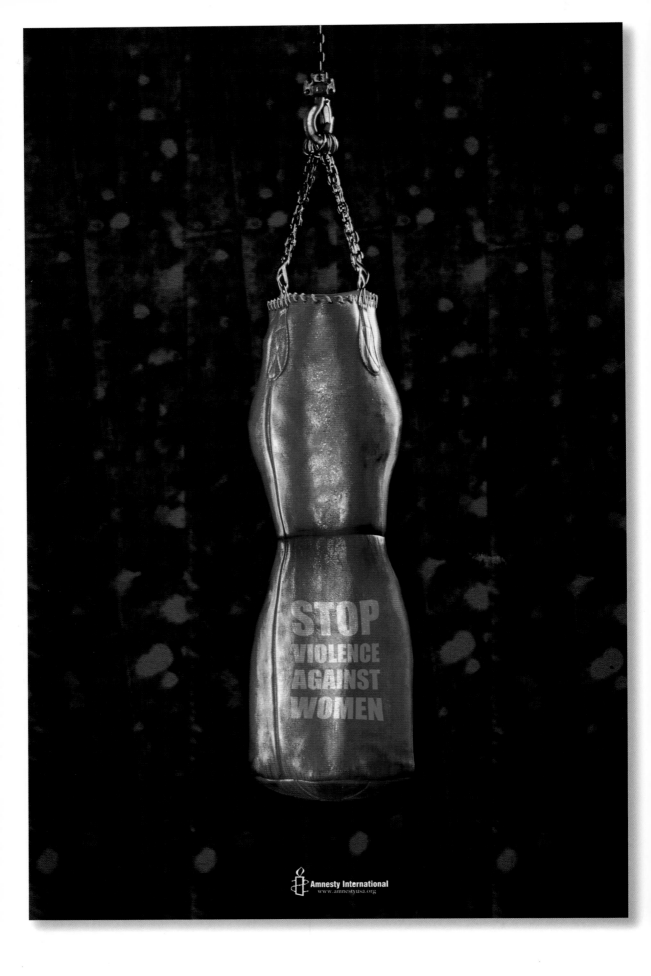

STOP
VIOLENCE
AGAINST
WOMEN

Amnesty International
www.amnestyusa.org

Vinny Tulley School of Visual Arts **Deniz Yegen**

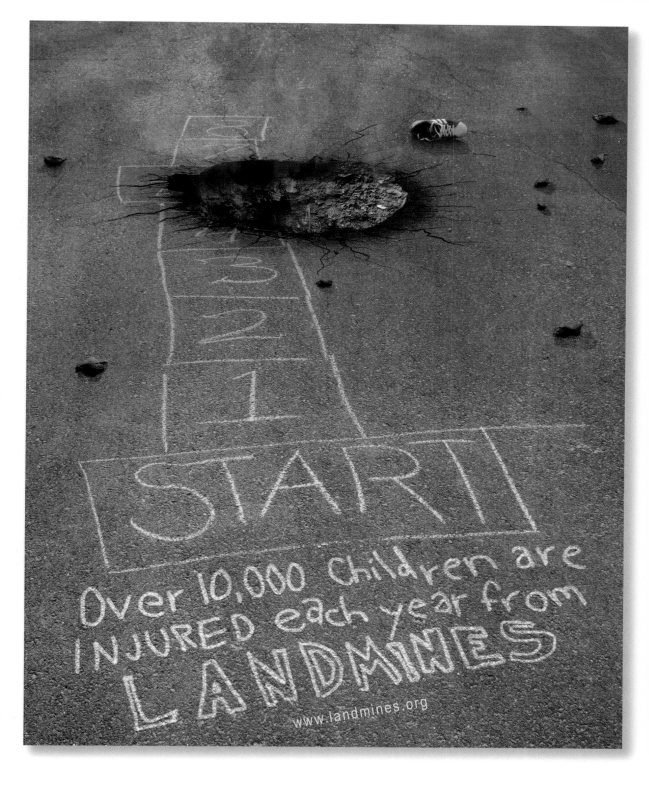

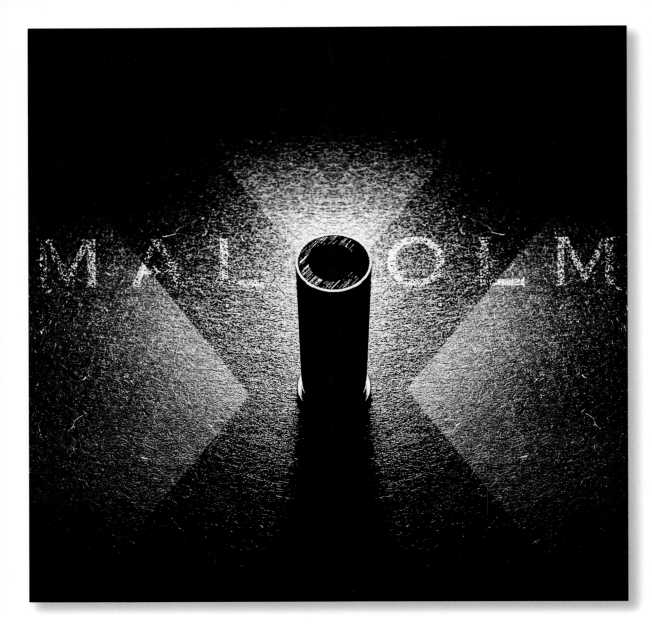

Skip Sorvino School of Visual Arts **Ian Mogilner**

STOP ENVIRONMENTAL DESTRUCTION

AMNESTY INTERNATIONAL

Amnesty International USA / 5 Penn Plaza, New York, NY 10001 / phone: (212) 807-8400 / fax: (212) 627-1451 / http://www.amnestyusa.org | International Secretariat, London, UK / 1 Easton Street, London, WC1X 0DW, UK / phone: +44-20-74135500

(this spread)

FREEDOM OF RELIGION

AMNESTY
INTERNATIONAL

Amnesty International USA / 5 Penn Plaza, New York, NY 10001 / phone: (212) 807-8400 / fax: (212) 627-1451 / http://www.amnestyusa.org | International Secretariat, London, UK / 1 Easton Street, London, WC1X 0DW, UK / phone: +44 20-74135500

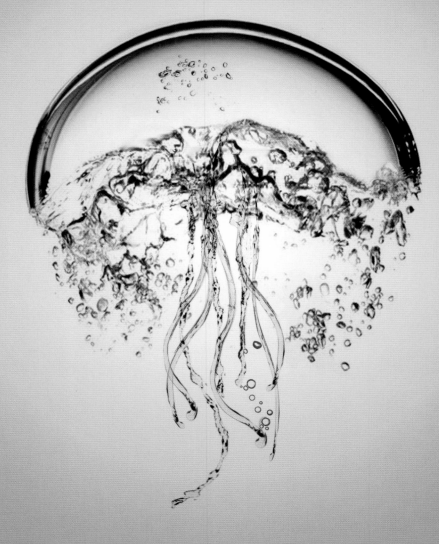

Keep our rivers and oceans clean

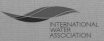

INTERNATIONAL
WATER
ASSOCIATION

WATER FOR LIFE

www.iwa.org

Alisa Zamir Pratt Institute **Seokwon Han**

a gay fantasia on national themes

tony kushner's
angels in america
part one: millennium approaches

walter kerr theatre
212 915 0664

New York Conservatory of Music

Holly Shields Texas State University **Aline Forastieri**

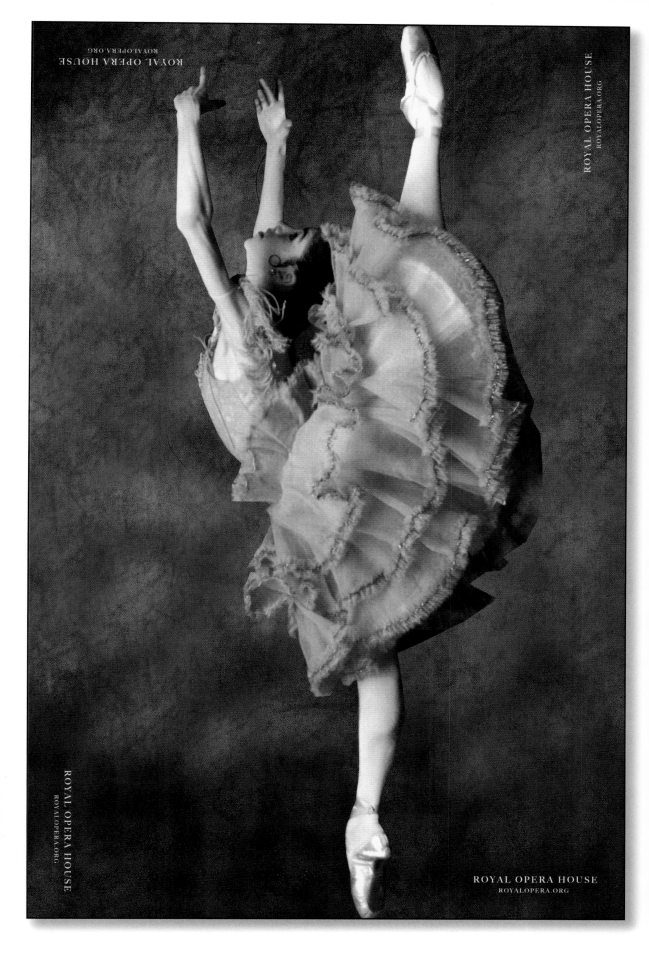

ROYAL OPERA HOUSE
ROYALOPERA.ORG

ROYAL OPERA HOUSE
ROYALOPERA.ORG

ROYAL OPERA HOUSE
ROYALOPERA.ORG

ROYAL OPERA HOUSE
ROYALOPERA.ORG

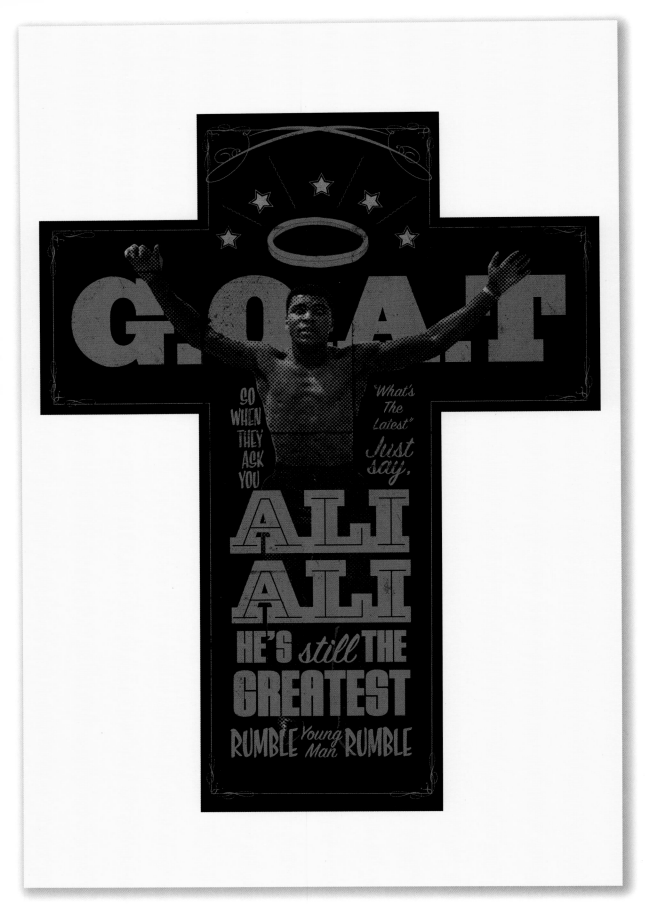

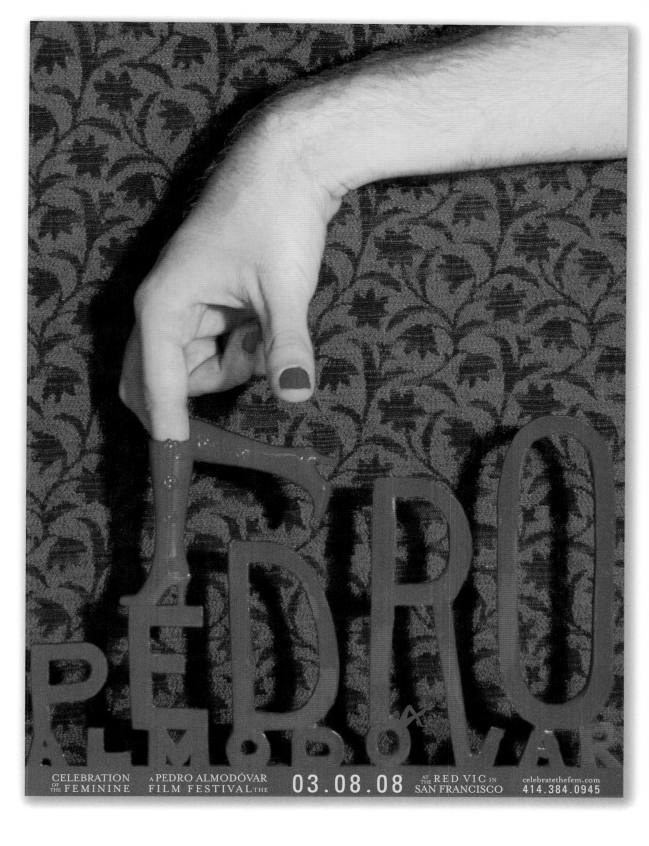

CELEBRATION OF THE FEMININE A PEDRO ALMODÓVAR FILM FESTIVAL.THE 03.08.08 AT THE RED VIC IN SAN FRANCISCO celebratethefem.com 414.384.0945

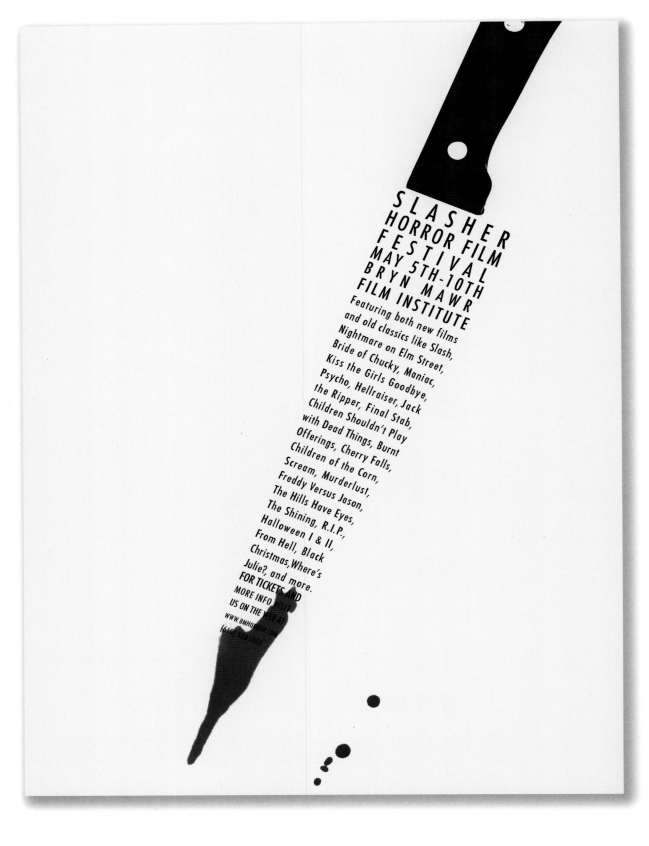

SLASHER HORROR FILM FESTIVAL MAY 5TH-10TH BRYN MAWR FILM INSTITUTE Featuring both new films and old classics like Slash, Nightmare on Elm Street, Bride of Chucky, Maniac, Kiss the Girls Goodbye, Psycho, Hellraiser, Jack the Ripper, Final Stab, Children Shouldn't Play with Dead Things, Burnt Offerings, Cherry Falls, Children of the Corn, Scream, Murderlust, Freddy Versus Jason, The Hills Have Eyes, The Shining, R.I.P., Halloween I & II, From Hell, Black Christmas, Where's Julie?, and more. FOR TICKETS AND MORE INFO VISIT US ON THE WEB AT WWW.BMHORROR.COM (610) SLASHER

 Kelly Holohan Tyler School of Art, Temple University **Heather Rosenfeldt**

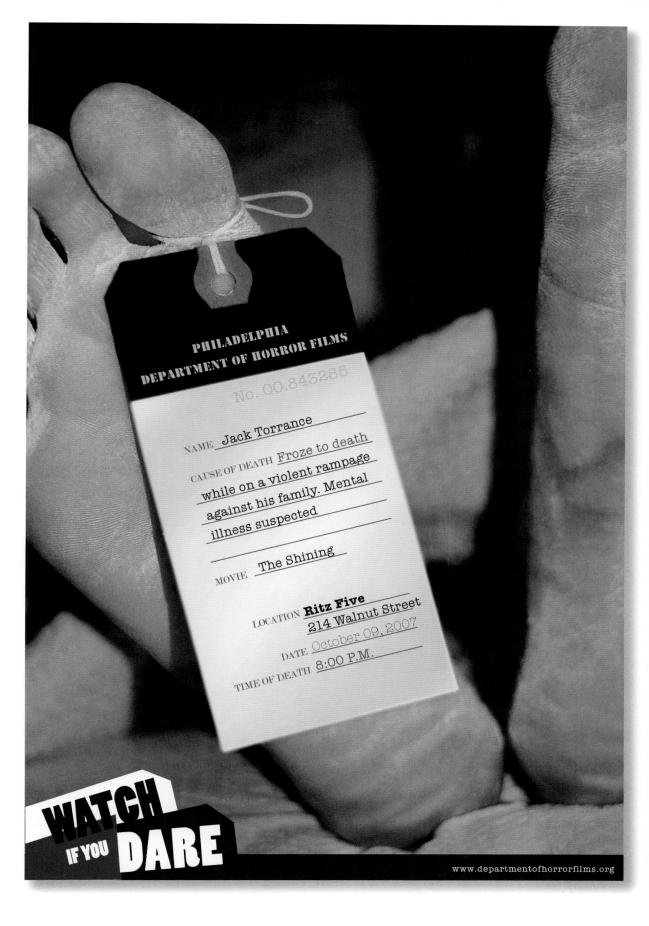

PHILADELPHIA
DEPARTMENT OF HORROR FILMS

No. 00.843285

NAME Jack Torrance

CAUSE OF DEATH Froze to death
while on a violent rampage
against his family. Mental
illness suspected

MOVIE The Shining

LOCATION Ritz Five
214 Walnut Street

DATE October 09, 2007

TIME OF DEATH 8:00 P.M.

WATCH
IF YOU DARE

www.departmentofhorrorfilms.org

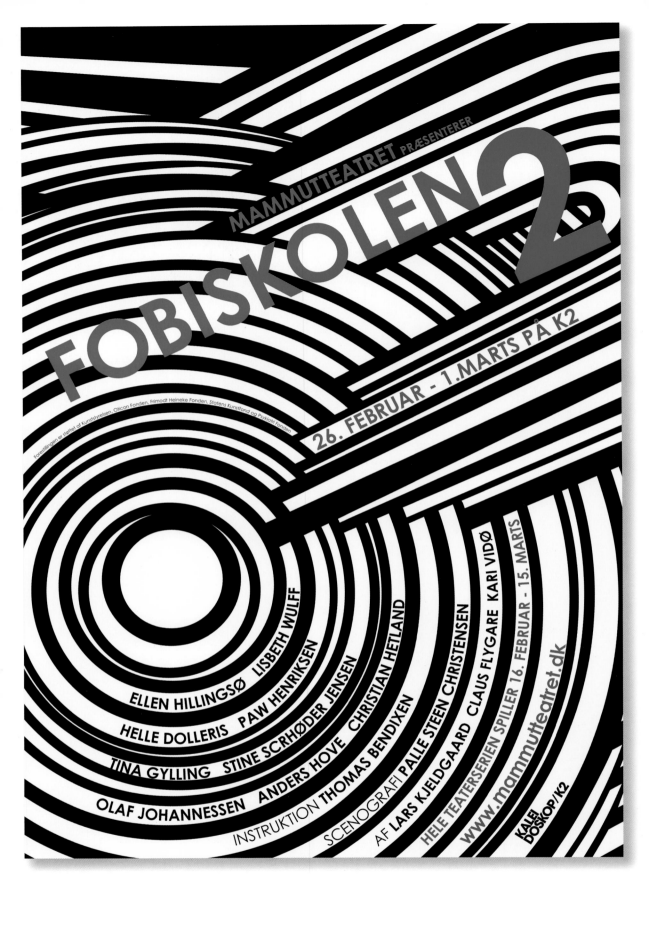

Peter Gyllan Danmarks Designskole **Lene Hojland Bergh-Hansen**

Eternal Ancestors:
The Art of
the Central
African
Reliquary
October 2, 2007–March 2, 2008

Special Exhibition Galleries, 1st floor
The Metropolitan Museum of Art · 1000 Fifth Avenue at 82nd Street · New York, New York 10028-0198 · General Information: 212-535-7710

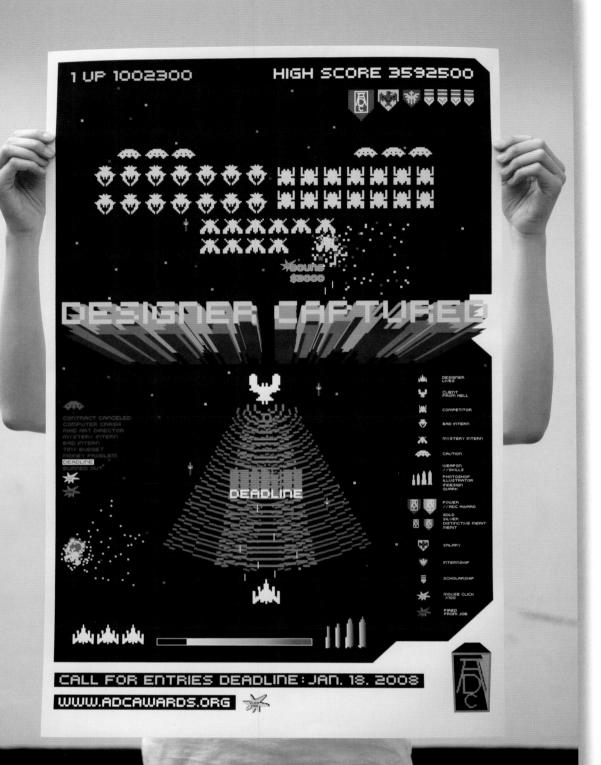

Tracy Boychuk School of Visual Arts Sanghee Jin

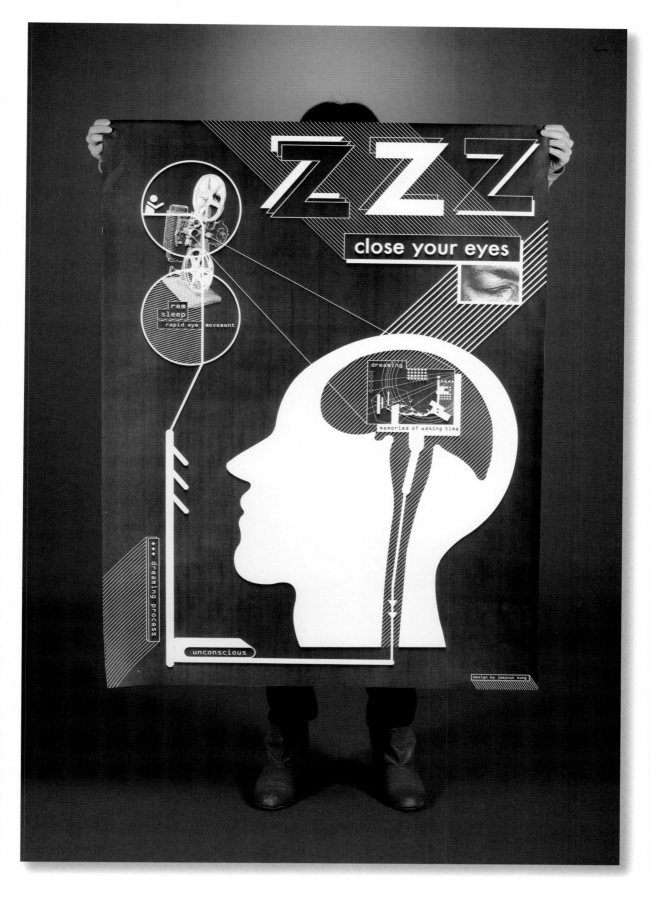

The poster reads:

RADIOHEAD
WEBSTER HALL
NEW YORK CITY
09.12.08
7 PM TICKETS $25

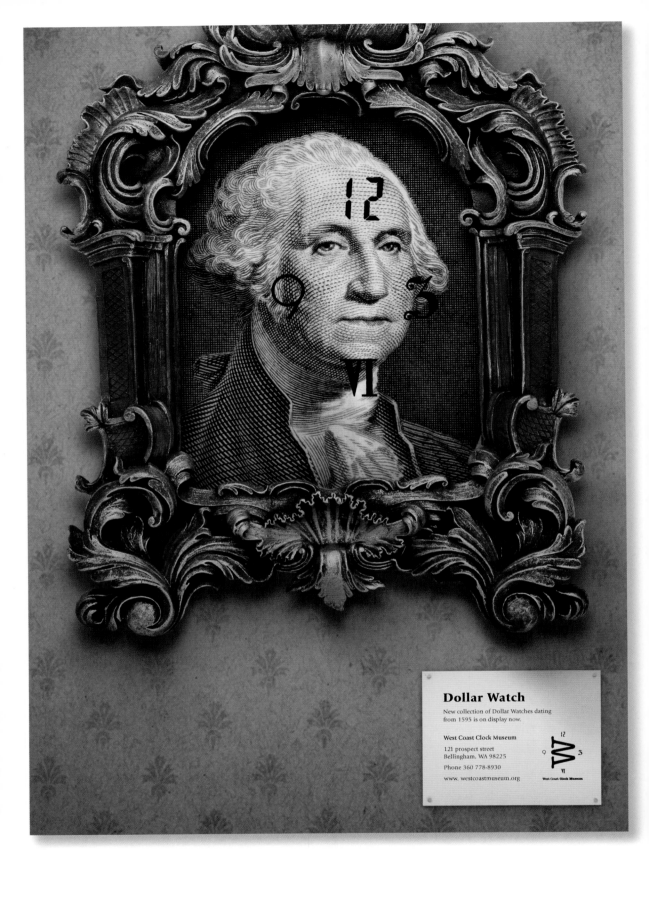

Dollar Watch

New collection of Dollar Watches dating
from 1595 is on display now.

West Coast Clock Museum

121 prospect street
Bellingham, WA 98225

Phone 360 778-8930

www. westcoastmuseum.org

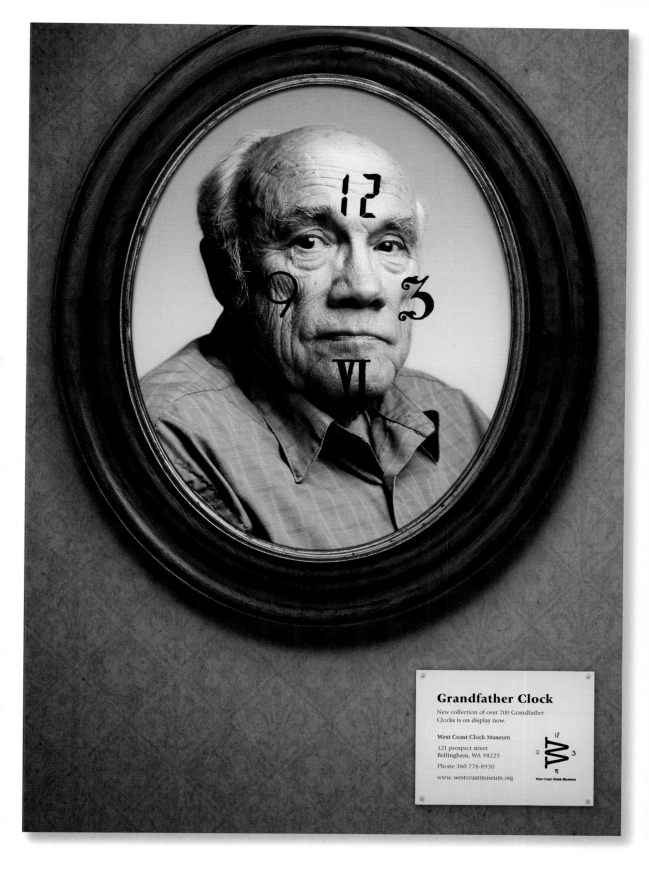

Grandfather Clock

New collection of over 700 Grandfather Clocks is on display now.

West Coast Clock Museum

121 prospect street
Bellingham, WA 98225

Phone 360 778-8930

www.westcoastmuseum.org

Kevin O'Callaghan School of Visual Arts **Sofia Limpantoudi**

Hank Richardson Portfolio Center **Amanda Babcock**

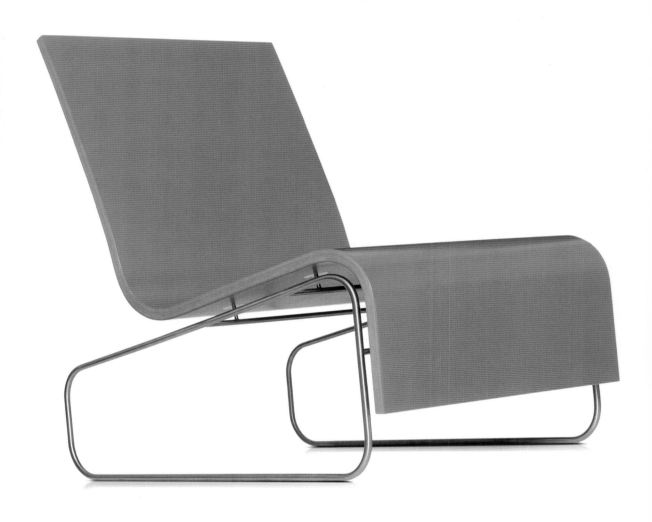

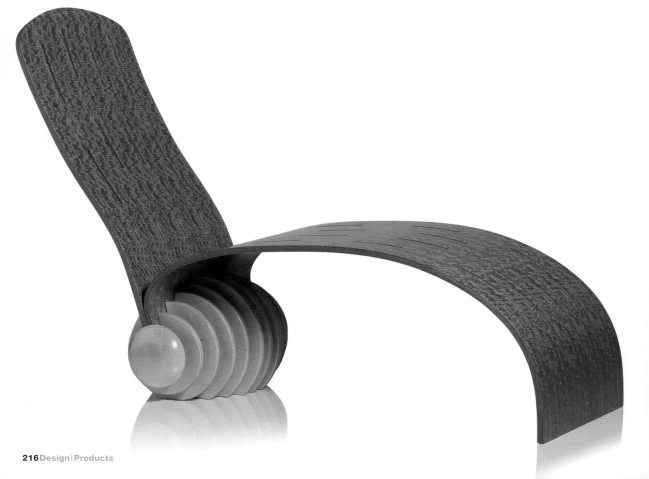

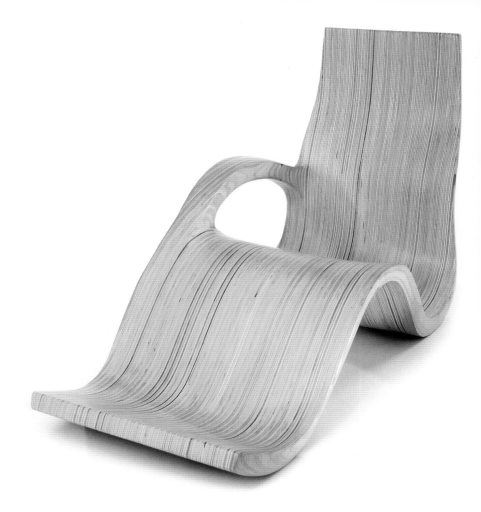

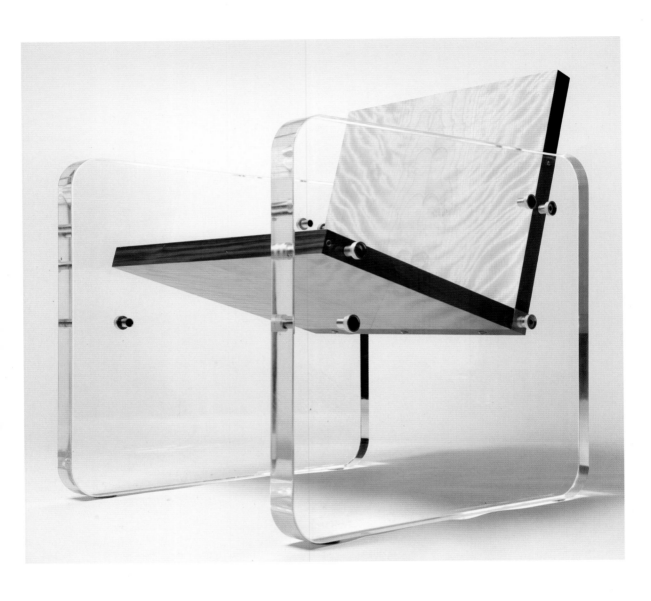

John Drew, Arnold Holland, Theron Moore, Jerry Samuelson
California State University , Fullerton **Sharon Huang**

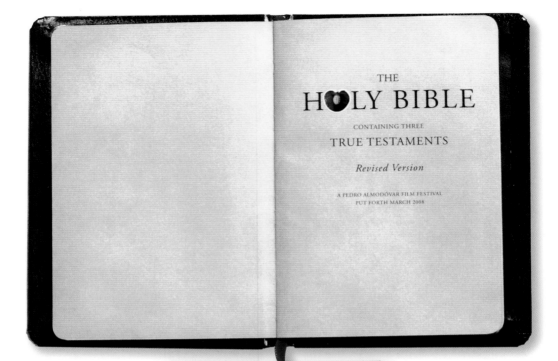

THE

H♥LY BIBLE

CONTAINING THREE

TRUE TESTAMENTS

Revised Version

A PEDRO ALMODÓVAR FILM FESTIVAL
PUT FORTH MARCH 2008

HOLY BIBLE
Revised Version

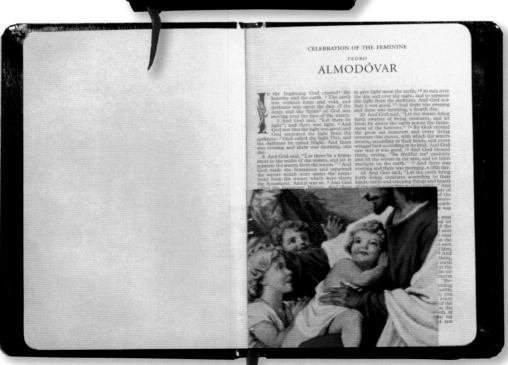

CELEBRATION OF THE FEMININE

PEDRO

ALMODÓVAR

In the beginning God created the heavens and the earth. 2 The earth was without form and void, and darkness was upon the face of the deep; and the Spirit of God was moving over the face of the waters.

3 And God said, "Let there be light"; and there was light. 4 And God saw that the light was good; and God separated the light from the darkness. 5 God called the light Day, and the darkness he called Night. And there was evening and there was morning, one day.

6 And God said, "Let there be a firmament in the midst of the waters, and let it separate the waters from the waters." 7 And God made the firmament and separated the waters which were under the firmament from the waters which were above the firmament. And it was so. 8 And God called the firmament Heaven. And there

to give light upon the earth, 18 to rule over the day and over the night, and to separate the light from the darkness. And God saw that it was good. 19 And there was evening and there was morning, a fourth day.

20 And God said, "Let the waters bring forth swarms of living creatures, and let birds fly above the earth across the firmament of the heavens." 21 So God created the great sea monsters and every living creature that moves, with which the waters swarm, according to their kinds, and every winged bird according to its kind. And God saw that it was good. 22 And God blessed them, saying, "Be fruitful and multiply and fill the waters in the seas, and let birds multiply on the earth." 23 And there was evening and there was morning, a fifth day.

24 And God said, "Let the earth bring forth living creatures according to their kinds: cattle and creeping things and beasts

Growing up in a small Spanish town where men were macho and women were pushed aside, where Catholicism entailed priests abusing boys, and where a strict religious doctrine formed the judgment of the masses, Almodóvar finds release in rebellion. His films are directly antithetical to the patriarchal society of Franco's Spain, in them he challenges its most respected taboos: sex, gender, religion

He delivers his work through the filter of a female perspective resulting in a celebration of womanly strength and femininity. His films look down on puritan middle class values and expose the humanity in the socially unacceptable, often blurring the moral distinction between the innocent and guilty. This festival is a tribute to these films, which, created with much fantasy and humor, shed light on the views of this extraordinary director.

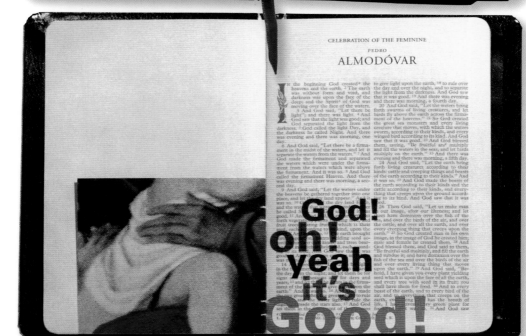

CELEBRATION OF THE FEMININE

PEDRO

ALMODÓVAR

God! oh! yeah it's Good!

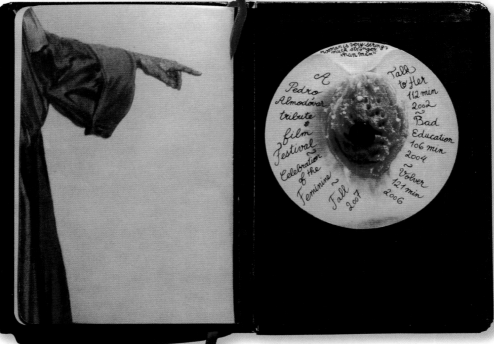

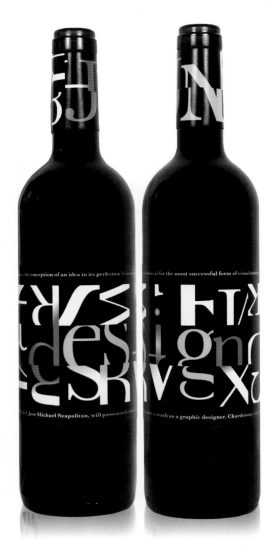

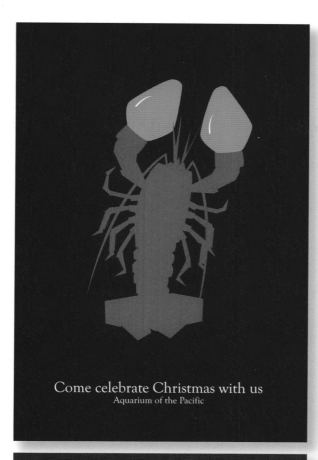

Come celebrate Christmas with us
Aquarium of the Pacific

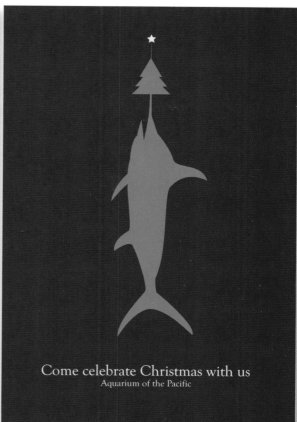

Come celebrate Christmas with us
Aquarium of the Pacific

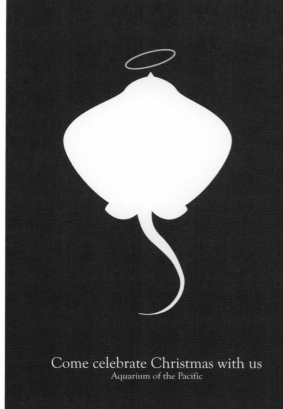

Come celebrate Christmas with us
Aquarium of the Pacific

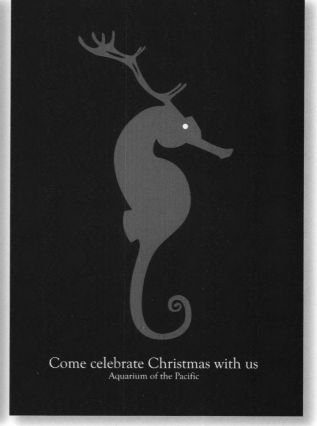

Come celebrate Christmas with us
Aquarium of the Pacific

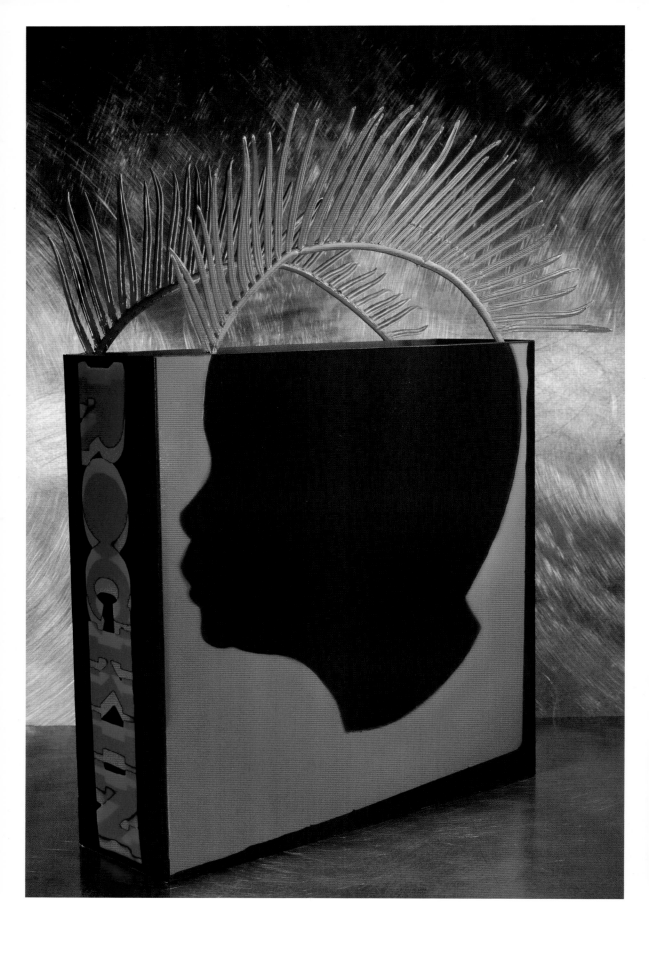

Lanny Sommese, Kristin Sommese Penn State University **Thomas Wilder**

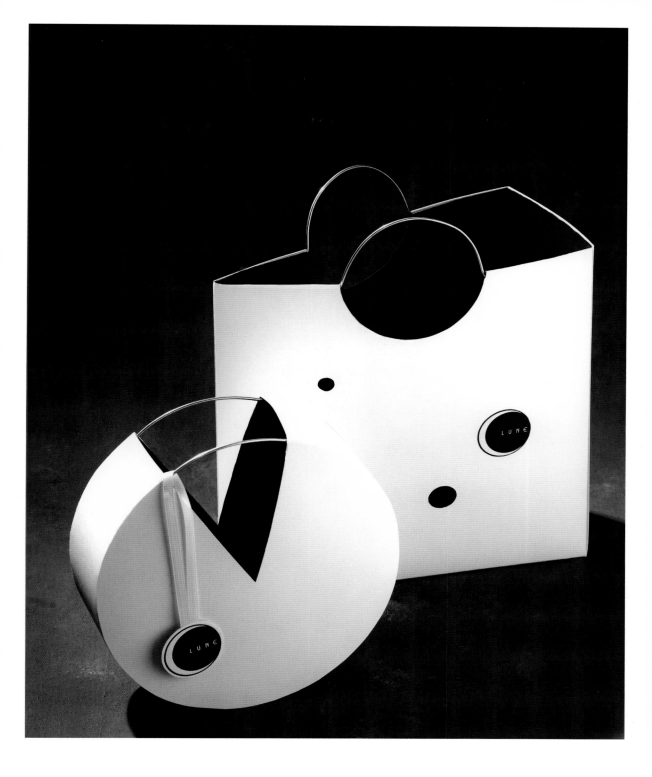

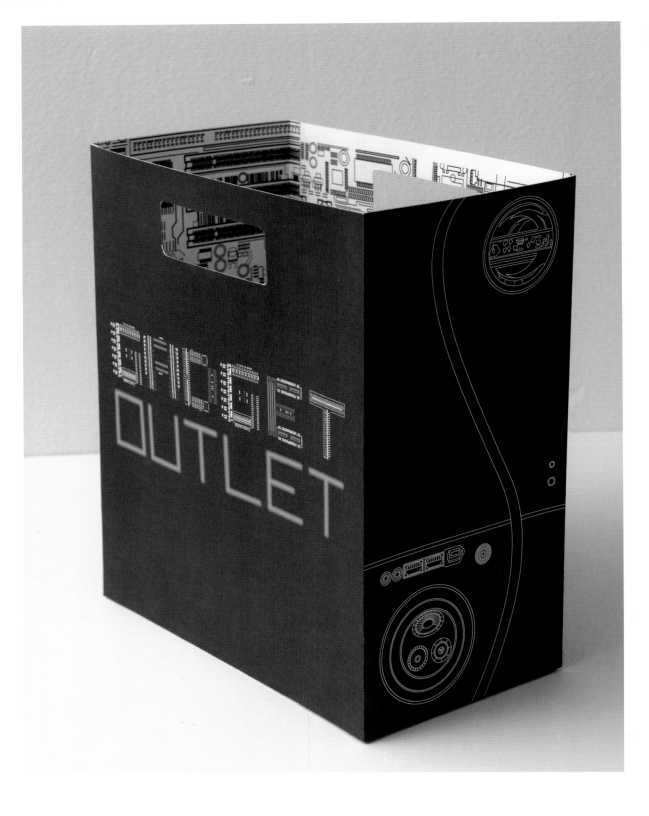

Theron Moore California State University, Fullerton **Victor Barreto**

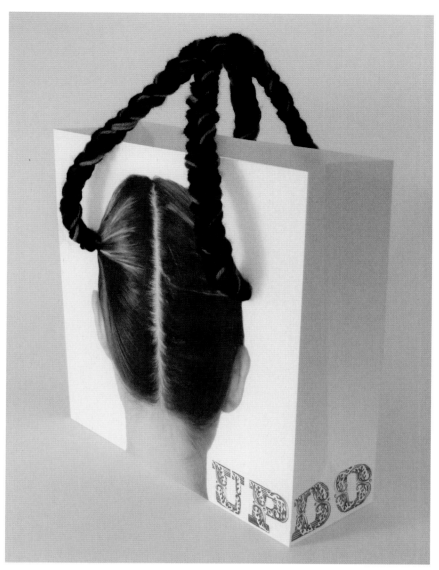

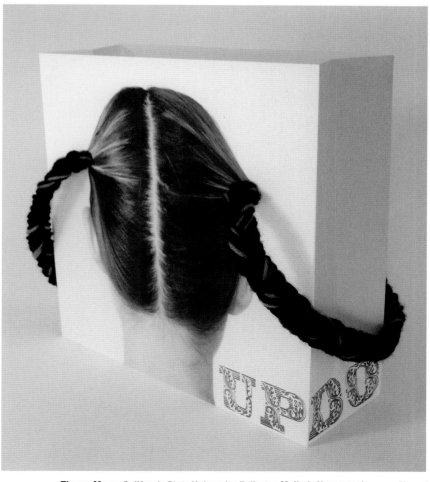

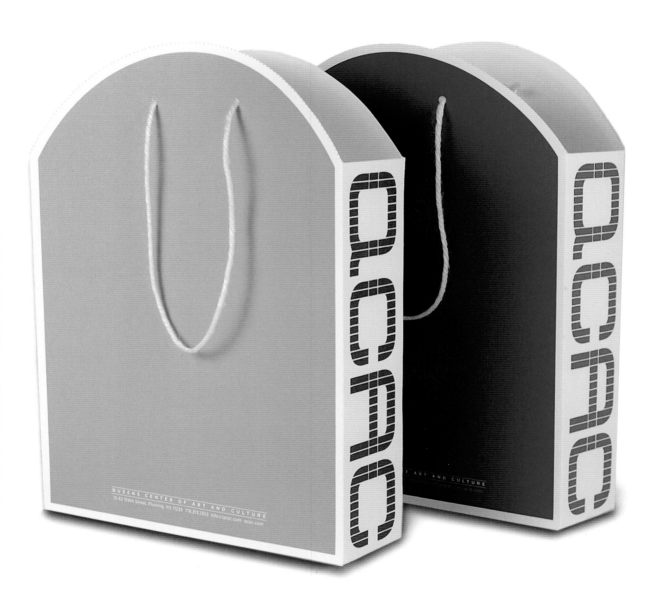

Steven Brower School of Visual Arts **Amy Wu**

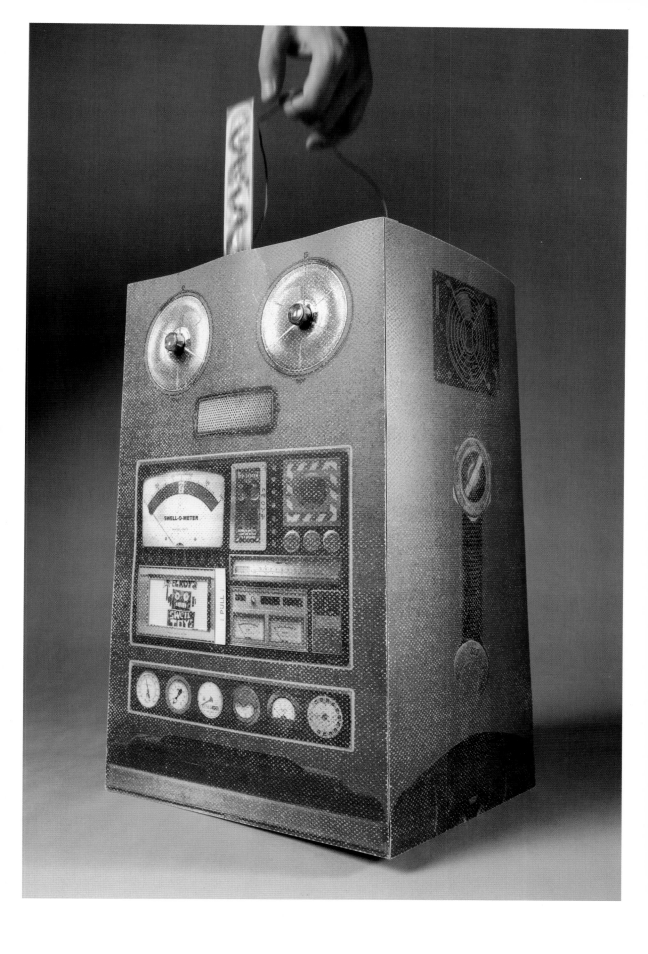

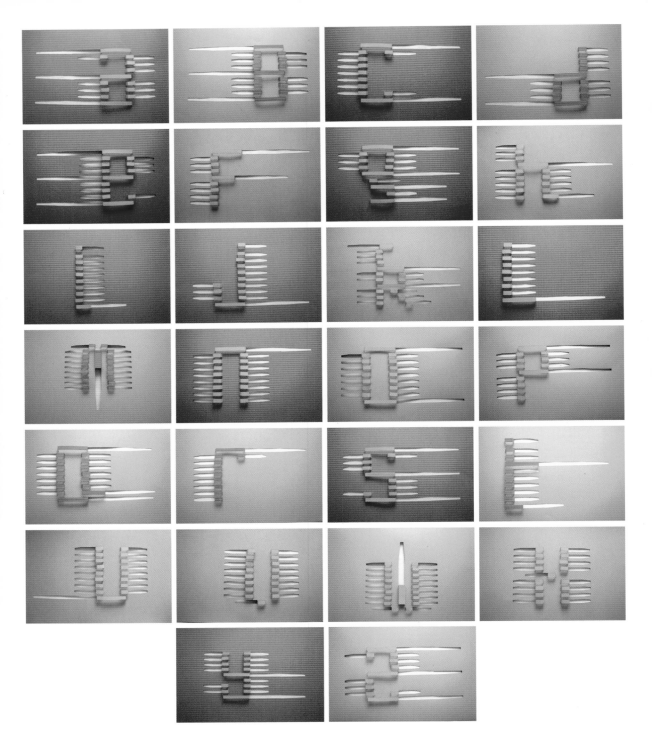

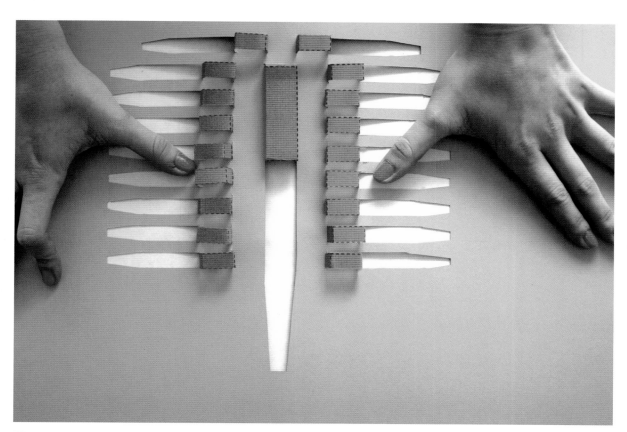

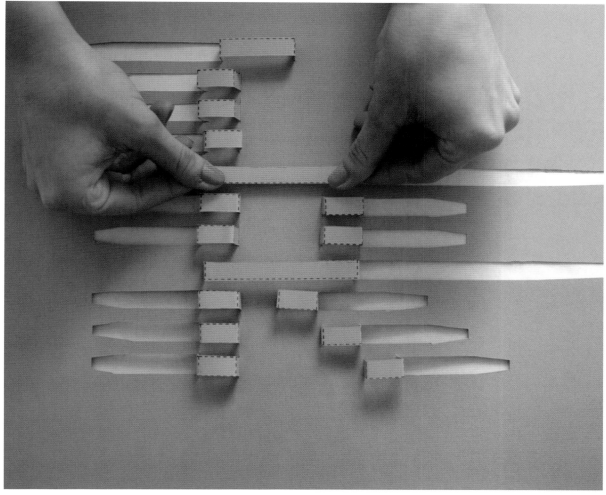

Fang Chen Penn State University **Nicole Angelica**

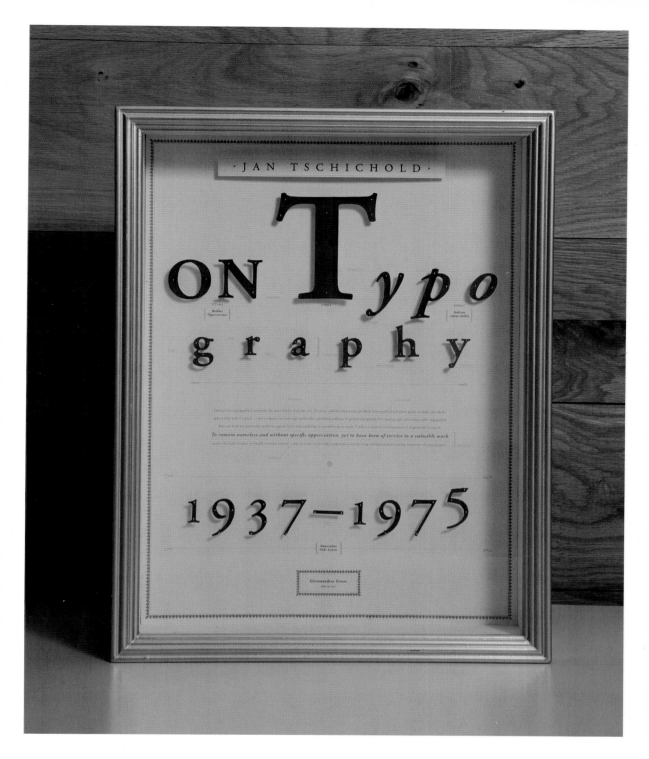

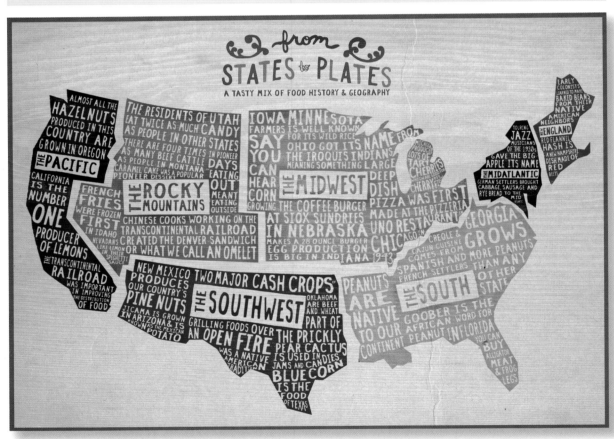

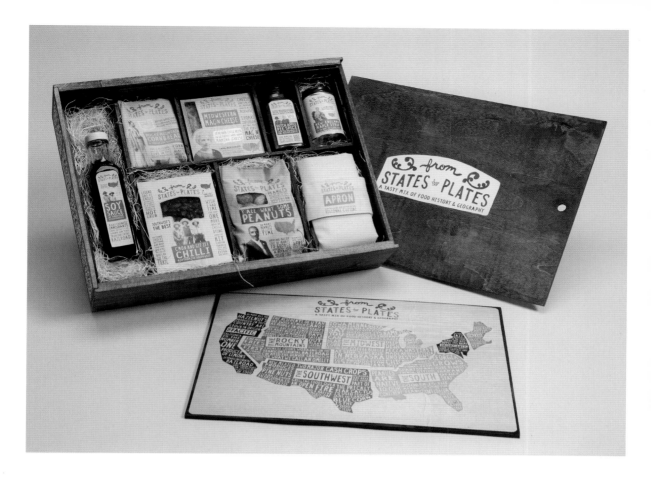

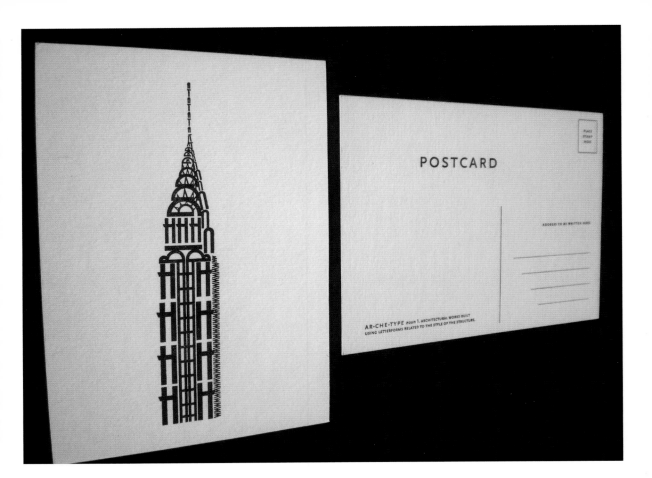

POSTCARD

AR·CHE·TYPE *noun* 1. ARCHITECTURAL WORKS BUILT USING LETTERFORMS RELATED TO THE STYLE OF THE STRUCTURE.

ADDRESS TO BE WRITTEN HERE

PLACE STAMP HERE

Linda Sullivan Brigham Young University **Jenny Willardson**

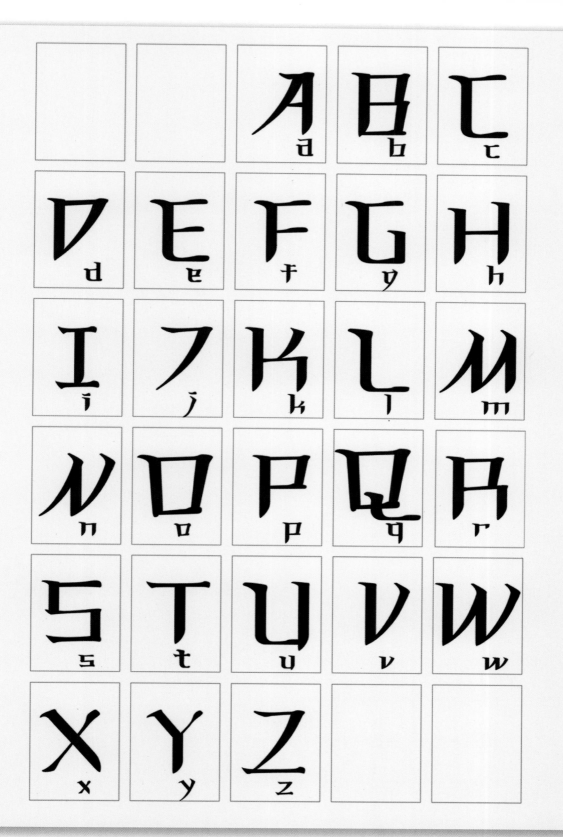

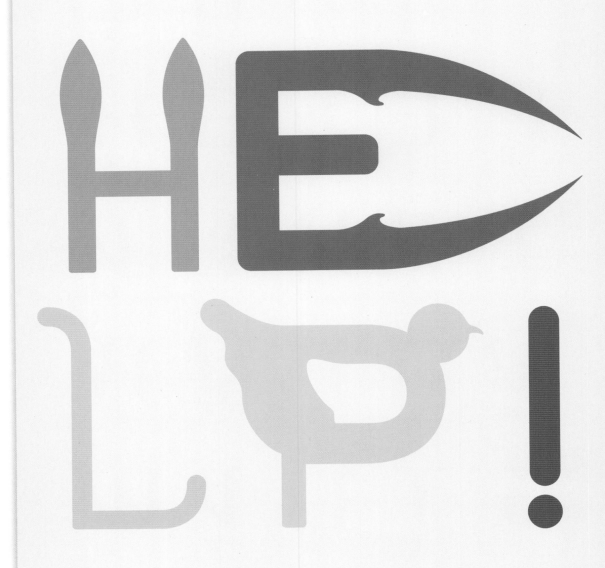

AN ENDANGERED ANIMAL ALPHABET

INSPIRED BY THE BOOK BY DAVID MCLIMANS

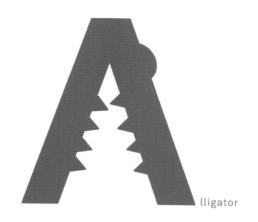

Alligator

ONLY A FEW OF THE MANY SPECIES
AT RISK OF EXTINCTION ACTUALLY
MAKE IT TO THE LISTS AND OBTAIN LEGAL
PROTECTION. MANY MORE
SPECIES BECOME EXTINCT WITHOUT
GAINING PUBLIC NOTICE.

Rhinoceros

Zebra

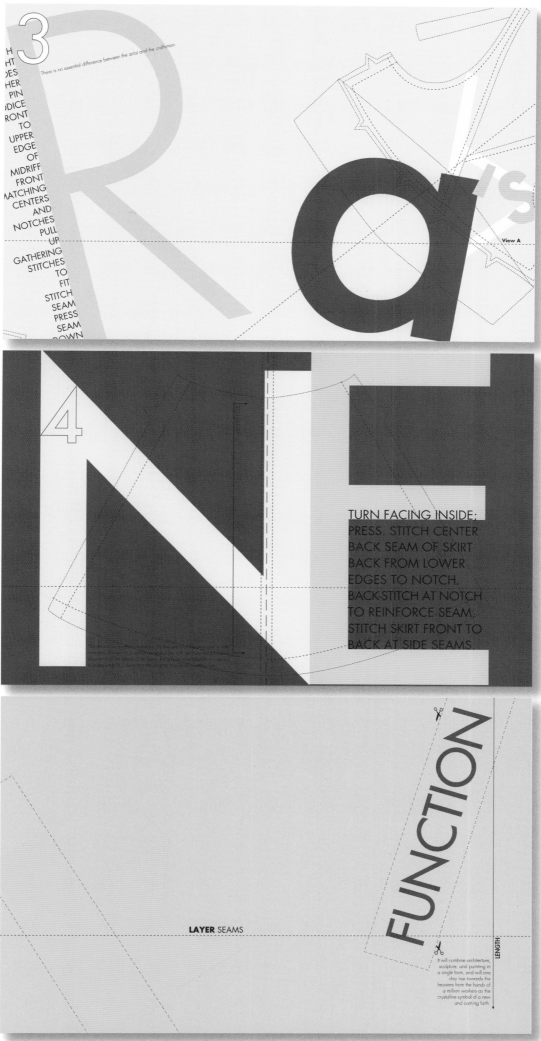

3

H
GHT
DES
HER
PIN
ODICE
RONT
TO
UPPER
EDGE
OF
MIDRIFF
FRONT
MATCHING
CENTERS
AND
NOTCHES
PULL
UP
GATHERING
STITCHES
TO
FIT
STITCH
SEAM
PRESS
SEAM
DOWN

There is no essential difference between the artist and the craftsman

R a 's

View A

4

N E

TURN FACING INSIDE;
PRESS. STITCH CENTER
BACK SEAM OF SKIRT
BACK FROM LOWER
EDGES TO NOTCH.
BACK-STITCH AT NOTCH
TO REINFORCE SEAM.
STITCH SKIRT FRONT TO
BACK AT SIDE SEAMS.

FUNCTION

LAYER SEAMS

LENGTH

It will combine architecture,
sculpture, and painting in
a single form, and will one
day rise towards the
heavens from the hands of
a million workers as the
crystalline symbol of a new
and coming faith.

Made for Work

Emily McVarish *California College of the Arts* **Allison Weiner**

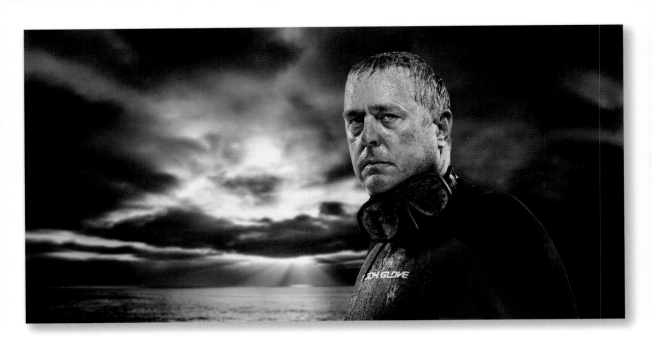

Stephen Sheffield, Dana Smith
New England School of Photography for Jean Gardner and Assoc.
Heather McGrath

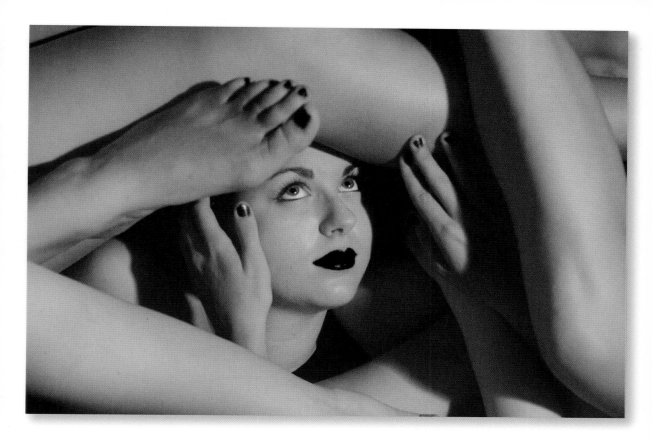

Credits&Comments

Advertising/Automotive

26 Signs | Art Directors: Nicolas Schmidt-Fitzner, Sascha Piltz | Copywriter: Tara Lawall | Instructors: Jan Rexhausen, Niklas Frings-Rupp | School: Miami Ad School Europe | Department: Advertising | Department Chair: Niklas Frings-Rupp

27 Roadside Savior | Art Director: Jose Eslinger | Instructor: Robert Esperti | School: The Art Institute of California - San Diego | Department: Advertising | Department Chair: John Judy

Description: With car trouble, all you wish for is a savior.

Advertising/Beverage

28 Blender | Art Director: Grace Eunhae Hwang | Instructor: Frank Anselmo | School: School of Visual Arts | Department: Graphic Design | Department Chair: Richard Wilde

Advertising/Billboard

29 It'll Move You | Art Director/Photographer: Maeden Cruz | Instructor: Henry Hikima | School: The Art Institute of California-San Diego | Department: Advertising | Department Chair: John Judy

30 (top) Tripod | Art Director/Writer: Igor Josef Brodsky | Instructor: Frank Anselmo | School: School of Visual Arts | Department: Graphic Design | Department Chair: Richard Wilde

30 (bottom) Ski Lift | Art Director/Writer: Grace Eunhae Hwang | Instructor: Frank Anselmo | School: School of Visual Arts | Department: Graphic Design | Department Chair: Richard Wilde

31 Field Goal | Art Director/Writer: Jeseok Yi | Instructor: Frank Anselmo | School: School of Visual Arts | Department: Graphic Design | Department Chair: Richard Wilde

Advertising/Broadcast

32 Dog Walking | Art Directors/Writers: Annie Chiu, Anna Echiverri | Instructor: Frank Anselmo | School: School of Visual Arts | Department: Graphic Design | Department Chair: Richard Wilde

Advertising/Computer&Software

33 Ultra-Thin | Art Directors/Writers: Ronnie Jaspers, Nick Plomp | Instructor: Frank Anselmo | School: School of Visual Arts | Department: Graphic Design | Department Chair: Richard Wilde

34 Bubbles | Art Directors/Writers: Ronnie Jaspers, Nick Plomp | Instructor: Frank Anselmo | School: School of Visual Arts | Department: Graphic Design | Department Chair: Richard Wilde

Advertising/Delivery Services

35 Hansel - Delivered | Art Director: Felix Hoffmann | Writers: Mircea Andronescu, J.J Lim | Instructor: Niklas Frings-Rupp | School: Miami Ad School Europe | Department: Advertising | Department Chair: Niklas Frings-Rupp

Advertising/Education

36 Piano Desk | Art Director/Writer: Jeongjyn Yi | Instructor: Frank Anselmo | School: School of Visual Arts | Department: Graphic Design | Department Chair: Richard Wilde

Advertising/Entertainment

37 (top) Paper Towels | Art Director/Writer: Sungkwon Ha | Instructor: Frank Anselmo | School: School of Visual Arts | Department: Graphic Design | Department Chair: Richard Wilde

37 (bottom) Pole | Art Director/Writer: Jeongjyn Yi | Instructor: Frank Anselmo | School: School of Visual Arts | Department: Graphic Design | Department Chair: Richard Wilde

Advertising/Fashion

38 Subway Bench | Art Directors/Writers: Annie Chiu, Anna Echiverri | Instructor: Frank Anselmo | School: School of Visual Arts | Department: Graphic Design | Department Chair: Richard Wilde

Advertising/Film

39 Peepholes | Art Directors/Writers: Ronnie Jaspers, Nick Plomp | Instructor: Frank Anselmo | School: School of Visual Arts | Department: Graphic Design | Department Chair: Richard Wilde

40 Film Strip | Art Directors/Writers: Hee Kyung Helen Shin | Instructor: Frank Anselmo | School: School of Visual Arts | Department: Graphic Design | Department Chair: Richard Wilde

Advertising/Food

41 Demolition | Art Director/Writer: Jeseok Yi | Instructor: Frank Anselmo | School: School of Visual Arts | Department: Graphic Design | Department Chair: Richard Wilde

42 Elevator | Art Directors/Writers: Vivian Dony, Stella Shi | Instructor: Frank Anselmo | School: School of Visual Arts | Department: Graphic Design | Department Chair: Richard Wilde

43 Fire Escape | Art Directors/Writers: Vivian Dony, Stella Shi | Instructor: Frank Anselmo | School: School of Visual Arts | Department: Graphic Design | Department Chair: Richard Wilde

44 Shopping Cart | Art Directors/Writers: Jelani Curtis, William Wang | Instructor: Frank Anselmo | School: School of Visual Arts | Department: Graphic Design | Department Chair: Richard Wilde

45, 46 Easier | Art Director/Writer: Grace Eunhae Hwang | Instructor: Frank Anselmo | School: School of Visual Arts | Department: Graphic Design | Department Chair: Richard Wilde

47 Deposit Envelope | Art Director/Writer: Sungkwon Ha | Instructor: Frank Anselmo | School: School of Visual Arts | Department: Graphic Design | Department Chair: Richard Wilde

48 (top) Water Fountain | Art Director/Writer: Sungkwon Ha | Instructor: Frank Anselmo | School: School of Visual Arts | Department: Graphic Design | Department Chair: Richard Wilde

48 (bottom) Straw | Art Directors/Writers: Annie Chiu, Anna Echiverri | Instructor: Frank Anselmo | School: School of Visual Arts | Department: Graphic Design | Department Chair: Richard Wilde

Advertising/Healthcare

49 Target | Art Director/Writer: William Wang | Instructor: Frank Anselmo | School: School of Visual Arts | Department: Graphic Design | Department Chair: Richard Wilde

50 Matchbook | Art Director/Writer: Jeseok Yi | Instructor: Frank Anselmo | School: School of Visual Arts | Department: Graphic Design | Department Chair: Richard Wilde

Advertising/Museums

51 United States Holocaust Memorial Museum | Art Director: Deniz Yegen | Creative Director: Jack Mariucci | School: School of Visual Arts | Department: Graphic Design | Department Chair: Richard Wilde

Advertising/Products

52 New Shoes on the Block | Designer/Photographer: Ray Dotterer | Instructor: Henry Hikima | School: The Art Institute of California-San Diego | Department: Graphic Design | Department Chair: Amin Khalil

53 Stinky Feet | Art Director: Jose Eslinger | Creative Director: Henry Hikima | School: The Art Institute of California-San Diego | Department: Advertising | Department Chair: John Judy

Description: What stinks more than sewer steam and garbage?

54 Tune Out the Madness | Art Director: Jang Soon Hwang | Writer: Gabriel Johnson | Photographer: Seong Bin Song | Creative Strategist: Sung Jun Kim | Instructors: Reexe Hoverkamp, Brandon Sides | School: Academy of Art University | Department: Advertising | Department Chair: Melinda Mettler

Description: This is intended to market Bose Quiet Comfort 2 noise canceling headphones to a younger audience. It targets 18-27 year old consumers willing to spend the extra money for a quality listening experience. They are impressed by bold displays and want their lives to be as wild or enchanting as the music they listen to.

55 Tunnel | Art Director/Writer: Grace Eunhae Hwang | Instructor: Frank Anselmo | School: School of Visual Arts | Department: Graphic Design | Department Chair: Richard Wilde

56 Products for Your Foot Problems | Art Director: Katherine Burns | Creative Directors: Allan Beaver, Robert Reitzfeld | School: School of Visual Arts | Department: Graphic Design | Department Chair: Richard Wilde

57 Teva Advertisement | Art Director: Whitney Grossman | Creative Directors: Jeffrey Metzner, Jack Mariucci | School: School of Visual Arts | Department: Graphic Design | Department Chair: Richard Wilde

58 Looseleaf Paper | Art Directors/Writers: Jelani Curtis, William Wang | Instructor: Frank Anselmo | School: School of Visual Arts | Department: Graphic Design | Department Chair: Richard Wilde

59 Pencil Sharpener | Art Directors/Writers: Annie Chiu, Anna Echiverri | Instructor: Frank Anselmo | School: School of Visual Arts | Department: Graphic Design | Department Chair: Richard Wilde

60 Street Lamp | Art Directors/Writers: Ronnie Jaspers, Nick Plomp | Instructor: Frank Anselmo | School: School of Visual Arts | Department: Graphic Design | Department Chair: Richard Wilde

61 Power | Art Director/Photographer: Andre Le | Instructor: Henry Hikima | School: The Art Institute of California-San Diego | Department: Graphic Design | Department Chair: Amin Khalil

62 Light | Art Directors/Writers: Roy De Jong, Mylene De Knegt | Instructor: Frank Anselmo | School: School of Visual Arts | Department: Graphic Design | Department Chair: Richard Wilde

63 Trash Can | Art Directors/Writers: Annie Chiu, Anna Echiverri | Instructor: Frank Anselmo | School: School of Visual Arts | Department: Graphic Design | Department Chair: Richard Wilde

64 The Sharpest | Art Director: Stella Shi | Creative Director: Vincent Tully | School: School of Visual Arts | Department: Graphic Design | Department Chair: Richard Wilde

65 Sharpie Extra Fine | Art Directors: Ratko Cindric, Dennis Wagner | Copywriter: Thomas Kuhn | Instructor: Niklas Frings-Rupp | School: Miami Ad School Europe | Department: Advertising | Department Chair: Niklas Frings-Rupp

66 Childhood | Art Director: Juri Zaech | Copywriter: David Aronson | Instructor: Jan Rexhausen | School: Miami Ad School Europe | Department: Advertising | Department Chair: Niklas Frings-Rupp

67 Tetris | Art Director/Writer: Jeseok Yi | Instructor: Frank Anselmo | School: School of Visual Arts | Department: Graphic Design | Department Chair: Richard Wilde

68 Spread | Art Director/Writer: Sunyoung Alex Koo | Instructor: Frank Anselmo | School: School of Visual Arts | Department: Graphic Design | Department Chair: Richard Wilde

69 Lifelong | Art Directors: Ratko Cindric, Juri Zaech | Instructor: Christian Vosshagen | School: Miami Ad School Europe | Department: Advertising | Department Chair: Niklas Frings-Rupp

70 Mondrian | Art Director: John Gilmore | Creative Director: Jack Mariucci | School: School of Visual Arts | Department: Graphic Design | Department Chair: Richard Wilde

71 (top) Bug | Art Director/Writer: Jeseok Yi | Instructor: Frank Anselmo | School: School of Visual Arts | Department: Graphic Design | Department Chair: Richard Wilde

71 (bottom) More Light | Art Directors/Writers: Ronnie Jaspers, Nick Plomp | Instructor: Frank Anselmo | School: School of Visual Arts | Department: Graphic Design | Department Chair: Richard Wilde

Advertising/Professional Services

72 Bad Hair Statues | Art Director: Dan Madsen | Instructor: Henry Hikima | School: The Art Institute of California-San Diego | Department: Visual Arts | Department Chair: John Judy

73 Resume | Art Director: Roy Shalev | Creative Director: Jack Mariucci | School: School of Visual Arts | Department: Graphic Design | Department Chair: Richard Wilde

74 Track | Art Director/Writer: Jeongjyn Yi | Instructor: Frank Anselmo | School: School of Visual Arts | Department: Graphic Design | Department Chair: Richard Wilde

75 Gold's Gym Car Cling | Art Director: Matthew Moran | Creative Director: Henry Hikima | School: The Art Institute of California-San Diego | Department: Graphic Design | Department Chair: John Judy

Credits&Comments

Advertising/Public Service
76 Welcome Mat | Art Directors/Writers: Annie Chiu, Ana Echiverri, Hee Kyung Helen Shin | Instructor: Frank Anselmo | School: School of Visual Arts | Department: Graphic Design | Department Chair: Richard Wilde

77 Punch | Art Director/Writer: Grace Eunhae Hwang | Instructor: Frank Anselmo | School: School of Visual Arts | Department: Graphic Design | Department Chair: Richard Wilde

78 Child Soldiers | Art Directors: Roy Shalev, Manor Gelber | Creative Director: Vinny Tulley | Instructor: Frank Anselmo | School: School of Visual Arts | Department: Graphic Design | Department Chair: Richard Wilde

79 Sign | Art Director/Writer: Jeseok Yi | Instructor: Frank Anselmo | School: School of Visual Arts | Department: Graphic Design | Department Chair: Richard Wilde

Advertising/Publishing
80 Thong | Art Directors/Writers: Catherine Eccardt, Hee Kyung Helen Shin | Instructor: Frank Anselmo | School: School of Visual Arts | Department: Graphic Design | Department Chair: Richard Wilde

81 One Page | Art Directors/Writers: Ronnie Jaspers, Nick Plomp | Instructor: Frank Anselmo | School: School of Visual Arts | Department: Graphic Design | Department Chair: Richard Wilde

82 Airport | Art Director/Writer: Sungkwon Ha | Instructor: Frank Anselmo | School: School of Visual Arts | Department: Graphic Design | Department Chair: Richard Wilde

Advertising/Restaurants
83 Library Cafe | Art Director: Victoria Labra | Creative Director: Henry Hikima | School: The Art Institute of California-San Diego | Department: Advertising | Department Chair: John Judy

Advertising/Retail
84 Truck | Art Director/Writer: Jeseok Yi | Instructor: Frank Anselmo | School: School of Visual Arts | Department: Graphic Design | Department Chair: Richard Wilde

85 Laundromat | Art Director/Writer: Hee Kyung Helen Shin | Instructor: Frank Anselmo | School: School of Visual Arts | Department: Graphic Design | Department Chair: Richard Wilde

Advertising/Social Commentary
86 Thermometer Stick | Art Directors/Writers: Roy De Jong, Mylene De Knegt | Instructor: Frank Anselmo | School: School of Visual Arts | Department: Graphic Design | Department Chair: Richard Wilde

87 Animal Cookies | Art Director/Writer: Grace Eunhae Hwang | Instructor: Frank Anselmo | School: School of Visual Arts | Department: Graphic Design | Department Chair: Richard Wilde

88 Map | Art Director/Writer: Igor Josef Brodsky | Instructor: Frank Anselmo | School: School of Visual Arts | Department: Graphic Design | Department Chair: Richard Wilde

Advertising/Sports
89 Couch | Art Director/Writer: Jeseok Yi | Instructor: Frank Anselmo | School: School of Visual Arts | Department: Graphic Design | Department Chair: Richard Wilde

90 Raise a Champion | Art Director: Nicolas Schmidt-Fitzner | Copywriter: Tara Lawall | Instructors: Jan Rexhausen, Niklas Frings-Rupp | School: Miami Ad School Europe | Department: Advertising | Department Chair: Niklas Frings-Rupp

Design/Annual Reports
92 2007 Coca-Cola Annual Report | Art Director: Ashley Ayres | Instructor: David Bennett | School: The Art Institute of Houston | Department: Graphic Design | Department Chair: Arden De Brun
Description: The concept is "Now and Then," and focuses on Coca-Cola's long life. The front color cover features today's trends, and the back cover shows what used to be in black and white. It demonstrates how the more things change, the more they stay the same. Coke has been an unchanging product despite popular trends.

Design/Books
93 The Accident | Art Director: Michael Irwin | Creative Director: John Fulbrook | Photographer: Mark Dye | School: School of Visual Arts | Department: Graphic Design | Department Chair: Richard Wilde

94 Drowned Book Jacket | Art Director: Thomas Wilder | Instructors: Lanny Sommese, Kristin Sommese | School: Penn State University | Department: Integrative Arts | Department Head: William Kelly | Dean of Arts and Architecture: Barbara Korner

95 Book Jackets | Art Director: Minhee Park | Creative Directors: Kevin Brainard, Darren Cox | School: School of Visual Arts | Department: Graphic Design | Department Chair: Richard Wilde

96, 97 Bret Easton Ellis Book Series | Art Director: Ramond Ferraro | Creative Director: Tracy Boychuk | School: School of Visual Arts | Department: Graphic Design | Department Chair: Richard Wildev

98 (top) Robert Ludlum Trilogy | Art Director: Jennifer Peake | Instructor: Melissa Kuperminc | School: Portfolio Center | Department: Design | Department Chair: Hank Richardson

98 (middle) Ted Kooser Book | Art Director: Dave Whitling | Instructor: Nicole Riekki | School: Portfolio Center | Department: Design | Department Chair: Hank Richardson

98 (bottom) Elie Wiesel Book Trilogy | Art Director: Audrey Gould | Instructor: Melissa Kuperminc | School: Portfolio Center | Department: Design | Department Chair: Hank Richardson

99 Typographism | Art Director: Gemma Bayly | Instructor: Patrick Dooley | School: University of Kansas | Department: Department of Design | Department Chair: Gregory Thomas
Description: This was designed as a leave-behind at job interviews. It was initially assigned as a folded, 4-panel print piece that conveyed a sense of self in typographic form. From the original concept of Typography as a religion, the book grew to be far more than what was expected. The targeted audience is fellow designers who appreciate, understand, and execute good typographic

skills. In comparing the practice of typography to an established religion, which includes a prayer, commandments, and saints, *Typographism* aims to speak to the spiritual nature of the designer's labor of love: the adoration of the letterform in all its beauty.

100 Zaha Hadid Monograph | Designer: Laura Pocius | Instructor: Richard Poulin | School: School of Visual Arts | Department: Graphic Design | Department Chair: Richard Wilde

101 A Vermont Tale Bookjacket | Art Director: Andrew Schoonmaker | Instructor: Richard Poulin | School: School of Visual Arts | Department: Graphic Design | Department Chair: Richard Wilde

102 Graduation Works Document: Hongik Visual Communications Design 2007 | Designer: Hyemi Choi | Design Director/Typographer: Jaewon Seok | Photographer: Jeongin Kim | Editors: Serom Park, Jin Kang | Instructor: Ahn Sang-Soo | School: Hongik University | Department: Department of Visual Communication Design | Department Chair: Don Ryun Chang
Description: This specially bound book was designed with the least graphic elements to best show the works of 100 students. The book introduces Hongik students internationally in 4 languages: Korean, English, Japanese and Chinese.

103 Shakespeare Book Covers | Art Director: Takashi Kasui | Creative Director: Michael Ian Kaye | School: School of Visual Arts | Department: Graphic Design | Department Chair: Richard Wilde

104, 105 Spectrum | Art Director: Jesse Kirsch | Creative Director: Chad Roberts | School: School of Visual Arts | Department: Graphic Design | Department Chair: Richard Wilde

106 Children's Army Kit | Artist/Designer/Illustrator/Writer: Matylda Bierdron | Associate Professor: Scott Laserow | School: Tyler School of Art/Temple University | Department: Graphic and Interactive Design | Department Chair: Alice Drueding

107 Are You Here? | Art Director/Designer/Photographer/Typographer: Kylie Phillips | Instructor: Mark Bradford | Location: Woodward Street, Wellington | School: Massey University | Department: College of Creative Arts (School of Design) | Department Chair: Claire Robinson
Description: Are you sometimes so focused on where you're going that you're oblivious to where you are? What would you do if you stopped and took the time to see what was around you? Would you willingly be a fly-on-the-wall and knowingly enter a public place with the intent of intruding on private exchanges? These were some of the questions posed, and the work reveals what was seen over 1197 minutes in Woodward Street, Wellington. Are You Here? is an ethnographic exploration of the interaction between a place of transience and those who pass through it. By investigating the contexts of contemporary culture, a candid social commentary can be offered on the human relationship to a specific place in time. Acting as a tour guide, this work aims to navigate the viewer through a maze of disordered, chaotic reality. From the banal to the throwaway, conversations have been recorded, behaviors observed, and discarded objects collected. Through documentation, preservation and translation of ephemeral artifacts, a visual heritage of the everyday is generated. If you were to really stop and look, what would you see?

Design/Branding
108, 109 Claude Maus Branding | Designer: Tyler Smart | Instructor: Adrian Pulfer | School: Brigham Young University | Department: Visual Arts | Department Chair: Linda Sullivan

110 Continental Airlines Branding | Designer: Austin Taylor | Instructor: Adrian Pulfer | School: Brigham Young University | Department: Visual Arts | Department Chair: Linda Sullivan

111 The Room Branding | Designer: Tyler Smart | Instructor: Adrian Pulfer | School: Brigham Young University | Department: Visual Arts | Department Chair: Linda Sullivan

112 Art Director: Takashi Kasui | Creative Director: Michael Ian Kaye | School: School of Visual Arts | Department: Graphic Design | Department Chair: Richard Wilde

113 Rag + Bone Branding | Designer: Nick Mendoza | Instructor: Adrian Pulfer | School: Brigham Young University | Department: Visual Arts | Department Chair: Linda Sullivan

114, 115 Cycles Gladiator Wine | Art Director: Ashley Ayres | Instructor: Michele Damato | School: The Art Institute of Houston | Department: Graphic Design | Department Chair: Arden De Brun
Description: I re-designed the original logo because I felt the imagery and type did not match the name's sound. The logo was very feminine, and I decided to make it more masculine. Cycles Gladiator Wine has a bicycle theme. I put an extra spin on the logo by replacing the old-fashioned bicycle with an old-fashioned motorcycle. Instead of a woman's illustration in the logo, I replaced it with a man wearing a top hat. The typography was hand-illustrated with pen and ink, and the illustration of the man was created with scratch board. The time period stays the late 1800s/early 1900s.

Design/Brochures
116, 117 Helvetica Wonder Book | Designer: Suhee Eom | Instructor: Eunsun Lee | School: Pratt Institute | Department: Graduate Communication Design | Department Chair: Roger Guilfoyle
Description: This brochure was made as a school assignment to promote one typeface. I chose the popular Helvetica, and titled it *Helvetica Wonder Book-the hottest typeface at 50*. The images inside are visual puns on each thickness of Helvetica Neue.

Design/Calendars
118, 119 Inspirations 2008 | Designer: Nicole Adelt | Instructors: Thomas Rempen, Volker Küster | School: Universitaet Duisburg Essen | Department: Kunst & Design | Department Chair: Claus Koch

Description: Big ideas start with a little scribble. We asked 12 outstanding personalities to give us initial sketches of their revolutionary ideas. Dressage World Championship, Jardin des Tuileries, Swiss Passport, cultbags, cooking, cars. These wonderful thoughts should inspire ideas in all of us.

120 (top), **121**(top) Comparative Statistics | Designer: Kevin Tzu-Shuan Lu | Art Director: Randall Sexton | School: San Jose State University | Department: Graphic Design | Department Chair: Randall Sexton

Description: Design a Bay Area (Redwood City Wharf) tide prediction diagram for each 24 hour day in June 2007. The information should be organized and easily accessible in both macro/micro views; the visual hierarchy should be presented.

120 (bottom), **121** (bottom) Twilit Motion Calendar | Designer/Photographer/Typographer: Jillian Haney | Art Director: Kristin Sommese | Location: The Hite Company: State College, PA | School: Penn State University | Department: Integrative Arts | Department Head: William Kelly | Dean of the College of Arts and Architecture: Barbara Korner

Design/Creative Exploration
122 Hanger Steak | Art Director: Alexis Shields | Creative Director: Kevin O'Callaghan | School: School of Visual Arts | Department: Graphic Design | Department Chair: Richard Wilde

123 NY Yellow Taxi Cab Carriage | Art Director: Sofia Limpantoudi | Creative Director: Kevin O'Callaghan | School: School of Visual Arts | Department: Graphic Design | Department Chair: Richard Wilde

124 Alchemist Chess Set | Art Director: Erin Scally | Creative Director: Kevin O'Callaghan | School: School of Visual Arts | Department: Graphic Design | Department Chair: Richard Wilde

125 Flower Drain | Artist: Leon Antar | Creative Director: Kevin O'Callaghan | School: School of Visual Arts | Department: Graphic Design | Department Chair: Richard Wilde

Design/Editorial
126, 127 Magazine Covers | Art Director: Ka Young Lee | Creative Director: Robert Best | School: School of Visual Arts | Department: Graphic Design | Department Chair: Richard Wilde

128 Ninth Letter | Art Directors: Jennifer Gunji, Daniel Goscha | Designers: Travis Austin, Aditya Bhargava, Samuel Copeland, Kelly Cree, Lauren Emerson, Sarah Esgro, Lauren Ferguson, Adam Fotos, Mark Hauge, Sarah Kowalis, Jonathan Lopez, Elise McAuley, Jessica Mullen, Archana Shekara, Brett Talbot, Ho-Mui Wong | Design Directors: Jennifer Gunji, Daniel Goscha | Chief Creative Officers: Jennifer Gunji, Nan Goggin, Joseph Squier | Creative Director: Jennifer Gunji | Editor: Jodee Stanely | School: University of Illinois at Urbana-Champaign School of Art and Design | Department: Graphic Design | Department Chair: Jennifer Gunji

Description: Ninth Letter began as an interdisciplinary collaboration between UIUC's MFA in Creative Writing Program and School of Art+Design Graphic Design Program. Our intent was to position ourselves as a hybrid at the intersection of visual and literary culture by developing a literary/arts journal produced by faculty and students in both programs and to feature original content from national and international writers and artists. We wanted to support traditional forms of writing but also reinvent and reinvigorate the definition of a literary journal.

129 Anthem Magazine | Art Director/Designer: Nick Mendoza | Instructor: Adrian Pulfer | School: Brigham Young University | Department: Visual Arts | Department Chair: Linda Sullivan

130, 131 Interventions | Art Director: Juhyun Park | Creative Director: Henrita Condak | Photographer's Assistant: Barbara Linz | School: School of Visual Arts | Department: Graphic Design | Department Chair: Richard Wilde

132, 133 Life/Love | Art Director: James Marababol | Creative Director: Cristos Gianakos | School: School of Visual Arts | Department: Graphic Design | Department Chair: Richard Wilde

134, 135 ARENA Magazine | Art Director/Designer: Arlo Vance | Instructor: Adrian Pulfer | School: Brigham Young University | Department: Visual Arts | Department Chair: Linda Sullivan

136, 137 PLAZA Magazine | Art Director/Designer: Libby Egan | Instructor: Adrian Pulfer | School: Brigham Young University | Department: Visual Arts | Department Chair: Linda Sullivan

138 History of Photography in Paris | Art Director: Minhee Park | Creative Directors: Kevin Brainard, Darren Cox | School: School of Visual Arts | Department: Graphic Design | Department Chair: Richard Wilde

139 Dance Magazine Redesign | Designer: Laura Pocius | Instructor: Richard Poulin | School: School of Visual Arts | Department: Graphic Design | Department Chair: Richard Wilde

140, 141 Type Specimen Newspaper | Art Director: Ka Young Lee | Creative Director: Tracy Boychuk | School: School of Visual Arts | Department: Graphic Design | Department Chair: Richard Wilde

142 Dojo Magazine | Designer/Illustrator/Photographer/Typographer/Writer: Jase Neapolitan | Creative Director: Lanny Sommese | School: Penn State University | Department: Integrative Arts | Department Head: William Kelly | Dean of Arts and Architecture: Barbara Korner

Description: An experimental magazine about martial arts. The spreads include a table of contents, an introduction to a photo essay, and an illustration.

143, 144, 145 Rolling Stone | Art Director: Emily Kim | Creative Directors: Terry Koppel, Genevieve Williams | School: School of Visual Arts | Department: Graphic Design | Department Chair: Richard Wilde

146 (top) Art Director/Designer/Illustrator/Photographer/Typographer: Jennifer Way | Professor: Lanny Sommese | School: Penn State University | Department: Graphic Design | Department Head: William Kelly | Dean of Arts and Architecture: Barbara Korner

Description: This is a photo essay about an up-and-coming indie actress for the magazine *Kitsch. Kitsch* focuses on vintage clothing and mid-century decor, designed to appeal to younger women in their 20s to 30s with an appreciation for quirky design.

146 (bottom) Designer/Photographer/Stylist/Typographer: Nicole Angelica | Creative Director: Kristin Sommese | Model: Sarah Allen | School: Penn State University | Department: Graphic Design | Department Head: William Kelly | Dean of Arts and Architecture: Barbara Korner

147 (top) Hide & Seek | Designer/Photographer: Kaleena Porter | Creative Director: Kristin Sommese | Model: Pearly Huang | School: Penn State University | Department: Integrative Arts | Department Head: William Kelly | Dean of Arts and Architecture: Barbara Korner

Description: The 3 page fashion spread is meant for a high fashion magazine. It features a vintage dress and takes on the story of a girl who has nobody to play with. A type and image relationship is used to showcase the dress within the spreads.

147 (bottom) Art Director/Designer/Photographer/Stylist/Typographer Madelyn Owens | Creative Director: Kristin Sommese | Model: Amber Chandler | School: Penn State University | Department: Graphic Design, School of Integrative Arts | Department Head: William Kelly | Dean of Arts and Architecture: Barbara Korner

Design/Events
148, 149 Swiss Spasssport | Designer: Susanne Meyer | Chief Creative Officer: Claus Koch | Design Director: Michael Mehler | Instructor: Andrea Rauschenbuch | School: Fachhochschule Muenster | Department: Design | Department Chair: Claus Koch

Description: Invitation for our company's 15th anniversary. All of us are invited on a 3 day trip to Zurich. The employees receive a personalized Swiss Spassport. Integrated Visa cards highlight the events of the trip. Visa stamps point out interesting sights in Zurich.

Design/Exhibitions
150, 151 It's All About the Information | Art Director/Designer/Artist/Writer/Photographer: Doug Thomas | Photographer: Steve McCurry | Creative Strategists: Doug Thomas, Adrian Pulfer, Eric Gillett | Instructor: Adrian Pulfer | School: Brigham Young University | Department: Graphic Design, Visual Arts | Department Chair: Linda Sullivan

Design/Illustration
152 Image Generation | Art Director: Victor Barreto | Instructor: Theron Moore | School: California State University, Fullerton | Department: Visual Arts | Department Chair: Larry Johnson

Design/Interactive
153 Chromesthesia | Designer/Illustrator/Photographer: Kyle Cook | Instructor: Jody Graff | School: Drexel University Antoinette Westphal College of Media Arts & Design | Department: Media Arts | Department Chair: Sandy Stewart

Design/Letterhead
154 Road Show Stationery | Designer: Marina Linderman | Instructor: Alice Drueding | School: Tyler School of Art/Temple University | Department: Graphic and Interactive Design | Department Chair: Alice Drueding

Description: Road Show is a traveling theatre troupe that performs plays for children based on Russian fairytales. This stationery captures the character of the group through hand-crafted typography, reference to simple, rustic materials and color.

Design/Logo
155 Hijacking Logo Series | Art Director: Takashi Kusui | Creative Director: Ji Lee | School: School of Visual Arts | Department: Graphic Design | Department Chair: Richard Wilde

Description: Political logos commentin on human rights abuses and their relations to the 2008 Beijing Olympics.

156 (top) Vampire Video | Art Director: Inez Guevara | Instructor: Henry Hikima: School: The Art Institute of California-San Diego: Department: Graphic Design: Department Chair: John Judy

156 (2nd from top) Pennsylvania Prescribed Fire Council | Designer/Illustrator: Kelsey Walsh | Professor : Lanny Sommese | School: Penn State University | Department: Graphic Design | Department Head: William Kelly | Dean of the College of Arts and Architecture: Barbara Korner

156 (middle) Knee | Art Director: Drea Zlanabitnig | Creative Director: Richard Mehl | School: School of Visual Arts | Department: Graphic Design | Department Chair: Richard Wilde

156 (2nd from bottom) Japan Cafe | Artist: Daniela A. Ponce | Instructor: Henry Hikima | School: The Art Institute of California-San Diego | Department: Graphic Design | Department Chair: John Judy

156 (bottom) Ink Tank Logo | Art Directors: Jonis Perez, Peter Delgado, Gabriel Soria Meza, Luis Cazares | Instructor: Lora Kueneman | School: The Art Institute of California, San Diego | Department: Graphic Design | Department Chair: Amin Khalil

157 Knyts Logo | Designer: Jennifer Peake | Instructor: Jeff Faught | School: Portfolio Center | Department: Design | Department Chair: Hank Richardson

158 Hair | Art Director: Dréa Zlanabitnig | Creative Director: Richard Mehl | School: School of Visual Arts | Department: Graphic Design | Department Chair: Richard Wilde

159 (top) NYC Lettering | Art Director: Jarrod Barretto | Instructor: Richard Mehl | School: School of Visual Arts | Department: Graphic Design | Department Chair: Richard Wilde

159 (2nd from top) Blind Pig Pub | Art Director: Steven Skadal | Instructor: Jeff Davis | School: Texas State University-San Marcos | Department: Art & Design | Department Chair: Erik Nielsen

Credits&Comments

Description: This bottle can be sent as a promotional piece to other designers on the holiday. It's a unique holiday, making it socially acceptable to curse and swear and say all the bad words you can think of. A dictionary of navy curse words comes in the box.

Description: Bath and body line designed specifically for men who spend most of the day at the gym or thinking about the gym. The bottles take the form of a dumbbell set, bound by a band created partially of jockstrap elastic. Manly men can feel comfortable pampering themselves because of the product's visuals.

Description: Nutritious snack for dogs. Objective was to develop a creative, 3-part package including brand name and product concept.

Description: Kirei, a bathing product company, takes on a marketing strategy to sell the most ordinary product—towels—in an extraordinary way. Towel's purpose is to clean. To expand its strength, the towels are packaged as a pencil, acting as the "eraser." They can be sold as an individual pencil or eraser or as a pack of colourful pencil crayons!

Description: Celebritology is a kit of religious materials that provides you with everything you need to become smarter, wealthier, sexier, and skinnier. Various stars were chosen as the embodiment of Celebritology, including Oprah Winfrey, Our Lady of Personal Empowerment, Donald Trump, The Patron Saint of Financial Misfortune, and Paris Hilton, Our Lady of Undeserved Fame. Included in this kit are candles, prayer cards, matches and an altar.

Description: Objective – To create a 3-part package, including a new brand name, container selection and system of product differentiation. This is a new way to protect a camera lens with metal containers and an upgraded image.

Description: No End in Sight is a documentary on the aftermath of the Iraq war. It contains a series of insider interviews and reveals the disastrous outcomes of the war. I wanted to show that even though the occupation of Baghdad was completed years ago, the war is lagging and peace is still far away. Hussein's fallen statue symbolizes a U.S. victory, but in the poster, a Black Hawk is dragging the heavy statue, which keeps it from speeding up, soaring to the sky, or flying back home.

Description: I designed an identity for International Water Association, a non-profit aimed at water conservation. This included posters for a bus stop. The earth is 97% water and our bodies are 70% water. The creatures made of water images depict that water is the most important nutrient keeping us alive.

202 Slasher Film Posters | Designer: Heather Rosenfeldt | Art Director: Kelly Holohan | School: Tyler School of Art/Temple University | Department: Graphic and Interactive Design | Department Chair: Alice Drueding

203 Horror Film Festival Poster Series | Designer: Sarah McLaughlin | Art Director: Kelly Holohan | School: Tyler School of Art/Temple University | Department: Graphic and Interactive Design | Department Chair: Alice Drueding

204 Fobiskolen | Designer: Lene Hojland Bergh-Hansen | Instructor: Peter Gyllan | School: Danmarks Designskole | Department: Visual Communication | Department Chair: Tine Kjolsen

Description: A 3-in-1 poster for the play "Fobiskolen" (The Fobia School) about 6 people suffering from severe phobias and 2 therapists trying to cure them. The play is devided in 3 parts performed over 3 nights. The poster(s) is also divided into 3 pieces that can function individually—but when all are put together it creates a whole new image (the word FOBI). The play was written and performed by the Danish theatre Mammutteatret in February-March 2008, Copenhagen, Denmark.

205 Mask Exhibition | Art Director: Monica Alverca | Creative Director: Chris Austopchuk | School: School of Visual Arts | Department: Graphic Design | Department Chair: Richard Wilde

206 Call for Entries | Art Director: Sanghee Jin | Creative Director: Tracy Boychuk | School: School of Visual Arts | Department: Graphic Design | Department Chair: Richard Wilde

207 Dreaming | Art Director: Jaeyoun Sung | Creative Director: William Morrisey | School: School of Visual Arts | Department: Graphic Design | Department Chair: Richard Wilde

208, 209 Radiohead | Art Director: Benjamin Thompson | Creative Directors: Kevin Brainard, Darren Cox | School: School of Visual Arts | Department: Graphic Design | Department Chair: Richard Wilde

210, 211 Grandfather Clock/Dollar Watch | Designer: Suhee Eom | Instructor: Bob Gill | School: Pratt Institute | Department: Graduate Communication Design | Department Chair: Roger Guilfoyle

Description: This series promotes a new collection at West Coast Clock Museum, which has an horologic collection of diverse clocks and watches, from grandfather clocks to dollar watches.

Design/Products
212 Hanging Adjustable Vase | Art Director: Sofia Limpantoudi | Creative Director: Kevin O'Callaghan | School: School of Visual Arts | Department: Graphic Design | Department Chair: Richard Wilde

213 Chiral Lamp | Designer: Rachel Strubinger | Instructor: Hank Richardson | School: Portfolio Center | Department: Design | Department Chair: Hank Richardson

214 Embrace Chair | Designer: Amanda Babcock | Instructor: Hank Richardson | School: Portfolio Center | Department: Design | Department Chair: Hank Richardson

215 Morris Lounge | Designer: Dave Whitling | Instructor: Hank Richardson | School: Portfolio Center | Department: Design | Department Chair: Hank Richardson

216 The Sister Chair | Designer: Rachel Strubinger | Instructor: Hank Richardson | School: Portfolio Center | Department: Design | Department Chair: Hank Richardson

217 One Memory Chair | Designer: Kevin Scarbrough | Instructor: Hank Richardson | School: Portfolio Center | Department: Design | Department Chair: Hank Richardson

218 Personae Chair | Designer: Mike Kelly | Instructor: Hank Richardson | School: Portfolio Center | Department: Design | Department Chair: Hank Richardson

Design/Promotion
219 The Smart Cookie | Art Director: Sharon Huang | Instructors: John Drew, Arnold Holland, Theron Moore, Jerry Samuelson | School: California State University Fullerton | Department: Graphic Design | Department Chair: Larry Johnson

220, 221 Celebration of the Feminine | Designer: Clara Daguin | Instructor: Eric Heiman | School: California College of the Arts | Department: Graphic Design | Department Chair: Cinthia Wen

222 Ideal Design | Art Director: Jase Neapolitan | Creative Director: Fang Chen | School: Penn State University | Department: Integrative Arts | Department Head: William Kelly | Dean of College of Arts and Architecture: Barbara Korner

223 Art Director: Melinda Haverstock | Instructor: John Drew | School: California State University, Fullerton | Department: Visual Arts | Department Chair: Larry Johnson

Design/Shopping Bags
224 Rockin' Rattle Shopping Bag | Art Director: Thomas Wilder | Creative Directors: Lanny Sommese, Kristin Sommese | School: Penn State University | Department: Integrative Arts | Department Head: William Kelly | Dean of College of Arts and Architecture: Barbara Korner

Description: This baby store was meant for rock stars who want their child to follow in their footsteps through music, fashion, etc.

225 Fromagerie Shopping Bags | Designer: Natalie Little | Art Director: Kristin Sommese | School: Penn State University | Department: Graphic Design | Department Head: William Kelly | Dean of College of Arts and Architecture: Barbara Korner

Description: The task was to create a shopping bag for a fictional cheese shop. I imagined a small, exclusive French cheese shop in Soho, called Lune. It is small, modern, and completely decorated in shades of white, stainless steel, and accented in royal blue. The bags reflect the atmosphere of the shop and the product's form.

226 Gadget Outlet | Art Director: Victor Barreto | Instructor: Theron Moore | School: California State University, Fullerton | Department: Visual Arts | Department Chair: Larry Johnson

227 Designer: Melinda Haverstock | Creative Director: Theron Moore | School: California State University, Fullerton | Department: Visual Arts | Department Chair: Larry Johnson

228 Art Director: Amy Wu | Creative Director: Steven Brower | School: School of Visual Arts | Department: Graphic Design | Department Chair: Richard Wilde

229 Elroy's Swell Toys Shopping Bag | Designer: Ethan Dahl | Creative Director: Kristin Sommese | School: Penn State University | Department: Graphic Design | Department Head: William Kelly | Dean of College of Arts and Architecture: Barbara Korner

Description: Elroy's Swell Toys features retro-style toys like wind-up cars, classic board games, Erector sets, and metal robots. The toy store's shopping bag features Elroy the robot, complete with light-up eyes and retractable antenna action.

Design/Typography
230, 231 Strata Typeface | Art Director: Isabelle Rancier | Creative Director: Tracy Boychuk | School: School of Visual Arts | Department: Graphic Design | Department Chair: Richard Wilde

232 Desginer: Nicole Angelica | Creative Director: Fang Chen | School: Penn State University | Department: Graphic Design | Department Head: William Kelly | Dean of College of Arts and Architecture: Barbara Korner

233 A Typographic Specimen | Art Director: Gemma Bayly | Instructor: Patrick Dooley | School: University of Kansas | Department: Department of Design | Department Chair: Gregory Thomas

Description: The task was to develop an opinion of Jan Tschichold's approach to Typography, and to visually portray that opinion. I concluded that Tschichold treated Typography as a science, delicately handling letterforms with very strict, mathematical logic, resulting in instinctual, natural design. Typography is not unlike the animal kingdom, with different species (fonts) and classifications (weights). Each typeface (species) has its own unique characteristics, yet retains a common thread (or DNA) that makes it legible. I created a typographic specimen box, featuring 'Garamondius Genus.' Each part is labeled with a fictional latin name, such as 'Boldius Maximus.' The specimen is a quote from Tschichold that summarizes his approach.

234, 235 From States to Plates | Designer: Jessie Sayward Bright | Art Director: Joe Scorsone | School: Tyler School of Art/Temple University | Department: Graphic Design | Department Chair: Stephanie Knopp

Description: This kit educates buyers about regional food history via packaging of ingredients specific to parts of the continental U.S. (e.g.,The South is represented by peanuts and George Washington Carver; New England is represented by maple syrup and Lucretia Mott.) The typography was hand-done to reference old painted signs one might see roadside, driving through the U.S.

236 Letterpress Type Buildings Postcards | Designer: Jenny Willardson | Instructor: Linda Sullivan | School: Brigham Young University | Department: Visual Arts | Department Chair: Linda Sullivan

237 Typeface-Hangulish | Art Director: SeungWon Lee | Creative Director: Richard Mehl | School: School of Visual Arts | Department: Graphic Design | Department Chair: Richard Wilde

238, 239 Containment: The Global Congnizance Issue | Art Director: Dréa Zlanabitnig | Creative Director: Jeff Glendenning | School: School of Visual Arts | Department: Graphic Design | Department Chair: Richard Wilde

240, 241 Futura's New Look | Art Director: Kylie Phillips | Instructor: Mark Geard | School: Massey University | Department: College of Creative Arts (School of Design) | Department Chair: Claire Robinson

Description: The intention of this brief was to re-energise interest for a chosen font in an unexpected manner through print media in the form of a novelty broadsheet (serving 2 requirements: a book cover and when unfolded a type specimen poster) and an interior booklet. Paul Renner's Futura was selected. It was Renner's association with the Bauhaus that was employed as the inspiration for this promotional item. The key idea was form follows function. Functional sewing patterns in light of the industrial revolution and mass production have been used as the foundation for the thematic visual narrative. Pattern pieces are perforated, and, in theory, could be cut-out to create new compositions and highlight individual letterforms. The sewing and a pastel coulour palette offer a softer, more feminine alternative to the bold Futura often presented. "New Look" is also the pattern manufacturer's name.

242 Made for Work | Art Director: Allison Weiner | Account Director: Emily McVarish | School: California College of the Arts | Department: Graphic Design | Department Chair: Cinthia Wen

Description: Lettering created for a book about Potrero Point, a locus of heavy industry since the 1860s. I photographed the deserted grounds and then merged fragments of the photos with bits of letters. The book charts the site's development and decline through factory workers' memories.

Photography/Portrait
244 Art Brewer | Artist: Heather McGrath | Instructors: Dana Smith, Stephen Sheffield | School: New England School of Photography | Client: Jean Gardner & Assoc.

245 Experimental Photography | Designer: Jillian Haney | Art Director: Kristin Sommese | School: Penn State University | Department: Integrative Arts | Department Head: William Kelly | Dean of College of Arts and Architecture: Barbara Korner

Description: Meant to disorient viewers and leave them intrigued.

AwardWinningStudentsIndex

AwardWinningInstructorsIndex

AwardWinningSchools

DepartmentChairs

PlatinumWinningInstructors

SchoolDirectory

How to dramatically save on Graphis Books:

Standing Orders: Get 50% off the list price on new Graphis books when you sign up for a Standing Order on any of our annual books or other titles that repeat every 2 to 5 years.

A Standing Order is a subscription to Graphis books with an annual commitment. Guarantee your favorite Graphis titles with our best deal at www.graphis.com. Click on Annuals, and add your selections to your Standing Order list, and save 50%.

Graphis Titles

DesignAnnual2009

Summer 2008
Hardcover: 256 pages
200-plus color illustrations

Trim: 8.5 x 11.75"
ISBN:1-932026-13 4
US $70

GraphisDesignAnnual2009 assembles an international trio of Designers as New York's **Stefan Sagmeister**, South Korea's **Ahn Sang-Soo**, and Pentagram London's **Harry Pearce** present their sagacious views on Design under the theme of "What's Personal Is Universal." Features over 300 award-winning designs in 30-plus categories by industry standouts like **Ogilvy, TAXI Canada, Frost Design, BBDO, Melchior Imboden, Turner Duckworth**, and **RBMM**, among several others.

PhotographyAnnual2009

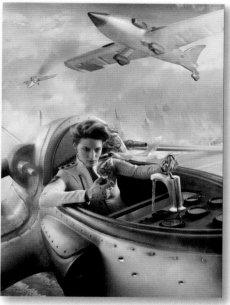

Winter 2008
Hardcover: 240 pages
200-plus color illustrations

Trim: 8.5 x 11.75"
ISBN: 1-932026-50-9
US $70

GraphisPhotographyAnnual2009 features a symposium of internationally respected Photography curators. Expert contributors in this issue include **Severine Pache** of the Swiss Camera Museum, **Tanya Kiang** of Dublin's Gallery of Photography, **Dr. Holger Broeker** of Germany's Kunstmuseum Wolfsburg, **Marie Laurberg** from Denmark's ARKEN Museum, **Greg Hobson** of the National Media Museum in England, and **Diana Edkins** of Aperture Foundation in New York.

AdvertisingAnnual2009

Fall 2008
Hardcover: 256 pages
300-plus color images

Trim: 8.5 x 11.75"
ISBN: 1-932026-52-5
US $70

GraphisAdvertisingAnnual2009 spotlights the year's best print ads from New York to New Delhi. This year, **Dangel Advertising** describes their latest Crate & Barrel campaign, **DeVito/Verdi** explains their Legal Sea Foods mock-newspaper ads, and **The Partners** discuss a unique outdoor exhibition for The National Gallery. Features 200+ Gold and Platinum winning ads from agencies like **The Martin Agency, MacClaren McCann, BVK** and **Goodby Silverstein & Partners**.

PosterAnnual'08/'09

Summer 2008
Hardcover:256 pages
300-plus color images

Trim: 8.5 x 11.75"
ISBN: 1-932026-12-6
US $70

GraphisPosterAnnual'08/'09 features a symposium of poster curators and collectors from MoMA, the German Poster Museum, Hong Kong Heritage Museum, Switzerland's Basler Afrika Bibliographien, Lahti Poster Museum, Cuba's Casa de las Américas, and Rene Wanner's Poster Page. Topics include selection criteria and current trends. Presenting over 200 of the year's best posters by Designers like **Milton Glaser, Niklaus Troxler**, and **Takashi Akiyama**, this is our best yet!

Available at www.graphis.com

www.graphis.com